GENERATION

25 Years of
Contemporary Art
in Scotland

Edited by
Moira Jeffrey

GENERATION

25 Years of
Contemporary Art
in Scotland

READER

National Galleries of Scotland
and Glasgow Life

Published by the Trustees of the National Galleries of
Scotland and Glasgow Life to accompany the series of
exhibitions, GENERATION: *25 Years of Contemporary Art
in Scotland*, held throughout Scotland during 2014.

Text © The contributors, Culture and Sport, Glasgow and
the Trustees of the National Galleries of Scotland, 2014

ISBN 978 1 906270 72 8

Designed and typeset in Solitaire by Dalrymple
Cover graphic designed by The Leith Agency
Printed in Spain on GardaMatt 135gsm by Grafos

The proceeds from the sale of this book go towards
supporting the GENERATION project.
www.generationartscotland.org

**This publication has been made possible thanks to the
support of British Council Scotland**

MANAGED AND FUNDED BY

SUPPORTED BY

IN PARTNERSHIP WITH

Moira Jeffrey

PREFACE

The GENERATION *Reader* tells the story of art and artists in Scotland in the last twenty-five years. The book can be read beside the GENERATION *Guide*, which provides detailed information about the artists and exhibitions in the GENERATION project, but it also stands alone as a collection of new essays and significant archive writings that capture a remarkable period.

In Nicola White's essay for this book, the novelist and former curator describes a recent meeting between herself and two artists in Glasgow. All of them are being interviewed for a television programme about the Glasgow art scene in the 1990s. 'What you remember depends on where you were standing,' she writes; 'the idea of a definitive version of the past, we agree, is laughable.' When dealing with a recent history, and one that continues to be made every day, there is a danger in imagining that any version can be complete or final. It is in this spirit that our commissioned essays are intended to provide very different and deeply personal perspectives as writers look back at individual artworks, moments and places in the story of recent contemporary art.

Similarly the selection of archive writings is a sample of very different kinds of voices, providing the textures of the time through the writings of artists and commentators. These texts range from fierce polemics and humorous reflections, to lyrical investigations of the nature of art making and of its role in the wider world. They are less about what artists specifically make, in art form or medium, than about the ways, the times and the places in which art is made.

If there is a common thread in this book it is how, in the last twenty-five years in Scotland, artists have worked from the immediate materials and resources to hand, how they have made new works from their lived experiences and imagined a future from the present. Their resources have been physical, intellectual and social: the things, ideas and people around them. Similarly we could not have produced this book without such resources and the kindness of the original authors, their

publishers and the many organisations who have supported, encouraged and often funded the work of the artists and writers involved.

By coincidence there is a single creative figure who bookends the publication: the Edinburgh-born novelist Muriel Spark. Louise Welsh explains that Spark's book *The Prime of Miss Jean Brodie* inspired her own writing, no matter how different their childhoods. Fiona Jardine uses the same novel to explore both art and education. As Jardine explains, the American philosopher of art Arthur Danto borrowed the title of his important 1974 essay *The Transfiguration of the Commonplace* from a treatise written by one of Spark's characters. 'I have coveted the title,' noted Danto, 'and resolved to steal it the moment I wrote something it might fit.' His words are a brilliant example of the way that artists (or writers or philosophers) collect what is useful and meaningful to them and how they create new material by transforming the everyday. We hope this book both describes and contributes to this process.

Louise Welsh is the author of six novels, most recently *A Lovely Way to Burn* (John Murray, 2014). She has written many short stories, articles and reviews and has written for the stage, including libretti for opera. She was writer in residence at the University of Glasgow and The Glasgow School of Art 2010–12.

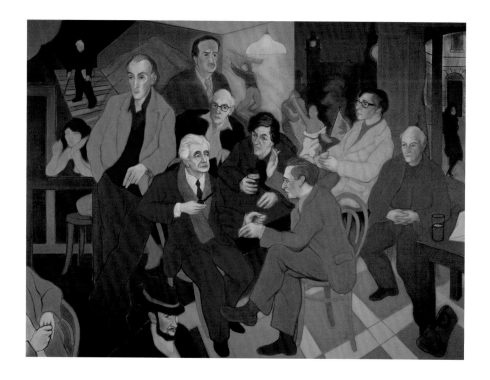

Alexander Moffat **Poets' Pub**, 1980
Scottish National Portrait Gallery, Edinburgh

INTRODUCTION: ABSENT VOICES, ABSENT VISIONS

Alexander Moffat's *Poets' Pub*[1] probably exemplifies how I imagined the world of art and literature when I was young. A klatch of erudite men gathered together in a pub with a few women constellated in their periphery, although in my imagination, unlike in the painting, the women had all managed to keep their tops on (while in the bar at least).

With the exception of Muriel Spark, whose *The Prime of Miss Jean Brodie* was entrancing (but as close to my Edinburgh childhood as Arcturus is to Glasgow), I was not introduced to the work of any Scottish women writers until long after I left school. Even *Sunset Song*'s fabulous Chris Guthrie had been conjured by a man. Think of all of those absent voices, the experiences lost to us, because they were not considered worthy of literature.

I read myself onto the page, as readers and artists who do not find themselves represented tend to do. My feet climbed the riven tower in Robert Louis Stevenson's *Kidnapped*, I screwed up my courage and descended into Hell with Sir Walter Scott's Wandering Willie, I issued tickets and despair with James Kelman's *Bus Conductor Hines*. Later I shot up in grungy flats with Irvine Welsh's Sick Boy, Renton *et al.*, and disposed of the body of my – I mean Alan Warner's, Morvern Callar's – dead boyfriend.

Throughout this time I read women authors and poets – Beryl Bainbridge, Doris Lessing, Mary Wollstonecraft Shelley, Maya Angelou, E. Nesbit and others, but Scottish writing seemed as male as it was white and heterosexual. Writers like James Kelman, Tom Leonard, Irvine Welsh and Alan Warner showed me that working-class experience was worthy of the page, but Scottish women writers seemed elusive. I experimented with a sub-Kelman dialogue and wrote stories about the closing of shipyards I had never entered. My stories also owed a debt to the pictures of Muirhead Bone, but they were no good. Unlike Bone I had never heard the noise of the shipyards, never experienced the smell of saltwater and steel.

In Alasdair Gray's *Lanark*, art student Duncan Thaw tells a friend who has asked why no one notices how magnificent Glasgow is, 'Think of Florence, Paris, London, New York. Nobody visiting them for the first time is a stranger because he's already visited them in paintings, novels, history books and films. But if a city hasn't been used by an artist, not even the inhabitants live there imaginatively.'[2] Perhaps something similar is true of becoming a creative artist. If particular sexualities, classes, ethnicities or genders are un(der)represented, it is hard for aspiring artists whose profiles do not fit to imagine themselves into the role.

I came to Glasgow in the mid-eighties. I was writing, but was not yet a writer, arty but not an artist. It was still possible to glimpse the city Gray had started writing about in the 1950s. Tenements glowered blackly, unaware that soon they would be sandblasted. The shipyards still existed, but they were no longer the mass employers they had been. It was a time rather like our own, a period of unemployment and low wages presided over by a right-wing government. It was also the era of the new Glasgow Boys: Steven Campbell, Ken Currie, Peter Howson and Adrian Wiszniewski (part of the generation before GENERATION). I was drawn particularly to the work of Currie and Howson. They seemed to be exploring visually some of the same themes that attracted me in literature: the lives of ordinary people, Scottish labour history, the bleakness of poverty and people's responses to it. The shipyards featured in some of their work too, but the Glasgow I arrived in seemed to have turned its back on the River Clyde. Prospects were bleak, but there was a buzz of creativity in the city. Poetry, novels and visual art were being produced by people inside and outside of the city's universities and art colleges. Bars like the Scotia and the Clutha hosted readings and jam sessions. There was culture for the making and the taking, if you were inclined to seek it out. Some decaying industrial buildings were turned into cheap studios for artists. And so ironically the source of the city's economic ills and their social consequences provided spaces in which some people managed to give artistic expression to those same concerns. It was not a straight swap. No one asked, 'would you rather have heavy industries or artists' studios?' Artists and writers are colonists. They slip into the gaps left by society, sometimes because the only space available to them lies in the gaps.

Glasgow experienced a dramatic change of image when it became European Capital of Culture in 1990. It was no longer simply perceived as a failing post-industrial city burdened by poverty and violence. It began to feature in tourist guides as a place where interesting things happened, a town where Turner Prize nominees and winners were nurtured.

A much-quoted philosophical thought experiment inspired by George Berkeley asks, 'Does a tree make a sound in a forest if no one is there to hear it?' The benefits of 1990 to the city went beyond a change of image, but artists and writers were creating interesting work before the year of culture prompted visits from London journalists. And of course not everyone benefited. As Professor Andrew Hook states, 'Real suffering and real pain lie in the world outside art galleries, and outside the pages of novels.'[3] But political activism and art are mainstays of how we express these conditions. The ability to explore, respond and give voice to the world around us is the essence of being a creative artist. That is why art is not

always beautiful and is frequently at odds with agencies who try to use it for propaganda. It is also why it is essential that artists and their voices are not confined to one class, sexuality, ethnicity or gender.

In 2013 representation of women in the Scottish Parliament increased from 33 per cent to 35.7 per cent, better than the UK Parliament where men currently outnumber women by four to one, but still some way short of equal representation. The gender pay gap in 2013 was 15 per cent. Parity is also missing from the media. In a typical month, 78 per cent of newspaper articles are written by men, 72 per cent of *Question Time* contributors are men and 84 per cent of reporters and guests on Radio 4's *Today* programme are men. Women continue to be under-represented in business, the justice system, education, defence and the arts.[4]

The fight for equality goes on. But as GENERATION's exploration of the last twenty-five years of contemporary art in Scotland demonstrates, many women are succeeding in making world-class art in Scotland. They include Alison Watt, Lucy Skaer, Corin Sworn, Sara Barker, Christine Borland, Karla Black … I could go on. Between March and November 2014 100 artists will exhibit work in over sixty galleries across the country. It seems that no one in Scotland will ever be far from a GENERATION exhibition.

We are not yet in a post-feminist age, but the 2014 Poets' Pub would look rather different to its 1980 incarnation. It might not even be a pub but, like GENERATION's various exhibitions, it would surely be crowded with women: Liz Lochhead, Jackie Kay, Vicki Feaver, Kathleen Jamie, Carol Ann Duffy and so many others (all fully dressed). But it is not yet time for celebration. Despite the increasing diversity of the central belt, writers and artists of colour are still under-represented. Even in twenty-first-century Scotland there are absent voices, absent visions. The ambitious scope of GENERATION will enable some young women and men to imagine what it might be like to be an artist. As Duncan Thaw suggests in Alasdair Gray's *Lanark*, being encouraged to imagine our cities, to imagine ourselves, is a step towards realising how magnificent we are. My hope is that it will also enable the emergence of another, brilliantly diverse, generation of artists in Scotland.

1 Alexander Moffat, *Poets' Pub*, 1980, oil on canvas, Scottish National Portrait Gallery, Edinburgh, PG 2597.

2 Alasdair Gray, *Lanark*, Edinburgh (first published 1981).

3 Andrew Hook, 'Irvine Welsh has lost the power to shock', *Scottish Review*, 18 December 2013, http://www.scottishreview.net/AndrewHook137.shtml

4 Statistics via The Fawcett Society, http://www.fawcettsociety.org.uk/

David Shrigley **The Explanation**, Drawing from *Err*, 1st edition, 1996, 8th edition, 2008
Courtesy the artist and Bookworks

AN EPLANATION

(OF SORTS, AS FAR AS IS POSSIBLE)

SOME MONTHS AFTER THE FIRST VOLUME WAS PUBLISHED WE ALL DECIDED TO SIT DOWN AND HAVE A GOOD LOOK THROUGH IT (THERE HAD BEEN SOME COMPLAINTS).

WE FOUND:

1. ERRORS IN ~~PRINTING~~ PRINTING (BACK TO FRONT, (UPSIDE-DOWN ETC.)

2. ERRORS IN ~~TEXT~~ TEXT (MISGUIDED GENERALISATIONS, GENERAL FALSEHOODS, ETC)

3. ERRORS IN ILLUSTRATIONS (USUAL KIND OF THING, ETC)

4. MIXED UP THEMES (NOT KNOWING WHAT YOU'RE TALKING ABOUT, ETC)

5. GENERAL ERRORS (TO DO WITH V. BASIC THINGS LIKE DIFFERENCE, ETC)

6. ERRORS OF A MORAL KIND (TOO MUCH EVIL ON ONE PAGE, E.T.C.)

WHAT FOLLOWS IS AN ATTEMPT TO HIGHLIGHT THESE ERRORS FOR THE BENEFIT OF THOSE WHO TRIED TO READ THE FIRST VOLUME. OUR TELEPHONE NUMBER IS ᕼ௰੧ ୵୲௦८4 ௦ ੧௹୲୲௦

2014

Nicola White grew up in Dublin and New York and worked in Scotland as an art curator and BBC producer. Her short fiction has been included in journals and anthologies and broadcast on Radio 4. Her first novel, *In the Rosary Garden,* won the 2013 Dundee International Book Prize.

Nicola White

IN MOTION

Orkney

November 2013. I am in a taxi from Stromness to Kirkwall in the pre-dawn dark. The ancient burial chamber of Maes Howe rises as we pass, a black mound against the grainy sky. Here and there, skylights glow on the roofs of cowsheds at the ends of rough lanes. On the edge of town we pass the Pickaquoy leisure centre, where, the previous night, you could see a live broadcast from the National Theatre in London – Benedict Cumberbatch as Dr Frankenstein. To my left, a floodlit car showroom is featuring an expensive speedboat tipped up at a dramatic angle like a sculpture in a gallery.

I'm starting a journey home, south by bus and boat and train. In my bag is a copy of Edwin Muir's *Scottish Journey*, a classic travelogue through the Scotland of 1934. Muir ended his northwards journey where I'm beginning my southerly one. He was an Orkney boy and thought of the place he returned to as a pre-industrial idyll. I wonder what he would have made of the speedboat.

Orkney is having something of a boom, it seems. Arriving at the airport, a slogan greets me: 'Orkney: Leading the Charge in the Marine Energy Revolution'. Long piers are being built at various points around the main island to service the development of tidal power, and the oil industry is far from dead. The distant past is also thriving; the vast complex of neolithic buildings and objects being uncovered at the Ness of Brodgar promises a generation's worth of excavation.

I spent a good portion of the previous day at the Pier Arts Centre, expanded since my last visit by a lovely 2007 extension that both echoes and reinterprets the huddled vernacular of Stromness. The Pier was established in 1979 around a collection of art loaned by Margaret Gardiner, mainly by artists associated with the St Ives group – Ben Nicholson, Barbara Hepworth and Alfred Wallis. These works, involved with both Modernism and the natural world, suit the Orkney seaboard as well as they did the Cornish one. The original collection has been expanded to

include twenty-first-century works by artists such as Eva Rothschild, Katy Dove and Camilla Løw that reflect and update the older collection. The effect is one of extraordinary continuity and sufficiency, much like Orkney itself.

I have coffee with Neil Firth, the Pier's director, and we talk about the last time we met, some time in the mid-nineties. He was in a more junior role on the organisation, and I was the curator at CCA, Glasgow, serving on the Scottish Arts Council's visual arts committee. Members of the committee paid yearly visits to clients with major funding, and it was something of a perk to be included in the delegation to Orkney, especially in those innocent days when the Loganair captain habitually offered the chance to 'sit up front' in the jump seat beside him and the co-pilot. I once got my hand up quick enough to be that passenger, and spent an unforgettable hour, on a clear day, surveying all of the Highlands over the nose of a small plane. No, they don't do that any more, Neil confirms.

I speculate whether the Pier had an unfair advantage over other SAC clients, given the excitement of the journey, the many charms of Stromness and the way our meeting was conducted over tea and shortbread around an open fire in the Pier's library. Neil just smiles.

'No shortbread today,' he says, and offers a plate of exotic, wafer-thin biscuits that curator Andrew Parkinson has brought back from Venice, where he has been visiting the Biennale.

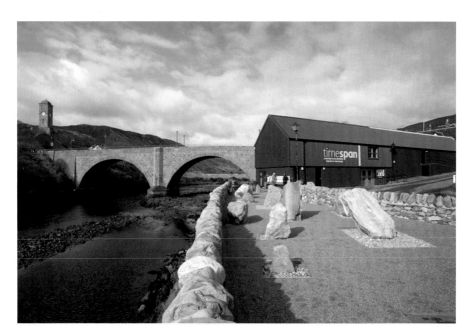

Timespan, Helmsdale

Helmsdale

On the mainland (or Scotland, as Orcadians call it), a bus takes me through dismal John O'Groats, picking up shoppers on their way to Wick, on through Caithness. The bare land tilts down to the coast and the houses seem to have slid to the edge, where cliffs slice into the wide North Sea. We change at Dunbeath, allowing time for the smokers to smoke, then hug the wild coast down to Helmsdale, my destination.

I am late for *The Big Lament*, an event at Timespan, a heritage centre that uses contemporary art and artists to animate issues of place and history. As I enter the space, a 1960s documentary by the experimental filmmaker and poet Margaret Tait is playing on the screen. The packed day includes a symposium, a parade and a ceilidh and has been organised by Oliver Mezger, a Glasgow MFA graduate who has been in residency here over two years. The Big Lament brings together the traditional piping form of the *pibroch*, modernist filmmaking and new literature to reflect on the history of the Clearances in this area. On the walls, hand-knitted digital QR codes are displayed. It is an event with a deep taproot, but employing all the resources of a connected world.

When we go outside for the parade led by piper Barnaby Brown, we pass two men putting up a large tartan sign on a gable wall. It reads, 'La Mirage – the North's Premier Restaurant'. From the top of his ladder, one shouts down to the artist, 'We'll be up to join you in a minute, Olly.' The kilted Sutherland Schools Pipe Band disembarks from a bus just as fat raindrops start falling.

During his 1934 journey, Edwin Muir wondered whether what he was experiencing was truly Scottish, and worried about the diluting influence of 'the wireless and American films'. Some eighty years on, it's doubtful whether anything could now be defined as 'purely' Scottish given the multiple influences and migrations of the here and now, and yet the event in Helmsdale has a particularity belonging to nowhere else. When Muir was writing, he was the mobile exception, travelling through communities of people who mostly lived and died where they sprang from. Nowadays, very few of us are locals. I have noticed, for instance, that all the bus drivers on my journey so far have had Yorkshire accents.

Artists commonly travel to make work about places new to them, adept at finding connections between their own practice and the characteristics of where they've landed. As in Orkney, the art may spring from the place, but the artist didn't. I suspect that some, like Mezger, have more of a catalytic effect for this very reason, unencumbered by how things are usually done.

At the time Edwin Muir set out on his journey, he had been living in London for fifteen years, and so, although Scottish, regarded himself as something of an objective observer. He cast his gaze around, on cities, town and countryside, the people in the streets. Yet it was his early experiences in Glasgow, and his own political and philosophical views, that coloured all he saw.

Glasgow

November 1983. I arrive in Glasgow from Ireland to take up a job as exhibitions co-ordinator at the Third Eye Centre. I travel by ferry and train with a very big suitcase. The vegetarian cafe at the heart of the building is smoky, steamy, packed with people sharing circular pine tables. I'm handed laminated vouchers for lentil soup, bean curry and carrot cake. My new boss, Chris Carrell, wears a rainbow-stripe jumper under a dark jacket. Afterwards, a taxi takes me to my new bedsit in Hillhead. Stacked bay windows, gaping entries with no doors, scaffolding, Indian restaurants, San-Francisco-steep hills. It's all completely foreign to me.

Two days later, I'm asked to the opening of an artist-run gallery, Transmission, in Parnie Street. One half of the gallery is no more than a walled-in lane, complete with pavement and cobbles. A man called Sandy Moffat gives a speech. The walls are packed with paintings. I don't know whether this opening is the kind of thing that happens all the time. I don't stay long as I know hardly anyone. Coming home though the city centre, I see a queue of people outside a black church and wonder at the piety of Glaswegians. When I get close, I see it is a nightclub.

Edwin Muir says of Glasgow, '[Places] where dirt and squalor are an inseparable and normal part of one's life […] have a sort of comfortable insensitiveness which cannot be found [elsewhere].' A comfortable insensitiveness is not the worst quality in a city. I have the feeling from the start that, in Glasgow, people are not examining you too closely – that there is space to live out your experiments, whatever they might be.

October 1990. I'm working at the newly-opened Tramway, running City of Culture exhibitions in its demandingly large space. I am also organising a series of off-site installations and performances under the auspices of *Edge 90*. Many of us are juggling several projects, and there are suddenly more events happening on a daily basis than anyone can keep up with. During an exhibition of contemporary French artists – *Le Cinq* – Douglas Gordon, then a student at the Slade School of Art, drops by and we stand up in the balcony, look down on Absalon's gigantic installation of white forms that fill the central aisle of Tramway 2, each piece as large as a car. 'It doesn't feel like Glasgow,' he says.

April 1993. It is the opening of Douglas's *24 Hour Psycho* at Tramway. There are television cameras in the crowd. The screen hangs in the dark space like an apparition. On a stage at the end of the long bar a drag queen sings torch songs in a black sequined dress. Random individuals are called to answer a phone, and when they pick up the receiver, a voice intones: 'I know what you have done.' The listeners look furtive and pissed off. Someone at the bar turns to me and says, 'This isn't like Glasgow,' gleeful.
Glasgow is something unfixed, something we can keep making up.

October 1994. The second opening for the New Art in Scotland exhibitions at CCA, where I now work as curator. It is the first big survey show for a decade. There are so many artists

we want to show that it has turned into three exhibitions, not one. The work is exhilarating. There is the sense of a certain mass being attained, an arts scene expanding and cohering. The sponsorship is by Absolut. The galleries closed at nine, and everyone is in the cafe, milling, dancing, ironically bouncing off each other to Blur's *Parklife*. Boys use each other's shoulders to leap higher. Suddenly, the crowd lurches sideways, as if someone his tipped the floor, everything in motion.

It was a time of intense activity and invention – but there was also a mean-minded under-current throughout the mid-nineties. Along with the inevitable funding slump after 1990 was a feeling that there was space for only one idea of art. As if it was a pie we were fighting over, and there wasn't enough to go around. The success of expressionist Glasgow painting in the late eighties was something that critics and mainstream gallerists wanted to stick with, and more conceptual forms of practice were seen to threaten that USP.

People like myself, Andrew Nairne, Charles Esche and Pavel Büchler – curators, educa-tionalists – were pilloried by critics in *The Herald* and *Scotland on Sunday* as a 'mafia', a force for deliberate obscurity, wrong-headed. Julian Spalding opened GoMA, the new Gallery of Modern Art in Glasgow with the bombastic volley that there would be no 'con art by con artists' in his gallery. He spent public money on his own tastes with an almost Victorian conviction of what the good people of Glasgow needed. But the artists he was excluding were also the people of Glasgow.

Looking through the comments slips one day at CCA, shortly before I left, I came across one that read: 'Nicola White should be taken out and shot.'

Dundee

October 2013. My train journey from Helensburgh takes me along the Clyde estuary, past a whisky distillery, Dumbarton rock, boats slowly sinking into the mud at Bowling basin. I'm travelling cross-country to another estuary, the Tay's, where a city described by Muir as 'the dirtiest and ugliest (town) of all' awaits me.

Ever since I have known it, Dundee has been building and rebuilding itself along the waterfront, that vast light-source of silver water stretching away to Fife. I leave the sta-tion and head to the Apex Hotel, a journey that involves pulling my wheeled case along the verges of roundabouts, and finding paths blocked by temporary fencing. I stop to take a piece of grit out of my eye. To my right, they are knocking down the slabbed bulk of the Hilton hotel, to make way for the new V&A. Looking back towards the station I can see the masts of Captain Scott's ship, the *Discovery*, more hemmed in by mediocre architecture than it ever was by Antarctic ice. Beyond it the back of the Dundee Contemporary Arts is weathered in, no longer new.

I cross the road by a huge mound of concrete-coloured dirt and rubble, so big as to con-stitute a geographical feature. The next day, at the Dundee Literary Festival, I learn that this hillock was once a building called Tayport House. The novelist A.L. Kennedy comments

that 'it has never looked better,' and the local audience laugh warmly. At a formal dinner, I meet Sandy Richardson, the Development Director for the Dundee V&A. He tells me the new building will house the largest museum-standard exhibition space in Scotland, and gives me a card that shows what the building will look like. It is a bold design in the Bilbao mould – like two gigantic ships headed out to sea – linking the solid world with the liquid, pulling the city somewhere.

Over dinner there is much hopeful talk of Dundee's City of Culture bid, yet to be announced. It is a place with faith in culture as a driver of economic regeneration in a way that seems oddly unchanged since Glasgow pulled off the same trick for 1990. Someone tells me about an event at which the Dundee Makar, poet W.N. Herbert, drew together a poem imagining a future Dundee from ideas submitted by the public. The result was deliciously surreal, featuring suggestions that Law Hill be reinstated as a volcano and that a giant wave-powered organ should play sea shanties on the changing tides.

The Scotland of the thirties that Edwin Muir described was monochrome in its grimness, its general poverty. Culture was a private matter or else a strictly bourgeois one – theatre, recitals. Now every town of any size has it own public arts venue, its cultural festival or festivals. The very idea of a Dundee Makar or Literary Festival would be staggering, alien.

On a daily basis, we do not believe we have it so good, especially in a time of growing inequality and market rules. The 'cultural industries' emphasis of public funding is depressing in its conception of art as a promotional activity rather than a way of understanding ourselves, yet the sheer choice and variety and mobility of contemporary life seems dizzying in comparison to the empty roads, blackened towns and real hunger of the thirties.

Glasgow

March 2012. It is almost fifteen years since I worked as a curator, and in that time, certain events have slipped into history. Sometimes, curators or journalists email to ask about particular exhibitions that happened in the late eighties or in the nineties. The BBC get in touch about a documentary they are making on the Glasgow art scene. I don't much like talking, especially on camera, but I know that if you don't tell your own version, no one else will. Besides, they say, they are short of women interviewees.

After the filming, I bump into the artists Ross Sinclair and Craig Richardson outside South Block in Glasgow. They are being interviewed too. We catch up quickly, comparing memories about the nineties that are strikingly divergent. What you remember depends on where you were standing; the idea of a definitive version of the past, we agree, is laughable.

None of us makes it into the final documentary, and I'm not surprised. With a certain inevitability, it ends up focusing on half a dozen artists who have met with conspicuous success, and the attention of the Turner Prize judges, rather than the more complex milieu from which they emerged. Let's face it, a 'milieu' is a damned difficult thing to film, yet the result felt disappointingly partial, missing completely the collective, egalitarian feel of Glasgow, the multitude of practices and groupings, the respect for hard work, the 'now'.

I think of characteristic events like the Lights Out Listening Group, a monthly meeting in a room above a bar, where an audience of artists, musicians, performers and interested others sit in the dark and listen to live and recorded audio pieces. The atmosphere is strangely intimate – flickers of torchlight, bursts of laughter, sighs. There is no admission charge and submissions are open to new work. All over the city, people present their creative output to each other in all kinds of ways, but profit is rarely a motivation. Success is being able to continue making work.

In the nineties, I felt that I had a good grasp of things, of the work that was being made, of what was happening in the city, in Scotland, and beyond. Even if that was true, I'm not sure that such an overview is possible now. There are literally hundreds more artists working in the city than there were twenty-five years ago, intertwined networks enriched by artistic immigration, and new ways of working too.

The Rosneath Peninsula

December 2013. Scotland does not lend itself to easy encapsulation. Like all populated worlds, it is, to use Louis MacNiece's phrase, 'incorrigibly plural'. Yet this year, with the independence referendum looming, people struggle to articulate what it is that makes this place different from its neighbours. In particular, what makes its aspirations separable.

Standing in my garden, I look out on Loch Long and across to the unchanging hills of Cowal. A nuclear submarine is sailing slowly up the water, coming in to the Coulport depot, accompanied by a flotilla of escort ships, including three tugs – one in front, two tucked tight to its sides – two military patrol vessels and several fast inflatables manned with dark-clad troops. The matte black of the submarine's coating sucks the light. In its missile bay is more firepower than was expended in the Second World War – that includes every bullet, every explosion, the bombings of Dresden and London, Nagasaki, Hiroshima. It is almost incomprehensible that such a thing can exist and that we should think it necessary to possess it.

As the submarine draws opposite, a grey seal slips from a boulder by the shore, next to a tideline where the seaweed is dotted with bottles, fishing debris, and an uncountable multitude of plastic cotton-bud sticks. Everything always in motion, gathering, circulating, changing.

1991

The exhibition *Windfall '91* took place 5–25 August 1991 at the Seamen's Mission on the Broomielaw in Glasgow, a building that was subsequently demolished. It featured the work of twenty-five artists from eight European countries including many from Glasgow. The first *Windfall* had been held in London's Hyde Park in 1988, the second in the docklands of Bremen in 1989. During 1990 David McMillan, a Glasgow-based artist, had travelled in Europe meeting artists for *Windfall '91*.

Windfall '91 was notable for many reasons. Organised by artists, it was a collaborative venture that helped consolidate the pattern of artist-led activity in Glasgow, cementing relationships between artists that would be longstanding and influential. Like many subsequent ventures it took place in an atmospheric found building rather than a formal art institution. Above all it was an outward-looking exhibition that suggested it was possible to build artistic relationships in Europe directly from Glasgow rather than artists moving to London, the traditional centre of the art world in the UK.

This essay by the artist Ross Sinclair for the *Windfall* catalogue expresses the optimism and energy of its times and the determination of young artists to make opportunities and control their own destinies rather than waiting for institutional approval. Sinclair had graduated from the Environmental Art Department at The Glasgow School of Art in 1990 and was undertaking his Masters in Fine Art. Alongside his own work he wrote numerous catalogue texts for fellow artists and reviewed for art magazines. Now a prominent contemporary artist and an influential teacher at The Glasgow School of Art, he continues to use the written word, including text and song lyrics, in his art today.

First published in *Windfall '91*, exhibition catalogue for an artist-initiated exhibition at the Seamen's Mission in Glasgow, 1991

→ Ross Sinclair

BAD SMELLS BUT NO SIGN OF THE CORPSE

THE WAIT

Once there was an artist who everybody thought was very good. He had a few doubts about this, but it was true – he was smitten with the idea of art. So he painted. And painted. Soon someone said that he should have a show. 'Not yet', he said, and went back to work.

He entered his works in local competitions now and then. The local library showed one of his paintings and the art critic of the town paper mentioned his name. A relative said his paintings looked like a linoleum floor and asked if he could draw. He knew that he was slowly becoming an artist. 'You should show your works in a one man show.' 'No,' he said, 'Not yet,' and went back to work. Fellow art students rose to fame; they sold, they had shows, people talked, they moved to big cities. 'Come' they said. 'No, not yet,' he replied. Soon his work had authority, had insight, had maturity. Should he show, he thought. No, he answered, though rewards beckoned.

One morning he walked into his studio and it was clear. His work was pivotal, even seminal. The time had come for a show.

He showed and nothing happened.

Moral: Artists come and go.

(John Baldessari, from *Ingres and other parables,* 1972)

Once upon a time, far from cities and towns, there lived two painters. One day the king, hunting nearby, lost his dog. He found him in the garden of one of the two painters. He saw the works of that painter and took him to the castle.

The name of that painter was Leonardo da Vinci. The name of the other painter disappeared from human memory.
(Braco Dimitrijević from *Tractatus Post Historicus*, 1976)

Anyone who follows the fortunes of the contemporary art world in Britain could not help but notice over the past few years a renaissance of what can be described as non-gallery, gallery shows noticeably in London and Glasgow. These are often housed in disused, industrial spaces or in temporarily dormant commercial office spaces. *Often they are initiated by artists.*

Artist initiatives are a valuable way of demystifying the business of art. They promote a sharing of information, skills and experience while also nurturing relationships between artists which can often become fertile breeding grounds for a horizontal and organically developing infrastructure of cultural activity. They often embrace a desire to communicate with that great unfashionable and unknown quantity, the general public. *But, it is often asked whether these kinds of exhibitions really acknowledge their local contexts?*

Events of this nature which occur outside London have the added (dis)advantage of being forced to justify themselves as something other than a regional showroom for the 'jaded palates of the metropolitan centre'. Do these kinds of exhibitions have any intrinsic meaning or do they only represent a limited window of opportunity onto the merry-go-round of the market for those individuals involved? Certainly they represent a valuable and energetic self-determination, but to what end? Is this situation merely symptomatic of the old guard being replaced by the avant garde, the establishment v the new establishment?

Are these kinds of shows only regional showrooms for the hungry market or do they slowly build an international awareness of any given city which could prove to be to everyone's benefit? Are notions of increased value and engagement through site specificity and claims of greater public accessibility only excuses to placate (public) funders? Artists gain valuable experience by getting involved in all aspects of initiating / funding / curating / administrating, but why then does the public still feel alienated and excluded from projects where every effort is made to engage them?

THERE IS A BAD SMELL AROUND BUT SO FAR NO SIGN OF THE CORPSE

There has come to exist in Western culture a certain perception of artists which has taken to characterising them to a large extent as passive, distant (elitist) and politically impotent. In other words, that complex, problematic and largely undefinable grouping 'the public' seems to have been persuaded that those individuals, who choose to spend their time producing what is sometimes referred to as 'high culture', are unable or **unwilling** to operate reciprocally in a world outside that which cocoons the realm of aesthetics. This situation can be conveniently illustrated by the time honoured and persistent cliché of (male) artists toiling in garret studios (often by candlelight because they are too poor to pay the bill, but in this equation: **property = integrity**). They are of course *necessarily divorced from the world as it is*. How else could they honestly promulgate their **personal vision** with the adequate degree of integrity, intensity and above all autonomy? These hypothetical artists

are generally ploughing through some torturous scenario or other designed to show that they (he) just weren't made for these times i.e. they are suffering for their art. Often they are represented rendered powerless by some inexplicable malaise, trapped in a kind of aesthetic limbo. They never seem very happy or contented with their present situation because they always seem to be waiting for something to happen. What they are doing (or in most cases not doing) is biding their time before being recognised and valorised by external forces – i.e. they are **waiting to be discovered.**

This cliché of artists at odds with the real world has been developed consistently over the past 500 years but made a spectacular leap forward in the last few decades with the rise of popular culture, particularly in the film industry. The classic exponents of this genre have included Tony Hancock in *The Rebel* or Kirk Douglas caricaturing Van Gogh for Hollywood in *Lust for Life.* The cliché of the artist as the misunderstood outsider still dominates television of all kinds. A current television commercial continues to prove that this image has a strong popular currency which has as much kudos today as it ever did. This advertisement, part of a large series which depicts a broad cross section of British society (i.e. white, middle class), features people who tell us what they really want from their lives, the coda of which is, 'Whatever you want in life … you want to be with the Prudential.' Unusually an artist is represented in this imagined cross section of United Kingdom citizens. This artist is a woman (still more unusual) with an unmistakably (Northern) Irish accent. She is depicted in the studio putting the finishing touches to a ridiculous sculpture of a hand which fills the large studio (too large of course for an undiscovered artist). The index finger of this hand is extended upwards as if towards the stars. While other individuals in this advert express generally a desire to take control of their lives with some degree of self-determination, this artist says simply … **I want to be discovered.**

This advertisement projects an assumption that artists, particularly women artists, are always at the mercy of some external forces and therefore unable to organise themselves into any relevant or meaningful situations. The subtext of the ad, revealed by the artist's accent further, proposes that 'regional art' exists only when appropriated and approved by the centre and reveals the basic assumption that it is disenfranchised, marginal and ultimately of no value whatsoever within its own social context (if indeed it is of any value outside of that situation). It is thus defined through the mechanics of the metropolis as inferior to cultural activity which takes place at the centre.

Of course this is only one example of a crude and reductionist TV view (perpetuation) of the problem. But the duplicitous relationship between metropolitan mass media and the historification of 'high culture' plays an increasingly important part in defining public (i.e. everybody's) perception of culture (and everything else). And anyway it really seems to have a lot to do with the fact that metropolitan based 'cultural organisers' can't be bothered to get out of the city.

I think that's a specifically British problem. Nobody in London thinks that anything outside London's worth looking at. It's a real problem. They always talk about France being centralised. Well, they haven't seen anything like this. Oxford, Cambridge, Glasgow, wherever – nothing exists any more. It might as well be open sea.
(Karsten Schubert – London gallerist)

Of course, any artists with any meaningful contribution to make do not sit around waiting to be discovered in quite the way represented above. But this perception does persist and you know if you are told something often enough maybe you start to believe it. Often artists conspire to their own marginalisation by accepting projected views of the parameters of cultural activity, particularly in regional areas and of course by accepting and patronising the cultural hegemony enforced from the metropolitan centre.

So where does all this leave you, the young artist just out of art school in Glasgow or Liverpool, Belfast or Hull? When you're standing at the top of the steps of your college, twenty years of education behind you, is the only way really down? … Well, it is if all you are going to do is retreat to your bedroom/studio for ten years piling up the canvases while you 'wait to be discovered'. Even if you manage to plough through most of what you imagine might be on the Whitney Independent Study Program reading list it doesn't mean that when the selectors for the British Art Show 1998 (or whenever) come a calling at your studio (which they are unlikely to do anyway) they are going to be bowled over by your work. Why wait for your work to be approved / validated / confirmed by some ex-public schoolboy in a sharp suit / jeans 'n' sneakers? (But maybe you knew him already from prep school). You get out there, do some fucking hot shows and invite them over on your own terms.

Art schools have become ever more intensive and frenetic, and increasingly close to the market. They have also, however, witnessed a retraction of sixties radicality and have become increasingly conservative and apolitical (if in fact they were ever anything else). Generally speaking, many of the teaching staff reflect this shift and now consist of artists who couldn't cut it on their own terms and mistakenly believe that their personal failure and spectacular mediocrity is a valuable foundation for their 'teaching' methods. Moulded by draconian changes in public education funding, art schools will now become a new kind of finishing school for upper-middle class children of the successful 70s/80s generation. This highly pressurised situation means that students come careering out like a fast train, fuelled up in a speed frenzy where you've *fucking had it* if you're not famous by the time you're twenty-five. The production and turnover of ideas is deemed all important. New ideas must be churned out at a rate of three or four a term, say a round dozen a year. And, if you are any good, maybe just one of these ideas could warrant thorough investigation and development for a year.

So what do you do? You get together with other artists and set up some shows. Starting modestly and getting more ambitious. Then before you know it you're getting public funding, putting on important shows of new work in (con)temporary galleries which are often much

better and more representative than fake survey shows like New Contemporaries or the New Scottish / Irish / Welsh / Northern / Eastern / Polish / Czech / Slovakian, etc., etc., season held at your local Arts Council gallery. In London this might mean the chance of selling work to collectors, or if you're lucky becoming involved with a decent gallery. In Scotland if often means wrangling with public funding bodies and meagre private sponsorship. But the situation certainly forces you to learn a thing or two, it teaches you to be resourceful and now the metropolis is coming up to see what all the fuss is about.

Far Fresher than Fresh Art.

Artist-initiated projects are of course born out of a desire to get out there and do something. To create a context for initiating and exhibiting work – *on your own terms*. They express a belief in themselves. They are positive examples of the implementation of *self co-determination*.

They are the impatient and aggressive rejection of the perceived notion of artists as passive and apolitical.

This current milieu of artist-led projects does point to a different direction from previous artists' projects, certainly in Scotland. In the past, artists have sought to create lasting, enduring establishments to further the situation of art and artists in Scotland and internationally, e.g. large art centres / print studios, etc. – permanent structures. These have now become the cornerstones of what could be somewhat generously described as the Scottish contemporary art scene. The new generation of active artists is less interested in creating lasting monuments to their efforts. The structures of organisation / initiation are more fluid and devolved. The idea of constant expansion as a strategy is being questioned. There has been a general deconstruction of traditionally accepted strategies and possibilities but more attention should/is being paid to a horizontal or organically developing infrastructure both geographically and socio-economically. Scotland has, historically of course, had very strong links in a European context and these will continue to be developed to the fullest extent. *Windfall '91* and the many exchange projects that have occurred, particularly in Glasgow, are evidence of addressing this and these will grow. Already more projects and shows are in the pipeline. Although London will always have a strong pull, there exists a valuable and potentially more reciprocal relationship with the European context.

But there are curatorial problems for artist initiatives. The loose committee structure, usually adopted in groups, tends to devolve responsibility for curatorial decisions to such an extent that it becomes problematic to reach consistent levels of good work. Sometimes neat packages of work are promoted at the possible detriment of a broader expanse of ideas. Thus often (and arguably correctly) the act of organising and discussing the project takes precedence over quality of work. This is a situation which cannot remain unaddressed for ever or the art being exhibited becomes a homogeneous veneer of stylistic vacuousness where the overemphasis on presentation destroys the potential for meaningful engagement.

Unfortunately along with the freedom that is a part of projects which retain a large degree of autonomy, it seems that in some quarters it has become fashionable to dispense

with a contextual agenda indigenous to geographic and social situation and instead adopt one which issues forth from the pressures of what could broadly be termed the centre, to suit its needs. This is often a strategy adopted by individuals who do not, for whatever reason, create their own opportunities and vicariously feed off the efforts of others. This shifting of agendas is undoubtedly a contributing factor to the alienation felt by certain sections of the public who engage with the work first hand rather than those who gain their knowledge from the mediated channels of books and magazines. This alienation is easily understood when the artist makes it manifestly clear (intentional or not) that his/her work has nothing to do with them, the 'public' – it doesn't relate to them, it isn't for them – and in fact they, the artist, couldn't give a **flying fuck ...** but hey! Why should it be made easy? I'm bored to tears hearing whingeing apologists justify terrible, patronising art by professing its supposed site-specificity and public significance. Maybe it's better not even to try. If you had never seen a football game before, it would seem like an incomprehensible farce. But if it's in your blood, you play at school, go to a few games, you learn as you go along – football is the most popular sport in the country. Why should things be so different for Art. It's really not that difficult to understand.

By embracing the agenda of the centre the artist necessarily begins to erode the chance of creating and/or developing an indigenous and independent cultural agenda which even begins to address the problems and needs of any kind of cross section of people who live where the artist is working. This of course includes the artistic community. The artist there-fore turns his/her back on an important context where his/her work may have a real and meaningful social function. When the context of art dissolves into the realm of formalism and the art world exclusively, it has relinquished much of its potential for social function. It loses an important dimension and diminishes from a potentially rounded, holistic art prac-tice and becomes a two-dimensional veneer. Then its meaning and location exist primarily for the market and the cultural activity, Art, ceases to have a wider social function other than in matters of economics. And this is where many feel art functions best, disengaged and estranged from the inconveniences and untidiness of the 'real' world.

One of the biggest problems I have is to get it to where it looks like a blob on the canvas that has dripped or whatever, and there are no real life associations at all.
(Ian Davenport, Turner Prize nominee quoted in *Broken English* catalogue)

What is clear, however, is that these arguments of regional/central issues can be both diverting and exhausting. There is a real danger for artists involved in this debate expending all their efforts, as has happened in the past, shouting about their own value and perhaps not enough time developing and disseminating the work. A significant feature of the current situation is that the focus of discussion is slowly returning to a discourse about the work, about art. Energy is being harnessed and moulded into forms which proclaim an over-whelming attitude of just getting out there and getting on with it. In Glasgow at any rate, whingers get short shrift. What has finally been exorcised is a feeling evident in years gone by

that coming from Glasgow, or Belfast or any other city meant having a chip on your shoulder, feeling short-changed because you weren't born in New York or London. What is happening now is active – not reactive. That is where its indigenous values lie. The forms taking shape from this energy, north and south of the border show clearly that all that separates Scotland or Ireland or anywhere else from the rest of the world is geography alone, nothing else. Past prejudices have been shrugged off and a passionate internationalism is being embraced. James Hall of *The Independent* discussing *Windfall '91* said that 'as far as he was concerned, all the artists were from abroad, Scots and Europeans alike.' This is a sentiment which should be reciprocated. For Scots know from bitter experience that anywhere outside Scotland is international, whether it is England or Wales, 'Russia' or the USA and they have had many centuries to get used to the fact.

So, now, more than ever, the parochialism which has dogged the Scottish visual arts for so long seems at last to have gone knocking on metropolitan doors. These appear to be slowly closing while elsewhere doors lie open all over the world.

All it takes is for us to go through them.

2014

Andrew Patrizio is Professor of Scottish Visual Culture at Edinburgh College of Art, the University of Edinburgh. He is an art historian and curator specialising in modern and contemporary art. His main research interests are Scottish art and cross-disciplinary projects across art, ecology and theory. He often works closely with artists, ranging from collaboration to commissioning and writing.

Andrew Patrizio

A STATE OF EXCEPTION /
AN EXCEPTIONAL STATE: 1989–1995

I

Twenty-five years have passed since a once 'young curator'[1] moved to Glasgow Museums to work. In the space available, I will try to set out what were for me the salient features in an impossibly contradictory, conflicted and strange period in Scottish public life. Ultimately my view is simple: the artwork produced between 1989 and 1995 was so strong that new cultural space was created out of its impact – museums and galleries across the world opened to it, opportunities emerged, publics both expert and general flocked, in recognition of what Glasgow and a wider artistic community across Scotland created. The work conjured up the context as much as the other way around.

November 1989 was a big month for the people of Berlin as they tore down their Wall and for me as I started my first job. My first meeting was with Malcolm Dickson and Christine Borland who were plotting a fast-and-dirty intervention in Kelvingrove Art Gallery and Museum. This was part of EventSpace's city-wide project *Sites / Positions*, facilitated by the European City of Culture Festival Office.[2]

Borland was a relatively recent returnee from her MA studies in Belfast under Alistair MacLennan, and my task was to help her negotiate a one-tonne compressed rubbish bale into the pristine archaeological cases at Kelvingrove and another alongside a neoclassical marble sculpture from the fine art collection. To complete this cyclical meditation on preservation and obsolescence, a parallel part of her project entitled *Human Being*, included a visit to Summerston Dump, the source of the rubbish.[3] *Sites / Positions* was not only a formative event for me but a marker of the 'devastation aesthetics' that were to insinuate themselves into Scottish art from the early 1990s onwards. These practices, of which Borland's was exemplary, drew on international trajectories in the art of the 1970s and 1980s and on the educational vision of the Environmental Art Department at The Glasgow School of Art where many, though not all, of these early artists studied.[4] What emerged was some of the most haunting work of the 1990s in Europe.

These were nevertheless strange times. One year on from working with Borland, I was present when prime minister John Major, newly instated following Margaret Thatcher's deposition in 1990, visited the McLellan Galleries in Glasgow's Sauchiehall Street. He sat on a Robert Adam ironwork bench where he and his wife Norma had their photograph taken. Only a few minutes after his museum tour, exiting out of McLellan's long tunnel, Major was greeted on Sauchiehall Street by left-wing militant activist Tommy Sheridan, only recently expelled from the Labour Party, demonstrating with comrades against the Poll Tax, the First Gulf War and water privatisation. Such telling moments burn into the memory almost as vividly as the art of the time.[5]

II

We never needed a generation of hindsight to sense the hopeless inadequacy imposed by style labels such as 'lyrical conceptualism' or the family resemblances of a 'Scotia Nostra' genealogy. No single aesthetic encapsulates the work of artists as diverse as Ross Sinclair, Richard Wright, Dalziel + Scullion, Smith/Stewart, Claire Barclay, Dave Allen and David McMillan, to name but a few. It was instead a moment of emergence, a genesis of related approaches expressed diversely, and it created space in the imagination that younger generations have now occupied.

The urgency of the artwork seemed to express the many disturbances that had entered social thought in the late 1980s and early 1990s. The artists looked to unsettle familiar themes of concept-led art (from Pop to Fluxus and performance[6]) but turn them into new problems, often but not always with local inflections.[7] Such strategies emerged in honour of some of their teachers, comfortable as they were in public and vernacular spheres, yet also as a means to acknowledge local traditions, Scottish loyalties, and the many realms of the non-expert. Artists found new weight and new resistances in their work, whether created within Scotland or increasingly abroad.[8] They condensed, with peculiar intensity, concerns showed by many non-Scottish artists of the 1990s, in art prescient with dread, working the borderlands of ethics, nature, urbanism and violence.

Before social media sent projects suddenly viral, for many of us simple word of mouth was enough to make Glasgow stand still in 1993 when *24 Hour Psycho* was conjured into existence by Douglas Gordon at Tramway on Glasgow's southside.[9] Here was a work that could not be missed, its metronomic surface ticking deep in the cavernous post-industrial Tramway, insisting that all of us attend it, and ever since, *attend to it*.[10]

Work in this period was marinated in ideas; it was aware of precise formal frames but not obsessed by them. Among many shows, I recall Julie Roberts's solo exhibition at CCA, Glasgow in 1992, only a year after her involvement in the group show *Windfall '91*.[11] The emerging work in the city seemed concerned with violence and terrorism, urban blight and dystopia, the end of Modernism, abuse of power, constructions of identity, biopolitics, schizophrenia, religion, sectarianism and play. Tramway hosted another major work in 1994 – Borland's *From Life*, with its forensic reconstruction of an Asian female from her mail-order

skeleton, activating the illicitness of bio-trade through art. Conceptually it was dirty, alloyed and hybrid – so much so that Borland became increasingly uneasy with the compromises involved in selling work through the commercial gallery sector.

III

The period I deal with here is bookended by the third and fourth incarnations of the *British Art Show* (both of which I saw unfold from the inside, first in Glasgow in 1990 then when I moved to the Hayward Gallery in 1995), and they offer a way of reading what was being attempted in Scotland at the time. The troubled character and anxious Minimalism of the *British Art Show 3*[12] surely had some influence on the 1990s generation of Scottish artists visiting the McLellan Galleries. *BAS3* pushed the pre-Damien Hirst generation at London's Goldsmiths college yet found a culmination of sorts in the following *British Art Show* of 1995–6, which Richard Cork in his catalogue essay intuited as a kind of 'injury time' for British art.[13] He was surely, in part, picking up on earlier texts around 'the sociology of collective fears and aspirations'[14] and the 'shared "secret" histories'[15] north of the border. In any case, it was certainly a high point of recognition for Glasgow and Scotland, when Gordon, Roberts, Borland and Kerry Stewart were selected alongside the 'Young British Artists' Hirst, Mark Wallinger, Chris Ofili, Gillian Wearing and others. *BAS4* caught Gordon just before he scooped the Tate's Turner Prize, the Guggenheim's Hugo Boss Prize and the Golden Lion at the Venice Biennale – all simultaneously. By this time, the emerging had emerged.

IV

To conclude my 'contaminated' witness statement, I would offer the suggestion that the institutional weight and geographic reach of GENERATION in 2014 renders this period a true historic moment and this is surely due to the initiating power of the elders in this geneal-ogy. Surprising as it may seem, 1989–95 appears an improvised rather than a calculated moment. When the artist and teacher Thomas Lawson tried to make sense of this period in his essay in the catalogue of *BAS4*, he warned that 'Coherence is a lie.'[16] One finds the same character in texts by the chief activists. The curator Tessa Jackson reflected on 1990 with: 'Thus Glasgow gave collective birth to a beast of unknown species. Who knew what shape and characteristics it would develop, once fully formed?'[17] David Harding, as head of the Environmental Art Department at The Glasgow School of Art, echoed this emphasis on improvisation: 'Socialising came to be seen as an important part of the education and became an expectation, a tradition of the department. Of course this was not planned.'[18] Later observers recognised the improvisatory nature of the period too, Neil Mulholland writing: 'There was no game plan, no strategy involved here. An extensive exchange of ideas was initiated largely through internal interactions, through self-organising and self-defining of their boundaries … .'[19]

Yet this period is not notable in historical terms because of the networking, the self-organisation and the self-determination. Formations called in retrospect 'The Scotia Nostra'

or 'The Irascibles' provided an injection of confidence and a collective support structure, but those artists not part of that family (Callum Innes, Graham Fagen, Chad McCail, Kenny Hunter, Louise Hopkins or Carol Rhodes, for example) were also producing stunning work. It is the art itself that has to stand in historical terms, when the groups have dispersed and those of us who appeared in the first iteration of Gordon's *List of Names* (an early wall text piece of 1990, since much expanded, in which he sets out the names of all those he remembers having met) are all long gone.[20]

The major works of art that were summoned into existence in the first five years of the 1990s were so rich, prophetic, quixotic and nuanced that they created a cultural space that, whilst it could not perhaps have been anticipated, now seems inevitable. As with an exploded star, some semblance of the gravitational weight still remains and pulls back those of us who remember this time as if it were yesterday.

ACKNOWLEDGEMENTS
The author would like to acknowledge the conversations with Ross Sinclair and Malcolm Dickson in the preparation of this text.

1 Craig Richardson, *Scottish Art since 1960: Historical Reflections and Contemporary Overviews*, Farnham, 2011, p.160.

2 The Office was run by Tessa Jackson. The activities of the Office are well summarised in Tessa Jackson and Andrew Guest (eds), *A Platform for Partnership: The Visual Arts in Glasgow – Cultural Capital of Europe, 1990,* Glasgow City Council, Glasgow, 1991.

3 The refuse area has long since been filled and Summerston is now a residential area with a Police Academy and an ASDA superstore. The *Sites/ Positions* project as a whole featured other new work by Douglas Gordon, Alison Marchant, Euan Sutherland, the Prolific Pamphleteer and Gillian Steel. The EventSpace co-curators were Malcolm Dickson and Ken Gill.

4 Discussed more fully in D. Harding and P. Büchler (eds), *Decadent: Public Art – Contentious Term and Contested Practice*, Glasgow, 1997; David Harding, 'Friendship, socialisation and networking among Glasgow artists 1985–2001: The Scotia Nostra – myth and truth', talk given at ZKM Gallery in Karlsruhe, Germany in March 2001 and published in the catalogue *CIRCLES* by ZKM, April 2001, online http://www.davidharding.net/?page_id=11; Neil Mulholland, 'Self-conscious stateless nation: Neoconceptualism and the renascence of Scottish art', *Third Text*, March 2008, vol.22, no.2, pp.287–94.

5 The Major photograph was soon transformed into a 500-piece jigsaw and sold, without great success, in the McLellan Galleries shop. Strange times indeed.

6 Richardson, *Scottish Art since 1960*; Mulholland, 'Self-conscious stateless nation'; Malcolm Dickson, 'Coals to Newcastle', *This will not happen without you: From the collective archive of The Basement Group, Projects UK and Locus+ (1977–2007)*, John Hansard Gallery, Southampton / Hatton Gallery, Newcastle / Interface, Belfast, 2006.

7 Malcolm Dickson 'Another year of alienation: On the mythology of the artist-run initiative', in D. McCorquodale, N. Siderfin and J. Stallabrass (eds), *Occupational Hazard: Critical Writing on Recent British Art*, London, 1998; Dickson, 'Coals to Newcastle'; and Neil Mulholland's introduction of the term 'disglossia' in his 'Self-conscious stateless nation'.

8 Prominent international shows include *Walk On*, Jack Tilton Gallery, New York, 1991; *General Release: Young British Artists*, Venice, 1995; *Sawn-Off*, Stockholm, 1996; and *Life/Live*, Musée d'Art Moderne de la Ville de Paris, Paris, 1996.

9 Gordon (then 26 years old) was invited to make the work by Nicola White and her successor Charles Esche in the newly reopened Tramway space.

10 The work *24 Hour Psycho* is included in my university teaching each year and seems an inexhaustible source of readings and interpretations by students from Scotland and beyond.

11 Roberts's show was insightfully reviewed by Ross Sinclair in *Frieze*, issue 6, September–October 1992, http://www.frieze.com/issue/review/julie_roberts/

12 The terms 'empty, mute, impoverished, anaesthetised, pathos, pain, grief, melancholy, tragedy, loss, nihilist, stifling, weary, decay, doubt, dumb, suffer, unheroic, oppressive, aloneness, meaningless' were used by *Glasgow Herald* art critic Clare Henry throughout her review, 'Not so great British picture show', 27 January 1990, http://www.heraldscotland.com/sport/spl/aberdeen/not-so-great-british-picture-show-1.593290

13 Richard Cork, 'Injury Time', *British Art Show 4*, Hayward Publishing / National Touring Exhibitions, London, 1995.

14 Liam Gillick, 'From Coatbridge to Piacenza', in Nicola White (ed.), *New Art in Scotland*, CCA, Glasgow, 1994, p.11.

15 Ross Sinclair, 'Nietzsche, the Beastie Boys and masturbating as an art form', *New Art in Scotland*, ibid., p.29.

16 Thomas Lawson, 'Unrelenting Jet Lag and Iron-Hard Jets', *British Art Show 4*, p.89.

17 Tessa Jackson, 'Introduction', *British Art Show 4*, p.7.

18 Harding, 'Friendship, socialisation and networking among Glasgow artists 1985–2001', n.p.

19 Mulholland, 'Self-conscious stateless nation', p.289.

20 *List of Names* was first included in the exhibition *Self-Conscious State* curated by Andrew Nairne at the Third Eye Centre (now CCA). A later version called *List of Names (Random)*, much expanded as Gordon's career grew, was purchased in 2000 by the National Galleries of Scotland and is permanently installed at Modern One / Scottish National Gallery of Modern Art.

Transmission Gallery was set up in 1983 by a group of graduates of The Glasgow School of Art who were frustrated at the lack of exhibition opportunities for young artists in the city. It quickly widened its remit to invite artists from outside the city to show and develop artistic exchanges with like-minded groups in the UK and overseas. In over thirty years since its foundation it has been a crucible for artist-run culture and its model of a membership organisation, with a rotating committee of artists working as volunteers to manage the gallery, has been admired and imitated worldwide. Its street-front premises, first at Chisholm Street and then King Street in the city, have hosted key exhibitions, screenings and performance by artists from Scotland and significant works by international artists. From its early days Transmission developed ways of working including discussion events and symposia, self-education and publishing that reflected its emphasis on dialogue and exchange.

In 1993 Transmission planned a tenth anniversary book that was never published. Ross Sinclair's essay written for the book is a satire in which, 100 years from its foundation, Transmission still lives on in a Scotland that is independent, but has become a theme park. The essay reflects on Transmission's role at the heart of debates about cultural politics in the early nineties, about the gentrification of the Merchant City where the gallery is based and about Glasgow's role as 1990 European City of Culture. Sinclair's art is concerned with ideas of identity and belonging and as part of this he has addressed ideas and images of Scottishness, often examining its role in idealised forms, traditions and clichés.

Written for Transmission Gallery, but first published in *ROSS SINCLAIR*: *REAL LIFE*, CCA, Glasgow, 1996

Ross Sinclair

AN OPEN LETTER TO WHOMSOEVER IT MAY CONCERN REGARDING: SCOTLAND – A BRIEF AND FRACTURED INTRODUCTION TO THE HISTORY OF THE PERIOD 1983–2083

*Thinking about the things that people forgot about
because they weren't written down in history books.
The year is 2083 Anno Domini and Transmission Gallery
is one hundred years old today. The place is The People's
Republic of Scotia, a small, northern European nation
with agreeably changeable weather. More than twenty years
have passed since Scotland achieved its long cherished
ambition, independence from England and the Crown.
However, this occurred at some cost to the Scottish people …*

The Path to Freedom?

At the Stirling Bridge Referendum of 2061, a handsome majority of the Scottish people decided that they wished to secede from the United Kingdom of Great Britain. There were five million or so inhabitants in this poor, damp country, for so long under the sword of one conquering invader or another. And this populace eventually decided, once and for all, to leave the Union in order to implement a novel plan to completely reinvent the Nation in a manner never before heard of anywhere in the world. The new official name they chose to reinvent Scotland, from those suggested, was: *Scotia – The Living History of a Small Nation*. At first glance this may sound like a strange name of a small country, newly independent after 500 years of struggle, but to explain the unprecedented move: the Scots had voted en masse to turn the whole country, and everyone in it, into the world's first national scale historical theme park. *And it was to be of truly epic proportions.*

In 2062, almost overnight, a big fence was built along the border with England. This was not to keep the poor Scottish people in, as you might have thought, but to keep everyone else out, because now you were going to have to pay to get in – and it wasn't going to be cheap.

Most people north of Hadrian's Wall were initially very enthusiastic about this new development, as Scotland in the middle twenty-first century was suffering an horrific depression, the likes of which had not been seen since the Middle Ages of the previous millennium. Diseases which had lain dormant for centuries had returned with a vengeance and were killing off poor people in tens of thousands. Those who couldn't afford the simple drugs which prevented these grotesque diseases became truly outcast, living in pathetic ragged groups like the leper colonies of biblical times. Thus they were not represented on any voting rolls and therefore did not take part in the 'democratic' Stirling Bridge Referendum of 2061.[1] Officially they did not even exist. By the 2040s they had become such a problem that large walls were built round the major cities to keep them out and the people who lived inside them tried to forget about those poor wretches who were outside.

When the idea for the theme park was first mooted in the mid-2050s it fired up the Scottish peoples' imagination, galvanising them into an intense debate and direct action not witnessed for many decades. The publicity generated by these debates slowly encouraged many ex-patriots to return home. There were at least twenty million people around the world who considered themselves Scottish by ancestry, but had never actually been 'home'. This turned out to be quite fortuitous as some of these folk were very rich and brought back their fortunes with them to invest in the park. It was the first good idea anyone in Scotland had thought of for quite a while so it was no wonder it caught on so quickly. It also helped them forget about all the horror that went on outside the city walls.

At this point in the 2050s, before the park was built, the Parliamentary Monarchy of England had many problems of its own. Its coffers were much depleted after protracted wars with France and Ireland.[2] It simply could not afford to worry about Scotland any more, particularly since the oil had run out. England's international reputation had sunk to an all-time low and it was the popularly held belief that Westminster was, in fact, quite happy finally to get rid of its troublesome and costly northern appendage.

Most poor parts of the world were really wasted with wars and famines while diseases and bad planning had made millions of people unhappy. Everywhere had been discovered, nowhere was remote or savage any more. Scotland wasn't actually too bad in comparison with the war torn 'outside world'. Although there certainly were plenty of poor and diseased and unhappy people (mainly those living outside the city walls), there had never really been any kind of modern, technological warfare to physically mar the natural beauty of the place. When proposals for the park became public, it transpired that the outsiders (as these outcast people were known) were to be rounded up and put into hostel camps to be rehabilitated out of harm's way, in the northern parts of the country, because now it suited the country's leaders to help them as plenty of workers would be needed for the park. There were big areas in the north of Scotland where most of the people had been thrown out in what was called the Highland Clearances, which began in the nineteenth century. They were replaced with sheep during the blockades of the Napoleonic wars because these animals were actually more profitable than people. The outsiders were to repopulate these remote areas for the

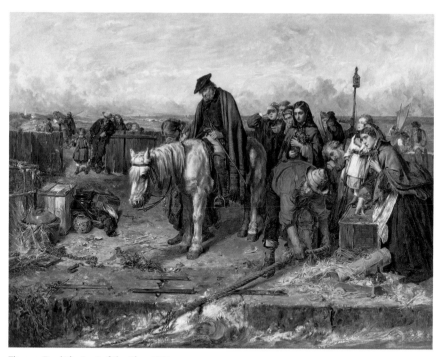

Thomas Faed **The Last of the Clan**, 1865
Glasgow City Council, Glasgow Life (Glasgow Museums)

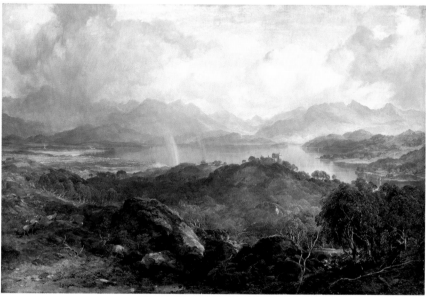

Horatio McCulloch **My Heart's in the Highlands**, 1860
Glasgow City Council, Glasgow Life (Glasgow Museums)

benefit of the tourists, in what became known as: 'The Highland Clearances in Reverse'.[3]

The basic idea for *Scotia –The Living History of a Small Nation*, when it opened in 2062, was very simple. Each area of the country would adopt the look and lifestyle of a certain epoch in Scottish history. Everyone who lived in these areas would adopt the mores and manners of their designated period. Our best actors would play the great figures in our history, except they wouldn't so much play them as be them, since they never got the chance to be off set or out of costume. This should be stressed. The whole country was subsumed into the park, you couldn't escape it. Anyone else who happened to live in Scotland at the time got the chance to stay on, if they wanted. This was to reflect for the tourists, the tolerant atmosphere created by the mixture of people who originally came from elsewhere to settle in this small country. However, you couldn't really have people coming and going all the time so it was decided that employment for the lower ranks in the park would be a bit like the volunteer armies of the twentieth century, where you signed on the dotted line and agreed to stay for something like three years at a time.

All Scotland's most spectacular battles and events were re-enacted daily in the hills and glens of the Highlands; tourists would flock to the most barren and remote places searching for the theme park's most authentic experiences. Thus a visitor from China or Peru could easily get a vivid impression of the whole history of our small nation in only a week or so, not to mention seeing the wonderful scenery. All the original flora and fauna were restored – complex deciduous forests filled with wolf, boar and all the other interesting animals that used to live in the place, but had eventually died out because the Scots didn't take care of them properly.

The Scottish people appeared to be quite happy in their new occupation as Real Life extras in this simulated version of history. Scotland became very successful and prosperous and everyone agreed that reinventing itself as a theme park had been a really great idea. Everything was free for Scottish people, although the tourists paid frankly outrageous prices just to be breathe the same air as the Scots. From the outside it might have seemed like a bit of an odd situation: the Scottish people were basically providing a service for the tourists while achieving just about the same standard of living as them. But the Scots were tied to this way of life in the theme park, they could never go home to somewhere real or do a normal job – it was twenty-four hours a day, seven days a week. Even leisure pursuits were open and available for the global tourist to gawk at. However, it was a comfortable life, and few people complained, especially the ones who had previously been forced to live outside of society for the want of a few pounds worth of cheap drugs.

The Main Cities of the Central Belt, Edinburgh and Glasgow

The City of Edinburgh elected to represent the pre-industrial Enlightenment period of the city's history,[4] while Glasgow adopted the post-industrial or 'cultural period'. This era in the history of Glasgow originally occurred during a ten-year period at the end of the twentieth and the beginning of the twenty-first centuries, when Glasgow was briefly very popular with

global tourism. New museums of art and culture were built at an extraordinary rate and on the surface everything seemed to be going very well. These new repositories of culture championed a popular kind of art which everyone was supposed to be able to access.

There was a major problem though. The educational establishments which taught people from five years old upwards had, at this time in the late twentieth century, stopped telling people anything about art and culture because it couldn't get you a job in an office when you left school at seventeen. So, it came to the point where nobody felt they really knew anything about art and culture any more, which was a great pity as Scotland had once been a very bright country. This made the public suspicious of the people who still made art and culture – and who could blame them? This self-proclaimed 'renaissance' was advertised as providing art for the people but the problem was that the people never asked for it.

The flaw in this 'renaissance' was the approach the city fathers took to make culture more accessible to the public. They made all the culture so simplified and banal that it would appeal to everyone, even those who knew nothing about any form of cultural activity beforehand. Productions of plays which dealt with complex and difficult issues were discouraged, in favour of Busby Berkley-style musical extravaganzas – everyone loved these. Visual art was reduced to greeting card designs, though painted in oils, naturally. Glaswegian literature, which was once incisive, politicised and independent, was now produced by the city itself, in defence of its own strategies. This New Glasgow Culture (as it became known) was very easy on the eye and on the ear, and provided a cosy hour or two of distraction out of the rain, and everyone – even those who stood against the imposition of this cultural equivalent of flock wallpaper – agreed that all these places of culture had lovely coffee bars.

However …
… The initial appeal and excitement of this era quickly dwindled when the people began to understand that they were being patronised. By the end of the first decade of the twenty-first century this period was already seen by any one who knew anything about life and culture to be truly daft. It eventually stupefied the locals by patronising them into thinking that they couldn't understand any kind of culture that you had to think about for more than ten seconds. This led to the Scottish people becoming lazy. After being fed this sickly sweet culture mulch for many years they could no longer digest any kind of solid cultural food. They faded away to mere shadows of their former, robust selves, becoming thinner and paler and lethargic. They were losing the ability to think for themselves. Internationally, New Glasgow Culture was an embarrassment.

The Trongate Affair
This period ended for good in 2013 in what became known as 'The Trongate Affair'. By this time various members of Transmission Gallery and other independently-minded cultural spaces located in the area, had successfully infiltrated over the year various committees and held numerous important positions in the local and national cultural councils. From these

positions they were able to undermine the whole sorry system and eventually brought the whole New Glasgow Culture crashing down around the ears of those who had been too deaf to listen to the detractors, who had foreseen this moronisation of the people.

This 'coup' was unfortunately deemed to be illegal and resulted in Transmission becoming a proscribed organisation and being forced underground. Here it flourished under the patronage of a local artist who had become very rich and famous by selling his work outside Scotland and who asked nothing in return except that the gallery continued in the way it always had. Just after the debacle of 'The Trongate Affair', the final nail in the coffin for the city fathers was the 'Purple Wednesday Crash' of 2014. Printed money became obsolete overnight, causing mayhem and revolt across the globe, particularly from those who didn't have credit cards and were therefore excluded from the new system. Since many people in Scotland still lived a hand-to-mouth existence this was, indeed, bad news for the city fathers. It was all over for them. New Glasgow Culture has gone for good (or so everyone thought).

The Irony

So, ironically, although the period of New Glasgow Culture is now wholly discredited, and has in fact become an aphorism to describe the banalisation of culture, it is this period the new city fathers chose to represent in *Scotia – The Living History of a Small Nation*, fifty years after the debacle itself. This was simply because it was the period that had garnered the most global media attention and everyone remembered it, for better or worse. Some say there's no such thing as bad publicity, but I'm not so sure.

Epilogue

Thus, as it was in Real Life, now it is in the theme park. Transmission is still a proscribed organisation but continues to flourish to this day, presenting thoughtful, challenging exhibitions in temporary out of the way spaces. Some aspects of its exhibition structure resemble the popular rave culture of the late twentieth century, where you hear of a new exhibition[5] from a complex grapevine of friends and acquaintances. People gather illegally on their days off from working in the theme park,[6] arranging to meet at a particular ferry terminal somewhere, desperate to see something new and real and engaging. For although the park is fascinating to the tourists, it is, of course, very, very boring for those who live and work there.

Transmission events and exhibitions have become somewhat voguish with the more intrepid tourists who vie with each other over the most obscure and exciting shows they have seen, but it is mainly the indigenous population who enjoy them. Unfortunately these exhibitions get closed down with great rapidity as they are illegal. Records are always kept in the old book form and these get distributed widely although they are banned and destroyed if found. Sometimes these books are produced in such a way as to look like a relatively innocuous text or history book, so they can be surreptitiously inserted into public library collections. A strategy currently popular is to place these books into public collections of times gone by, using a standard linear time shift document transferral. Thus the books

and information of the future are already in circulation decades before the actual events described have happened.

If you haven't guessed already, this is how you are able to read this history now, almost 100 years early. This document transferral technique usually doesn't change much of the course of history because the future always seems too fantastic to believe before it actually happens. I mean, who would have believed the incredible history of the twentieth century if you'd foretold it in 1899? Thus it is with the twenty-first and twentieth centuries. So let us take a moment to join together, raise a glass and make a toast to Transmission. Happy hundredth birthday, here's to the future …

To be Continued …

1 These poor disenfranchised people may not have had the vote in any election but they didn't have to pay tax either.

2 Ireland had become very rich in the first decades of the twenty-first century with the discovery of certain natural elements found only in its indigenous peat bogs which proved to be a panacea for many cancer-based illnesses.

3 While the English were always willing to encourage anything that would destabilise Scotland, it should be pointed out that in this respect the Scots have more often than not been their own worst enemies. The Highland Clearances were just as much the fault of the money-grabbing Scots landowners as the English. When the political and economic situation changed many years later, most of these folk who'd left never went back because they'd gone far away to Ireland or the Americas or to the cities in the lowlands of Scotland. Wherever they went they had got used to it and probably quite liked it and forgot about Scotland except in a vague romantic way, based more on the Hollywood movies of the time than anything they actually remembered, as they probably hadn't been back home for 150 years. So most of them just stayed wherever they ended up. Better the devil you know, they thought – until they heard about the park, that is …

4 This involved the reconstruction of the Royal Mile, which was completely destroyed by the Disney Castle riots of 2025.

5 These exhibitions are usually in the remoter parts of the Highlands or on uninhabited islands.

6 'Illegally' because no one is ever supposed to be seen 'out of character'.

The Czech-born artist Pavel Büchler, who is now Research Professor at Manchester Metropolitan University, is an influential figure who taught at The Glasgow School of Art from 1992 to 1996. He wrote this robust and provocative essay on what he saw as the small-mindedness of much of Scotland's culture for *Variant*, a radical arts magazine, which was founded by the artist Malcolm Dickson in 1984 and re-launched by Leigh French in 1996. Büchler's essay was written in 1997 in the light of debates about the role of collections and institutions in contemporary art in the mid-nineties. It continues a long tradition of artists engaging in criticism of art institutions and reflects on concerns published in the press about the gap between Scotland's international reputation for contemporary art and a more adversarial or neglectful atmosphere at home. However, while he acknowledges criticism of institutions in Scotland, Büchler does not take them seriously. Instead he suggests that artists should not need the validation of institutions at all.

First published in *Variant*, issue 2, spring, 1997

→ ## Pavel Büchler

BAD NEWS

According to press reports, Scotland faces a nearly certain condemnation in the history textbooks of the twenty-first century. The immediate cause of this shameful fate is the society's attitude to contemporary art. 'Culturally, as a nation, we will be judged on how we have treated Mr [Richard] Demarco', prophecies Giles Sutherland in *The Scotsman* on 11 December. Four days later, in *Scotland on Sunday*, Iain Gale predicts that 'the Scots face future vilification as cultural reactionaries,' because 'the Glasgow Museum of Modern Art contains not one work by any of [a generation of younger Glasgow] artists.' Sutherland and Gale are not the first to raise the alarm – just over a year ago, the nation was being publicly cautioned by a bitter painter with a vigorous imagination who complained that his works had been banished to the company of 'stuffed giraffes in the Kelvingrove Museum' – but their call to arms rings with a sudden sense of urgency. History doesn't wait. 'Unless there is a collective pooling together of resources and energy', warns Sutherland, and 'unless something is done very soon', hastens to add Gale, the Scots will be in trouble. They will have to shoulder the blame for the institutional 'indifference' which threatens to deprive Demarco's European Art Foundation of its home in Edinburgh's St Mary's school and which denies the talented artists in Glasgow their share of the wall space at the Gallery of Modern Art.

Or worse: this may be a case of a reckless conspiracy of negligence in the face of impending historical embarrassment. The identity of this artistic culture is already being shaped elsewhere, on someone else's terms, and the official domestic 'cultural sector' does not even care to come out and play. Iain Gale makes no bones about it. It is 'not the established mainstream' but a 'close-knit body of artists, curators and critics' who are seen abroad 'as the ambassadors for a new, epoch making strain of Scottish art.' Yet, 'when ten years hence, the history of Scottish art in the 1990s comes to be written, the art itself will not be in Scotland, but in London, Switzerland, Germany and the USA.'

This is bad news for the people of Scotland. The nation can rightly demand that its nominal representatives take care of its future reputation. But the stakes are too high and history is not a particularly fair arbiter. The common apex of the bleak prognoses seems to be the suggestion that, in Scotland, the blind rule in the kingdom of the myopic. As the municipal cultural policies and practices of Edinburgh and Glasgow are putting the good name of the country at risk, the community as a whole must be mobilised to do or be damned. It wouldn't be for the first time that history forgets the culprit and condemns the culture. Even where cultural misdemeanours are committed by men of a greater stature, resolve or power than those currently sitting on the committees in the respective city halls, it is their broad constituencies that are made responsible in the final account. Remember, 'the Germans' banned Kandinsky from teaching, 'the French' put Genet in jail and 'the Russians' drove Jesenin to suicide. Passing the responsibility from people onto 'the people' is history's oldest trick.

Promises of eternal damnation are often the last resort where all other arguments have failed. But in the case of contemporary art in Scotland, such arguments are yet to be rehearsed. There has not been much public debate, for instance, about the nature of what Gale calls 'Scotland's art establishment', nor for that matter about the terms of the 'debate on contemporary art in Scotland' itself – despite the record number of column inches devoted to lamentations about the blinkered vision of the former and complaints about the absence of the latter. The 'debate', such as there is, seems to suffer from serious confusion. What or who comprises the 'art establishment'? By what standard do we define 'the mainstream'? What does the word 'art' mean in the context of such institutions as Glasgow Gallery of Modern Art? What do the terms 'Europe' or 'international' stand for when it comes to the artistic culture of Scotland?

The truth is that we don't quite know – or that we don't even ask. Take, for example, the Gallery of Modern Art. Its self-proclaimed identity rests squarely within the 'entertainment business' (Julian Spalding in *The Herald*, 28 March 1996). As a theme park it surely is one of the finest things outside Las Vegas and Euro Disney. But why on earth do we feel compelled to talk about it as though it had anything to do with art? Or take the generation of artists who are supposedly ignored by and excluded from the 'established mainstream'. Excluded from what? What is there that the 'art establishment' (whatever that means) could offer them? Why would they ever want to be involved with an 'establishment' remarkable only by its almost total obscurity and its manifest lack of ambition? (Think of the trickle of decorative pictures juried for seasonal exhibitions by a club of gentleman-painters of a bygone era 'world famous in Edinburgh'.) Or the collections of contemporary art in Scotland – how do their agendas match the aspirations of work which is determined to assert itself within a living culture? Whatever their individual interests, it is unlikely that Scotland's cultural institutions and its 'art establishment', as they are, could provide more than a limited support to the uncompromising commitments of artists who know that the identity of living culture cannot be constrained by geography, let alone by the priorities of municipal politics. Granted, these artists' work should be collected and made more readily available

– not because it is Scottish, but because it is often very good. It also is, in many instances and in the most positive sense of the terms, European and international. Indeed, without the artists' efforts international art would not have much presence in Scotland. The same goes for Demarco. He too deserves support because of the genuine international aim of his enterprise – and because he shares with the younger artists the spirit of ambition. The whole culture which they claim as their own is aspirational and outward-looking. They are the ones who belong to the mainstream – not the regulated flow of populist entertainment, but that current in art and culture which engages and makes visible the experience of living in the world.

Just as we seem to massively overrate the cultural importance of institutions and the 'establishment', so we underestimate the oppressive power of mediocrity hidden within the institutional culture. This not only stifles the best efforts of those who work within or outside institutions to create a cultural climate of high ambition and excellence which all good art of whatever provenance demands, but it also perpetuates a general sense of limitation. As a result we are too ready to settle for crumbs of official benevolence which may save from closure a gallery in Edinburgh or secure 'for the nation' a video work by a young artist, but which will not, in itself, change anything else. And while we listen with sympathy to those well-meaning few who take it upon themselves in the name of 'the nation' to lead the charge against 'indifference', we fail to notice the tone of dependence in their alarmed voices. They have faith in the merits of the art which they advocate, but they too believe that the supreme gesture of recognition is a seal of approval by officers, local politicians and 'Scotland's art establishment'. Their anxieties about the future are themselves signs of surrender to the creeping regime of the official and the ideology of institutional culture. Their concerns are ultimately compromised by the very terms of their arguments. Unless these terms are questioned and challenged, all the practical victories which the 'collective pooling together of resources and energy' could bring about may still be our symbolic defeats. And this is the real danger today, no matter what history might think of it 'ten years hence'.

Meanwhile the public can be best advised to forget the judgement of posterity and to concern itself with the message of ambition that contemporary art contributes to our sense of who we are right now. The nation can be assured that cultural identity is not made up of institutions nor is it authenticated by them. Even less is it fabricated by planning departments or museums. Rather, it is formed by the tensions between what people do and what they aspire to. In its verdict on our attitudes to art and culture, history will look kindly at those who do not bow to mediocrity – which will undoubtedly be recognised as the tyranny of the late twentieth century.

1997

A distinguished teacher and a pioneering feminist, Adele Patrick studied Embroidered and Woven Textiles at The Glasgow School of Art from 1982 to 1984 and obtained her MA in Design in 1986. She taught in the Historical and Critical Studies Department there from 1991 to 2003. Patrick has been active in many women's initiatives in the city. She helped found Glasgow Women's Library, an important library, archive collection, education resource and information hub, now housed in Bridgeton, Glasgow. This essay is a fierce polemic on the role and recognition of women artists and designers. It reflects contemporary conflicts around institutions where women were under-represented in important art exhibitions and often missing from the historical record. The essay was a landmark of the period, linking the struggle of women artists in the nineties with the position of eminent women artists and designers in the nineteenth century. Reading it now demonstrates the changed circumstances of women in current art and institutions, a change that Patrick herself has helped bring about.

First published in the *Journal of Art & Design Education*, volume 16, issue 1, February 1997

→ Adele Patrick

BOY TROUBLE: SOME PROBLEMS RESULTING FROM 'GENDERED' REPRESENTATION OF GLASGOW'S CULTURE IN THE EDUCATION OF WOMEN ARTISTS AND DESIGNERS

Abstract: this essay is written as Glasgow celebrates its (unilaterally-nominated) year as UK City of Visual Arts and anticipates its year as UK City of Design and Architecture in 1999. In it I will suggest that women's participation in art and design (education) in Glasgow can be read as both problematic and political, pioneering and yet historically and currently contingent on 'binary oppositions'.[1]

Dispassionate essays on gender issues and Glasgow's culture are few and far between; attempts to produce a scholarly, measured paper on gender and The Glasgow School of Art seem just as likely to be beset by unruly emotions. Clearly, what follows is a personal view.

The Glasgow School of Art is located in a 'masculine' culture, one that the city and the school (self-) consciously reflects, rejects and promotes. This ambivalent response to gender issues makes Glasgow a paradoxical (marvellous and demoralising) context for creativity and education.

In 1981 as a newly enrolled English 'direct entry' student into The Glasgow School of Art I was aware, but sceptical, of Glasgow's notoriety as 'No Mean City'. Glasgow's culture was represented in the English press (pre-Garden Festival) as industrial, working-class, left-wing, sectarian, violent, hard-drinking and its culture, almost entirely represented by men – Billy Connolly, William McIlvanney, Rab C. Nesbitt, Jimmy Reid and Jimmy Boyle.

This crude (racist?) reading has been rigorously interrogated in the intervening years. Local and national politicians, doggedly committed to a wholesale 'makeover', have had occasional unlikely bedfellows in post-modern spokespersons bent on critiquing Glasgow's hard man profile as a sign of the historical 'othering' of Scottish culture and of English cultural hegemony.[2]

But to what extent are gender divisions preserved in recent representations of Glasgow (for example, in festivals designed for local and international audiences)

and in the profile of the contemporary school? What are the consequences for women artists and designers of 'gendered' representations of culture? Is Glasgow's culture really a more deeply divided model for feminist critics and activists, artists and educators?

Even the most cursory reading of Glasgow's art and design from the nineteenth century provides an essentially gendered picture; of 'Glasgow Boys' and 'Glasgow Girls'.[3] The two groups recognised as reinvigorating and exemplifying Scottish fine art in the 1880s and the 1980s are both known generically as the 'Glasgow Boys'. The popular perception of the 'Glasgow Style' of design and architecture is of the (Charles Rennie) 'Mackintosh Style'.

In Glasgow the visibility of men's achievements and authorship is pervasive; Hunter, Newbery, Bilsland, J.D. Kelly, Bourdon, Garnett, Glassford, Foulis and Mackintosh literally map the geography and architecture of the city and the school. There is only one public monument to a Glaswegian woman in the city.[4] There are no women on the scroll of honour in the foyer of the school of art. There are no women included in the much-vaunted Princes Square entrance where anamorphic renderings of heroes embellish the entrance. Although women have been notably prolific, innovative, vociferous and creative in Glasgow from the turn of the century, their role and importance has been continually sublimated, not least through the nomination of them as 'Ladies' and 'Girls' – persistently defined in their relation to male counterparts and precedents. Cixous has pointed out that 'binary oppositions' are not balanced, that, for example, passivity is not the equal of activity – that gendered paradigms fix the feminine side as 'the negative, powerless instance'.[5]

The work of 'second-wave' feminist art and design historians has demonstrated that women's achievements at the turn of the century were often subsumed, misattributed, hidden, ridiculed and minimised.[6] In the 'Second City of the Empire' then, as in other British industrialised cities, it is not surprising that it was male artists who forged a distinctive Scottish 'movement'. It is perhaps more troublesome, particularly for those of us working with women art students, that male artists were once again homogenised into a seminal 'movement' in the 1980s and 1990s.

The nomination of the 'New Glasgow Boys' occurred within a critical timeframe. In 1990 Glasgow was European City of Culture. In the years leading up to and including 1990, debates proliferated and intensified as to what Glasgow's culture was, where it was located and how it might be represented. Over this period Glasgow's guardians of culture (and advertising agencies such as Saatchi and Saatchi) elaborated on, ironised and revised its image. The Glasgow School of Art surfaced as a major player in the promotion of a cultural regeneration. The ubiquitous (patriarchal) figure of council leader Pat Lally vigorously pro-moted Glasgow's 'renaissance'. Lally personified the bravura confidence (arrogance even) of the 1980s and 1990s zeitgeist.

Whilst the 'commodification' of Glasgow as 'City of Culture' was publicly disparaged by the Workers City Group and others,[7] there was little support or resources for groups keen to use this opportunity to promote women's hidden histories. The Workers City project itself remained resolutely within the masculinised tradition of 'Red Clydesiders' (eighteen men

and one woman represented the group).

Anticipating the unprecedented attention Glasgow's fine arts were to garner in 1990, an exhibition, *The Vigorous Imagination,* was curated by the painter, and Head of Drawing and Painting at the GSA, Sandy Moffat in 1987. The exhibition and catalogue essays were influential in defining and contextualising the 'renaissance' (of 'New Scottish Painting') for international visitors and undergraduates alike.

Invoking as they did the precedence of the old 'Boys' and the almost magical properties of 'Mackintosh's masterwork', The Glasgow School of Art, the catalogue contributors fixed the notion of a 'New Scottish Art' in a traditional canonical trajectory and a specific location:

(it) came from the department of Drawing and Painting at the GSA.[8]
It was the 'seedbed and spearhead of the new movement'.[9]

The then director of the school, Anthony Jones suggested that the degree shows of Campbell, Wiszniewski and Currie, and graduates Mario Rossi and Peter Howson, *created the notion in many minds of the rise of the 'New Glasgow Boys' recalling the Golden Age of Glasgow painting exactly a century before'.*[10] Although the work of the most celebrated of the new Glasgow Boys was criticised from the outset for its transparently regressive themes and iconography,[11] it did seek to recuperate a Glaswegian (masculine) working-class culture, setting it apart from the concerns of Lavery, Hornel, Guthrie *et al.*

Critics, journalists and councillors were quick to collapse fine art and social history, past and present stereotypes and the real and fictional, romanticised experiences of under-graduates at The Glasgow School of Art in their efforts to capitalise on their investment in the City of Culture.

It seems to be Clyde-taught is to be Clyde Built![12]
It's got everything – sex, violence and humour. Bound to be a hit![13]

Despite the incorporation of the important, singularly non-traditional work of Sam Ainsley and Kate Whiteford in the exhibition, the new movement was often read as (anachronistically) affirming gender divisions.

The world that Peter Howson depicts is a decidedly masculine one: soldiers, boxers, bodybuilders, sportsmen … In this world of men, women, if they are depicted are seen as adjuncts, wives or lovers, with no independence … a folk history of Glasgow working class life.[14]

Interestingly, Jones chose to graft some new Glasgow Girls rather unconvincingly onto his recollection of the Boys' development into artists under his beneficent patronage and the tutelage of Moffat, 'the father of New Scottish painting' (unconsciously replicating the perceived role of Fra Newbery some 100 years earlier).

Somewhat unimaginatively, Jones cites Rosemary Beaton and Alison Watt as being, 'the second-wave … they were predominantly women'.[15]

The parthenogenesis of the New Boys was possible not merely through reference to their nineteenth-century namesakes. Investments in a mythology of gender stereotypes can be traced in numerous accounts of art milieus and artists at The Glasgow School of Art, where the agency of women was and is marginalised. King notes that by the 1970s, Scottish feminists had coined the word 'MacHismo' to describe this particular brand of cultural separatism.[16]

In the Sauchiehall Street cafes of the early 1960s (described so well by novelist Alasdair Gray in his book Lanark), Glasgow's bohemian set gathered to talk of Modern Art and folk music and wag their beards over the latest piece of Italian artiness on show at the Cosmo cinema.[17]

It is awesome to remember so much talent, and so much understandable arrogance. I came to Glasgow School of Art aged 15 and left aged 65 and by then I had the privilege of heading the School of Painting. We accomplished much. I owe a great deal to my staff and take this opportunity to thank Geoff Squire, Robert Sinclair Thomson, Bill Bone, Alix Dick, James Robertson, Sandy Goudie, Leon Morrocco, Duncan Shanks, Big John Cunningham, and Danny Ferguson who made it all possible. We were the greatest.[18]

It is perhaps the creativity of women of colour that has been under the greatest threat through investment in such mythologies. It is therefore ironic that arguably the current most famous Glaswegian artist is the black woman artist Maud Sulter. Sulter has traced her determination to become an artist to the moment in the early 1980s when a Scottish Arts Council representative informed her that they had no information on Scottish black artists (they did, however, know of works with black subjects).[19]

Orientalism and images of the 'other' are certainly key 'themes' in the work of the Glasgow Boys and Girls of the nineteenth century. Even recent criticism recalls such colonialism unproblematically:

Letters from Hornel describe his project for a picture. 'Very Burmese, dancing girls and peacocks with the Old Palace at Manderlay [sic] *in the background', he had, 'Some very Burmese dancing girls photographed in quaint costumes for the picture'.*[20]

The school's equal opportunities policy recognises our duty to 'promote harmony between persons of different ethnic groups' (1993), but Glasgow can still be a hostile environment for the artist, designer and student of colour. In 1995 to 1996, of 172 students enrolled into year one at The Glasgow School of Art, white students account for 168.[21]

Recent criticism of Chila Burman's show at Glasgow's noteworthy Streetlevel Gallery suggests what is still permissible:

Family photographs, be they of Liverpool or India, are important here – but Burman should take her minority chip off her shoulder, look for other subjects and realise that a happy home in Bootle with two loving parents, plus talent, looks, health and oodles of self-confidence is more than many folks have.[22]

Scottish women artists, writers, playwrights and historians influenced by feminism, have sought to address issues of gender in the representation of Glasgow's culture and the problematic (and fluctuating) relationship of women to creativity in this milieu.[23] The rubric 'Glasgow Girls' has been readily adopted by women (and men) to stand for a range of projects that variously problematise, ironise or endorse divisions in the city, but principally, 'Glasgow Girls' refers to women artists and designers from The Glasgow School of Art at the turn of the century.

In 1988, concurrent with the promotion of the New Glasgow Boys, the American artist and researcher Jude Burkhauser curated the first retrospective exhibition of the work of the 'Glasgow Girls' at The Glasgow School of Art. This 'pilot' project was followed by a major exhibition reinstating the work of over thirty women artists and designers, held in the Kelvingrove Art Gallery and Museum in 1990. Burkhauser entered in the project ingenuously,[24] but was 'politicised' in the research process and, significantly, through the acrimonious public battle that ensued, towards the end of, and after, the exhibition's run, with Glasgow Museums chief Julian Spalding.[25] The visibility of women's work was again a central issue; the battle with Spalding centred on his attempt to '(dis)own' the project.[26]

Burkhauser's extremely popular exhibition and publication proved a model for, and validated, concurrent and future related research, dissertations and documentation, but simultaneously posed the question of how such a huge and significant body of art and design work could have been so thoroughly sidelined in salesrooms, galleries and the school of art itself. The exhibition was,

curated in the face of ingrained hostility from [The Glasgow School of Art] *and Glasgow Museums and Galleries.*[27]

Burkhauser was motivated, in part, by a feminist concern that women (students) are empowered through exposure to women's historical achievements.

Had it been known that the students from Secessionist Vienna had strewn flowers at the feet of Margaret Macdonald to demonstrate their high regard for her work it might have altered one's destiny as a woman art student.[28]

Unlike the Glasgow Boys whose work did not have to be unearthed for the City of Culture year, and can be viewed in many local and national galleries and museums, works by women artists had not been assiduously collected or exhibited by Scottish museums and galleries.

Many of the works of interest to students today are in private (family) collections, overseas or lost. Even the lush book cover and poster image *The Opera of the Sea* by Margaret Macdonald Mackintosh is a German replica of the now-lost gesso original.

It is extremely unfortunate for historians, staff and students alike that neither the school nor city's art galleries and museums offered to house the 'Glasgow Girls' archive at the end of the project.

Although many Glasgow School of Art women graduates (and some staff) participated

in events and exhibitions during the City of Culture year in 1990, (for example, Castlemilk Womanhouse, Keeping Glasgow in Stitches, Photoworks, Women's Own Annual, Glasgow Girls exhibition) two significant high-profile disputes dominated discussions and media coverage of women and culture in Glasgow at this time. These revealed, to the council's chagrin, the deeply embattled position women perceived themselves to be in. Elspeth King, then acting curator of the People's Palace, and Burkhauser both had conspicuous and long-running campaigns against 'Lallygrad' officialdom and the newly-recruited unreconstructed head of Glasgow Museums, Julian Spalding. Spalding's strategic use of gender divisions, for example, 'There are no jobs for the girls'[29] and, 'there can only be one master of the [Glasgow Girls] exhibition'[30] was, somewhat surprisingly, unsuccessful, and King and Burkhauser engendered support from both press and public.

Elspeth King is a coalminer's daughter with a first class honours degree. She is a woman. She is a Scot. She is the wrong class, the wrong sex and she does not tow the Establishment's line. That is why she did not get the job [that is, the post of People's Palace curator].[31]

But it is easy to see how King and Burkhauser could find themselves demonised. In their respective fields of art and design and social history both were keen to use feminist methodology to highlight Glasgow's gender divisive history and create a space for the evaluation of women's contributions alongside those of men.

King, Burkhauser, Kinchin and others have demonstrated the libidinal economy at work in art and design history and criticism. For all students of critical evaluation of historical accounts of the role and work of women artists, (such as Morton Shand's views on Margaret Mackintosh's regarding his selection of the Mackintosh Memorial exhibition 1933, extracted below) is crucial to their understanding of strategies of erasure.

I hope the exhibition will not be so arranged or announced as to give the impression that Mrs Mackintosh was in any sense considered her husband's equal, or alter ego … Roughly speaking what will interest the Continent is purely Mackintosh's architectural-structural work; not the dead and forgotten artistic or decorative frills which so often marred it … Only when he had to build, and so to work in single harness, does he seem to have gone beyond the narrower orbit of his own vision which was his wife's. It would appear to have been the florid coarseness of her wholly inferior decorative talent and a firm insistence on 'me too' that too often led him into an uxorious ornamental vulgarity.[32]

Contemporary women graduates, particularly those working 'experimentally' are often easy targets for criticism by both 'serious' and 'tabloid press (in contrast to male counterparts such as David Mach, 'an international superstar,'[33] or George Wylie, 'Scotland's own expert in aesthetics'[34]) who still prefer women to be subject rather than maker.

Visitors to Kelvingrove Art Gallery have given a unanimous verdict on a recent exhibit [by Christine Borland]. *It's Rubbish! And they're right!'*[35]

But as Val Walsh points out, the woman art student whose strategy is to adopt a less 'confrontational', more traditional 'bohemian' role is as likely to be subject to prejudice.

Art femininity … is a 'professional aesthetic' which condenses two codes, 'art' and 'femininity' both stereotypically white, affluent and able-bodied, in a spectacle designed to embed the women within the fine art aesthetic, not as knowledge maker but as confirmation of the artists as hero (male and heterosexual). The pressure on women in art education is to produce, present themselves as bodies/art objects, in terms of a sexualised aesthetic which emphasises appearance and sexual availability. In the studio, women are expected to be girls, and visually compete with the art; to be unconventional, visually interesting, even shocking, but not speaking subjects.[36]

Criticism of Alison Watt, one of only two Glasgow women artists' works on show at the recently opened Gallery of Modern Art or 'Spalding-World' as it has already been dubbed,[37] and other contemporary GSA women graduates, has often rehearsed the paradigm of masculine agency subsuming feminine negativity.

The macho imagery of brawny socialists and beefy torsos in rags that made figurative painting famous in the 1980s is absent in the work of 24 year old Alison Watt.[38]

GSA graduate Muriel Gray is pragmatic about the penalties of 'art femininity':

Alison Watt is the most interesting and talented person I have encountered in years. She will obviously be held back in her career as a serious painter as she is a small, quiet, attractive woman rather than a large, loud and attractive man.[39]

Watt confirmed this in an early interview:

People tend to be quite patronising to me. I think if you are a man you're definitely taken more seriously.[40]

It is impossible to detail the huge range of approaches to art-making undertaken by women (and men) in the years I have been working at the school, but I recognise an increased degree of self-reflectivity in work by women students (and staff) using a range of media to literally put themselves in the picture. Jenny Saville, Gwen Hardie, Alison Watt and Sam Ainsley are currently perhaps the best-known exponents of this feminist-informed trajectory. Val Walsh suggests that this is an appropriate and challenging response to the limitations of 'art femininity'.

The woman's body becomes the terrain upon which patriarchy is erected and his has a specific resonance within art education and art; many contemporary women have shown imagination and ingenuity in using their bodies as sites of resistance in their art.[41]

Many women undergraduates and artists have, understandably, felt that the competition for recognition is too fierce, daunting or dangerous to identify themselves as a 'woman artist' or with 'feminist aims'.

Women artists have devised numerous strategies in order to reconcile their identities as women and artists. Not surprisingly many have involved attempts to internalise some aspects of masculinity in order to gain power in the public realm.[42]

In some cases this has meant literally adopting a male name; Ailsa Tanner states without irony that Stansmore Dean was advantaged by having a male-sounding surname.[43]

Women make up over half of students at the Scottish art schools. There are very few women art teachers in fine art departments and very few women go on to work as artists.[44] The Scottish Arts Council has noted that:

The role of the college tutor in influencing and guiding a student is crucial, but concede that in Scottish art schools women graduates are often encouraged into school teaching or other areas perceived to be more 'appropriate'.[45]

In 1994, the gender ratio of The Glasgow School of Art staff was 82 per cent male and 17 per cent female.[46] Walsh critiques the imbalance between the visibility of women students and the invisibility of women staff thus:

In art education … the stereotype persists of the bearded white older male heterosexual art tutor faced with mainly young white women art students. Female art students have accounted for 50–60 per cent of all students since the 1980s, (and mainly drawn from the middle and upper classes) acceptable, even necessary perhaps given the women as muse/mistress/model/child syndrome so persistent in Western art practice. The lack of full-time women tutors in particular within the fine art studio compared to art history or complementary studies suggests a taboo at work.[47]

The opportunities that exist nationally for women graduates to exhibit are still limited. Despite the fact that 65 per cent of British Fine Art graduates are women they are,

vastly under-represented in historical, theme and survey shows as well as in national contemporary collections and women artists still find it infinitely more difficult to show their work, develop careers and rise up gallery hierarchies than do men.[48]

Although most women artists seemed to welcome the Glasgow Girls exhibition, more than a few were critical that the recovery came far too late. (Of all the 'Girls' only Mary Armour has been fully recognised in Glasgow in her lifetime. She was exhibited at The Glasgow School of Art for the first time in the 'pilot' Glasgow Girls exhibition in 1988). The likelihood of an exhibition of contemporary Scottish women's art, design, or architecture in any of Glasgow's public galleries, including the school of art seems very remote.

However, women artists from The Glasgow School of Art have once again provided the inspiration for a popular new work. Recently, TAG theatre company commissioned the renowned playwright Sue Glover to produce a play for a young audience which was to tour schools and community centre's throughout Scotland.

The artistic careers of the play's three characters mark the period from the 1880s to the present. It is informed by, and successfully addresses, many of the key issues for women students and artists and designers over this period.

'Artist Unknown' reveals the experiences of women at the school of art as ambivalent, paradoxical. The interaction of Margaret Macdonald Mackintosh, Joan Eardley and Cassie (a fictional painting schoolgirl and subsequent painting undergraduate), offer up a contradictory model for the woman artist/designer, one that is not reductive. The women artist can be consumed by intoxicating ambitions, and self-doubt, can be selfless and selfish, demoralised and inspired by men, successful, impoverished, divided by class from her 'sisters'.

Although the three 'characters' are all represented as embracing the nomination 'artist' or 'designer', significantly the title hints at the fate of such work produced in Glasgow by women over this period. Cordelia Oliver chooses to see Cassie alone as the (as yet) 'Artist Unknown'[49] but, as I have suggested, the battle to contextualise and make visible women's creative achievements is still being waged. I await the evaluation of Margaret's contribution to the Mackintosh's architectural *oeuvre* in the forthcoming 1999 festival with interest; will it be represented as 'a half if not two-thirds' of Charles Rennie Mackintosh's output, as he himself suggested?[50]

Such work, particularly work that is designed to be seen in schools, is important, notwithstanding or perhaps because of the 'backlash' against feminist agency and the anti-'political-correctness' debate which has been embraced in Glasgow more readily than feminism ever was, adopted indeed before feminism has been even superficially embedded. (Glasgow District Council established its first women's committee as late as December 1993. It was disbanded in April this year.)

Many obstacles that prohibited women's full involvement in art, design and architecture in Glasgow in the 1890s persist in delimiting the educational and creative careers of women today. Childcare prevented Frances Macdonald from attending the Vienna Secession Exhibition of 1900 where her work was being exhibited, and yet in 1992, Christine Hamilton of the Scottish Arts Council stated that, 'it is [still] virtually impossible for women to pursue a full-time career in the arts with children'[51] and despite figures that show that there are more lone parents and less childcare provision in Scotland than in other parts of the UK,[52] there is still no crèche provision at The Glasgow School of Art.

Poverty, ill-health, poor housing and violence are issues confronting many contemporary undergraduates. Representations of Glasgow's culture may have changed but many of the social and political problems remain intractable.

Although women working in art and design (within and outwith the institution) continue to produce remarkable, challenging and popular work, students and staff at the school are aware that just as male staff predominate in the institution, so male students/graduates are more likely to be employed, promoted and offered post-graduate places and that women graduates will have to be better and more determined than their male counterparts to succeed, particularly in 'masculine fields'.

Particular departments continue to be (statistically) strikingly 'gendered' as are final degree grades. There is clearly a need to avoid the line unfortunately but unashamedly taken in the new Glasgow University prospectus for the School of Architecture where prospective students are promised the opportunity to learn from 'men's skills'. The 'under-achievement' of the (female majority) of graduates is also unwittingly promoted in the newly-published Directory of Design Capability in Glasgow.[53] Out of little over 500 named contacts for engineering, architectural, graphic, textile and other design firms in the city fewer than sixty are women.

Margaret Macdonald Mackintosh, who participated in over forty international exhibitions, identified herself as having 'no profession' on her 1878 passport. For many current undergraduates such self-identification as artist, designer or architect remains problematic. It is of vital importance that current and future graduates continue to defy the nomination of them as Boys and Girls and insist that forthcoming and future representations of themselves and their work, of Glasgow and The Glasgow School of Art are more appropriately heterogeneous and expansive.

1 T. Moi, Sexual/Textual Politics, London, 1985

2 C. Beveridge and R. Turnbull, *The Eclipse of Scottish Culture*, Edinburgh, 1989

3 R. Billcliffe, *The Glasgow Boys*, London, 1987; J. Burkhauser, *Glasgow Girls: Women in Art and Design, 1880–1920*, Edinburgh, 1990.

4 King 1993.

5 See note 1.

6 For example, Greer 1979, Nochlin 1971, Callen 1979.

7 F. McLay (ed.), *The Reckoning – Beyond the Culture City Rip-Off, Public Loss and Private Gain*, Glasgow, 1990.

8 Jones 1987.

9 Hall 1993.

10 Jones 1987.

11 Wulffen 1989.

12 Jones 1987.

13 C. Henry 1987.

14 Keith Hartley, *The Vigorous Imagination*, Scottish National Gallery of Modern Art, 1987, p.78.

15 Jones 1987.

16 King 1993.

17 Scotland 2000, BBC Scotland, 1987, p.162.

18 Donaldson in H. Ferguson, *The History*, Glasgow, 1995.

19 M. Sulter, quoted at Photogenic Symposium, Streetlevel Gallery, Glasgow, May/June 1995.

20 C. Henry, New Life for Glasgow Boy's Home, *Glasgow Herald*, 13 November 1992.

21 1995 to 1996 GSA figures.

22 C. Henry, Rare Pearls after Sweat and Tears, Glasgow Herald, 19 February 1996.

23 For example, Lynch, Macgregor and Parry, 'Women artists in Glasgow' in *The Visual Arts in Glasgow*, Glasgow, 1985; King, Burkhauser, Glover, Kinchin; L. Bird, 'Threading the Beads; Women in the Arts in Glasgow', 1870–1920 in *Uncharted Lives*, Glasgow, 1983.

24 J. Burkhauser, *Glasgow Girls: Women in Art and Design, 1880–1920*, Edinburgh, 1990

25 See for example, J. Burkhauser, 'Peculiar or Perceptive', *Art Monthly*, February 1991; J. Spalding, Correspondence, *Art Monthly*, August 1991.

26 J. Burkhauser, The Chicken and the Pig, *Harpies and Quines*, October/November 1992.

27 F. Byrne Sutton, *List Magazine*, Edinburgh, August 1990.

28 See note 24.

29 *Artwork* 44, June 1990, p.2.

30 See note 26.

31 *Glasgow Herald*, May 1990.

32 M. Shand, Correspondence, Mackintosh Collection, University of Glasgow, 31 May 1933

33 Glasgow *Herald*, 3 April 1990.

34 *Scotland on Sunday*, March 1990.

35 *The Glaswegian*, 31 May 1990.

36 V. Walsh, 'Eyewitnesses not Spectators/Activists not Academics: Feminist Pedagogy and Women's Creativity' in K. Deepwell, *New Feminist Art Criticism*, Manchester, 1995.

37 Gale 1996.

38 Flowers 1990.

39 M. Gray, the *Observer*, 10 July 1989.

40 J. Rafferty, The *Sunday Times*, 13 November 1988.

41 See note 36.

42 M.R. Witzling, *Voicing our Visions: Writings by Women Artists*, London, 1992.

43 See note 24.

44 Scottish Arts Council, *Women and the Arts*, discussion paper 31, 1992.

45 Ibid.

46 D.E. Fitzpatrick, 'Women, Glasgow School of Art and World War II', unpublished dissertation, Glasgow School of Art, 1994.

47 See note 36.

48 D. Duffin, 'Exhibiting Strategies' in K. Deepwell, *New Feminist Art Criticism*, Manchester, 1995.

49 C. Oliver, Girls who Suffer for their Art, *Glasgow Herald*, 16 February 1996

50 C.R. Mackintosh, Correspondence, Mackintosh Collection, University of Glasgow, 16 May 1927

51 Scottish Arts Council 1992.

52 Engender, *Gender Audit*, Edinburgh, 1993; 1994.

53 Glasgow Design Initiative, 1996.

1998

Douglas Gordon works across many mediums including text, video and installation, his art deals in both the specific conditions of the modern world including mass media, pop music, movies and popular culture and with far wider, and often older, questions about the nature of action and intent, good and evil. This text work first printed in 1998, just two year's after Gordon won the Turner Prize in 1996, is an important example of how he uses the conventions of the art world for his own creative purposes. The text purports to be a straightforward biography of the artist, of the kind that might be found in any published art catalogue. It describes his early upbringing and education in Glasgow and Dumbarton and his formative years as an artist. As such it provides an insight into both the artist's milieu and his ideas. The work is, however, ambiguous. It alludes to Gordon's unreliability as a witness to his own life and to the scepticism of the unnamed narrator and suggests undisclosed narratives and the possible role of supernatural forces. As such it draws on an extensive literature about the formation of character and the nature of fate, including twentieth-century writings on psychoanalysis and a Scottish novel of fundamental importance to the artist: James Hogg's *The Private Memoirs and Confessions of a Justified Sinner* (1824).

First published in Eckhard Schneider (ed.), *Douglas Gordon: Words*, published by Kunstverein Hannover, 1998

A SHORT BIOGRAPHY – BY A FRIEND

Douglas Gordon was born in Redlands Hospital, Glasgow, in September, 1966. He was the first born of four children to James Gordon and Mary MacDougall. The birth was not an easy one. From what he can remember or from what he can remember being told by his mother the labour lasted @ twenty-four hours. It was clear he didn't want to be out in the world. Eventually he had to be pulled out, by doctors using forceps. This may account for the odd shape of his head, and the small scar at the base of his skull, where the spine joins the cranium. The event was a traumatic experience for both child and mother. Mary MacDougall, his mother, died during the birth. But she came back to life again, after a few moments. Douglas feels guilty for all the trouble he caused his mother during this time. Perhaps this is why he is constantly travelling and putting off his return to Scotland. Maybe he doesn't like having to face the guilt that he feels when he sees his family.

His paternal grandparents were already long dead by the time he was born. His maternal grandparents were still alive, and living nearby the Gordon family home. But not for long. He has a vague memory of his maternal grandfather, John MacDougall, but these memories may have come from seeing photographs of his grandfather holding a baby on his knee; the baby being Douglas. He has a stronger, but still vague, memory of his maternal grandmother. He can remember the smell of the perfume that she used to wear, and the texture of the material of her favourite navy-blue 'twin-set', but over the years he had forgotten what her face actually looked like. He can remember her reading bedtime stories to him, and he still imagines that he has those old storybooks hidden away somewhere, although, in reality, they were consigned to the dustbin many years ago.

His family lived in Maryhill, an area in the north of Glasgow. His father's family lived at the top of the hill, and his mother's family lived at the bottom of the hill. When his parents were married they lived in a small tenement flat in the middle of the hill. At the age of five, Douglas enrolled at Gilshochill primary school (the

Protestant school) at the top of the hill. He had some friends who attended St Mary's (the Catholic school) at the bottom of the hill. Occasionally, the Protestant children would meet the Catholic children, at the middle of the hill and they would have childish, but serious, fist-fights about their religious and political differences – loyalty to the Crown, or to the Vatican. These political and ethical battles did not last long, for two reasons: Douglas's mother became a Jehovah's Witness, and then the family moved out of Glasgow to Dumbarton. No one really wanted to leave Glasgow, from what he can remember, but the Gordon family tenement was to be pulled down, and besides the new house would have a garden for the children (now two, with a third coming soon) to play in.

He has various and conflicting memories of life in Dumbarton. Perhaps the worst of these memories are stories best kept for another time, and another place. And maybe the best of these memories are stories best kept for another time, and another place.

Having said this, there are a few incidents that might be of some interest to the reader and have some influence on the work.

As mentioned previously, Douglas's mother left the Church of Scotland @ 1972 and began to attend the local Kingdom Hall of Jehovah's Witnesses. This was inspired in part by the religious activities of her parents and her family: all of whom were traditional Scots Protestants. He can't quite remember exactly what happened, or what inspired the shift in religious devotion, but he says that his grandfather was involved in a near-fatal car crash on the west coast of America, and only just survived. On returning to Scotland, his grand-father converted from Protestantism to Catholicism. Around this time, but slightly later, his grandmother went to visit two of her daughters in the United States. They had been in contact with some Jehovah's Witnesses. On returning to Scotland his grandmother, and all of the women in the MacDougall family, began to leave the Church of Scotland, and instead, began to attend their local Kingdom Hall. In fact, this is not quite true. His mother's family were six daughters and one son. Five of the daughters converted and one never did, despite various attempts by the others to persuade her. Her name was Maude MacDougall, and she was blind from birth, and then she could see, but this is another story. But the fact is that the blind sister would not have anything to do with this new religion, or any religion, as far as anyone can recall. And the only son, John MacDougall, played guitar and grew his hair long, but never joined any church, of any kind, at any time.

Douglas's father was a nominal Protestant, more by birth and education, than desire or faith. He worked as an engineering pattern maker, in Glasgow's ship-building industry, for most of his life, and his comments on religion can only be remembered as somewhat sceptical. He played bagpipes and urged his children to a good education, to be politically 'left', and to remain single until at least aged thirty. As Douglas gets older in years, he bears an uncanny resemblance to his father – in physique, physiognomy, and pedantry. Everyone is beginning to worry.

As a child, Douglas, like his sister and brothers (now four in total), was taken to his mother's church for spiritual and emotional education.

This involved some significant amount of time and emotional duress, giving Bible readings to a congregation of over 200 people, and 'door-to-door' preaching.

As a teenager, Douglas attended Dumbarton Academy – a rough comprehensive (mostly Protestant) school in the centre of the town. The fighting between this school and the local Catholic school continued, as usual, but as the children grew older, the violence increased and consequences grew steadily more serious. He tried to avoid these things. He liked to read books, listen to records, play football, and draw stuffed birds in the art class.

He can remember, quite vividly, although inaccurately, an event in the art class which could be said to sum up his time at school.

The time is late 1983, or early 1984. Douglas is working, after school hours, in a local super-market. He enjoys the work because the pay is OK and there are a good crowd of guys who share the same interests working together. Strangely, most of the staff are people who he doesn't know, because the workforce is predominantly Catholic, and as was pointed out before, the two communities are not encouraged to socialise together. Predictably, there is a lot of petty bigotry in the store, but everyone tries hard to get on with one another. After all, it's better to hate the boss rather than hate your workmates.

Douglas works on a very late shift at the supermarket because the pay is better, the crew is better, and they don't have to deal with the public. Also, it doesn't interfere with much else in life.

At this time, he is really interested in art, but is still swithering about whether to be an architect, a writer, or an artist. He liked drawing stuffed birds and rotting vegetables at first, but now it's becoming a bit too predictable, and he needs a change. He visits an architect's office for an hour and decides it's too dull. Deadly dull boring. Maybe writing could be more interesting. At this time he's reading a variety of material – Graham Greene, Tennessee Williams, William Shakespeare, George Orwell, Aldous Huxley – and they definitely seem to offer a more radical view of the world than Edgar Degas and Claude Monet. However, one of his English teachers suggests that he should forget about going to university, and go to art school instead. He is told that art school is much more fun, and that if anyone wants to keep writing, then they can just keep on writing, 'you don't need to go to university for that, son'.

But he's still concerned that he might end up in art school and continue to draw yet more birds and rotting vegetables. So, he talks to his art teachers. They already knew that he was losing interest and so they promised him that they would bring him some books on artists he might find interesting, even if they didn't quite approve.

It's the middle of the week, and Douglas is in the supermarket stacking up Coke cans – hundreds of them – cartons of fruit juice – thousands of them – while someone is being sacked for trying to steal a bottle of Bacardi from the alcohol and spirit shelves. So, he's shoving soft drinks around and talking to his mate about trying to get tickets for The Smiths concert, whenever they find out the dates, and he's thinking about what to do in life after school. The supermarket shift finishes quickly and he leaves the shop with about six

other guys. They walk home in the same direction, talking about parties, music, guitars, and girls, and then a passer-by calls over to them, asking what the football score was tonight. Rangers and Celtic have been playing, in Glasgow. The match has been long finished by now, it's almost midnight, and all the fans would be home by now. No one knows what the score is, and no one much cares: everyone is too tired and wants to get out of the rain that has just started to fall lightly.

On arriving home, Douglas makes a cup of tea and goes to bed. He switches off his bedside lamp, and listens to the radio quietly, and in the dark, so as not to wake his brother. He's listening out to hear if any dates had been announced for The Smiths coming to Scotland, but there is no news, except for the news. Around 12.30 am, a sombre voice reads the early morning bulletin. There had been some trouble in Glasgow. It was a little bit worse than usual. It was some trouble after the Rangers v Celtic game. 'Some trouble' is the phrase that usually meant serious trouble. And it was serious trouble: there had been an incident on a train coming from Glasgow and going to Dumbarton. Two guys, supports of one team, had thrown another guy, supporter of the other team, through the window of a train carriage. That is to say, they threw him out of the train, and onto the tracks. There was another train coming in the other direction. The police were looking for two youths from Dumbarton, in connection with a murder.

Douglas falls asleep.

He wakes up. He begins to remember the news on the radio from earlier that morning. He goes to school. Everyone is talking about the story. Everyone is talking about trouble. Everyone knows who was involved. Everyone knows who had done it.

He goes straight to class. Everyone says nothing.

He looks around at stuffed birds, broken chalks, rotting vegetables and silent faces. The classroom, which was normally buzzing with shouting, singing, flying rulers, pencils, obscene drawings and mutilated sculptures, is completely quiet.

Douglas sits down and waits for something to happen. He looks at a girl for a long time, trying to catch her eye in order to ask her, in silence, what's going on. It doesn't work.

Everyone sits in silence as if waiting for something to happen. Something happens.

The classroom door opens and one of the senior staff comes in and asks for a certain boy to accompany him to the headmaster's office. The police are waiting downstairs. The boy who had thrown the guy out of the train stands up and swaggers out of the room.

The art teacher walks up to Douglas and hands him two books. She looks quite upset.

'These are the books I told you about.' she says. 'It's probably about time you knew about them … '

'Thanks.' he says, as he looks at the names, MARCEL DUCHAMP, and ANDY WARHOL.

After this he went to art school in Glasgow. 1984–1988. He spent the first year in a general art course, trying a little bit of everything for a certain amount of time, as was the norm in art schools in Britain. Then he moved into the Environmental Art Department for the next

three years where he and his soon-to-be friends lived together, loved together, fought, ate, drank, played, sang and worked together in a decrepit old Victorian girls' school, far away from the departments of Painting, Sculpture, Architecture, and Design. They had a lot of freedom, and they enjoyed it to the full.

Then, after Glasgow, he went to London for two years, to study at the Slade School of Art. 1988–1990. The London stories are best told in a bar somewhere. There were good times and bad bits in London.

On finishing up in London, it seemed like the best thing to do was to go back to Glasgow. The atmosphere in London, at that time, felt like things were closing down rather than open-ing up. In retrospect this looks like it was the right decision made in response to the wrong reading of a situation. No matter. It was the end of the 1980s, and Glasgow seemed to offer something better than life on the dole and living in Crouch End, with barely enough money to get into the centre of the city, never mind doing anything if one could even get there. Why live in London, if you can't live in London.

That was then.

Arriving back in Glasgow, like he'd never been away, Douglas started to get involved in Transmission Gallery, an artist-run space in the city centre. This was, and still is, probably the most active place for the younger, and not-so-young, artists in the city to work, talk, drink and argue together. Douglas stayed around the gallery until @ 1993, and then began to do a lot more travelling and working outside of Glasgow, outside of Scotland, and outside of Britain. But anyone who knows the situation in Glasgow, or at Transmission Gallery, will realise that these are difficult ties to break. It always seems that there is a reason to go back home – lovers, friends, family, or work. People just seem to keep going back.

In 1993, Douglas was invited to make a new work for Tramway in Glasgow. It was, and is, a glorious industrial cathedral of a place, but a notoriously difficult space, too. He told me that he struggled with various ideas, and that the architecture of the space was a real problem for him. The simplest thing to do was to turn the lights off. He made the work *24 Hour Psycho*.

After this, things became a bit of a blur. Life moved very fast, and he made a lot of work. And he travelled a lot. People would often ask him 'how do you have time to make new work? You're always travelling. You're always on planes, or trains, or going to parties. Where can you find time to think, and make work?'

We had a long conversation about this issue one day. He was annoyed that even I, some-one who was supposed to know, had asked him the same question as those people who knew nothing. Normally, when people would ask him, he would just smile and say something polite in response, or change the subject, if he was feeling tired of it. But on a certain day I asked him and he ranted …

'Oh, come on. For God's sake, don't you ask that question. It's as if people ask the question because they don't believe that it's you who is making the work. I mean, if it's not me who's making the work, then who is it? If people don't believe that I can find time to do things, then who the hell else do they think is making the work?

Time to work? It's not only about time, anyway, but of course there's time to work. There's always time to work, if you just have the attitude to work all the time. And more than this, I mean, if you're travelling around then no one knows where you are, right? This makes it easier for someone to disappear. Right? I mean, if you are living somewhere and working somewhere, then everyone else knows where to find you, and how to reach you, and you end up with very little time to yourself. But when you're travelling you end up with a lot of extra time to be able to think, no? I can disappear this way. I can be "delayed" in places, or forget to go to other places, and stay somewhere quiet and just think. And thinking is working. So, when I'm flying from Scotland to Germany or from Holland to France, or whatever, I get so many more hours to think than I would if I was at home, spending the whole bloody day answering the telephone, paying bills and responding to letters or whatever. So, when I'm travelling, I'm thinking, I can disappear if I want, and I get a lot of work done this way. I also find time to read a lot of books this way. It's fine. OK?'

I never asked him that question again. He said things were fine, and so they seem to be.

The year 1996 was very busy. He won the Turner Prize, even when no one expected him to. He tells a funny story about a case of mistaken identity, on the night of the prize-giving. This story is best told in another place.

Then in 1997 he won a prize in Venice. And he won some prizes in Germany too. And this year he won a prize in New York where he gets to wear fancy clothes, or so he tells me. Maybe that's another story best told in another place.

I asked him if he worries about these prizes. He tells me that everything is fine and that it's other people who seem to spend time worrying about him.

Someone asked him, very late one night or early one morning – he can't remember, or doesn't know the difference – how he got to be successful. He cringed at the thought of the word 'success'. He said that he 'didn't believe in success'. He meant that he didn't know what it means. He said that he 'just worked hard, and things went well, so I worked harder'. It was a good Calvinist answer, but not quite convincing enough for his inquisitor.

She asked him again. He wouldn't answer any further. So she asked him if he had ever met a mysterious man, late at night, in a bar, and that he might have sold his soul to this shady figure. She asked this question as some kind of a flirtatious joke, but he looked thoughtful, and took it all quite seriously. He remained quiet and then tried to change the subject – but his silence was one or two seconds too long for the girl who asked the question. She looked worried and went home.

In 1997 he went to live in Hanover, where we met. It was the first time in seven years that he had lived outside of Glasgow. He told me that he enjoyed his time there. He didn't do so much work, but spent a lot of time listening to music and reading books. He said that reading books and listening to music IS working. He told me that an average day in Hanover would be to rise early, walk a few miles to the railway station, buy some English newspapers, some fresh bread, and walk home. Once home, make a simple lunch of eggs and bread. Sit on the balcony, in the sun, and read the newspapers until falling asleep. On waking, adjust

seating to suit the new position of the sun. Read a chapter of either Thomas de Quincey's *Confessions of an English Opium Eater* or Robert Louis Stevenson's *Weir of Hermiston* or Daniel Defoe's *A Journal of the Plague Years*. Repeat until falling asleep and hope for dreams related to what has just been read.

So, the experience of living in Hanover appeared to be quite healthy. I remember visiting him once at his place. He had even stopped drinking. He had been unenthusiastic about sitting alone and having a drink with no one but himself. He told me it was a disastrous experiment. After having no alcohol for eight days, he met a friend in town and they had two or three or four beers together. 'Oh', he says, 'it may have been five beers'. He said he felt unnaturally drunk and that on the next day he had a terrible headache which meant he couldn't read or write or listen to music or do anything but lie around and feel sorry for himself. This was not the way to live a life, he thought, and so he began to feel guilty. 'Some guilt is good', he said, 'but not that kind'. He decided to begin drinking again, in moderation, of course.

While in Hanover he completed three pieces of work, *From God to Nothing*, a large text piece which ran across four walls of a room of variable dimensions, *Three inches Black*, a photographic work based on a tattoo made for someone in Paris, and *Between Darkness and Light (after William Blake)*, a large-scale video work which was realised at the Münster Skulptur project.

After six or seven months in Hanover, he went to live in Berlin. I lost touch with him a little at this time – he claims he was either working or travelling, or hiding. In fact, he tells me that it's too early to reflect on his experiences in Berlin because he has not had enough distance from the city, as yet. I'm not sure what to believe about this. I tried to ask some friends of his, and one of them told me that he always spoke about life in Berlin as some kind of 'vampire' existence – that life would go on until quite late in the night, or early in the morning, and he would only return home just before the sun came up, then sleep until the evening, and start the whole day all over again. His friend told me that between November and late January he was extremely pale and it seemed that he never saw more than one hour of sunshine in any day. It was around this time that he started telling people that he had actually seen the devil in a cafe in Berlin. But that's another story for him to tell.

I've been trying to contact him over the last few weeks to check out some facts for this biography. I can't find him anywhere. His gallery tell me that he left Berlin, and is now living in Cologne. I called a number in Cologne, and they told me that he never arrived. I called Hanover, but they are looking for him too. I called a telephone number in Glasgow and spoke to someone whose voice sounded identical to Douglas's but who claimed to be his father, and also said that no one knew where his son was, and that the whole family were getting a little bit worried.

I don't know what to believe any more.

David Shrigley **Untitled (Artists Talk About Their Work)**, 1995
Courtesy the artist

ARTISTS

TALK ABOUT THEIR WORK

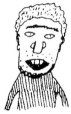

I DON'T ACTUALLY DO THE PAINTINGS MYSELF, I GET A BUNCH OF HANDICAPPED KIDS TO DO THEM FOR ME....

I USE A LOT OF FOUND MATERIALS IN MY WORK. MY LATEST PIECE IS FIFTY IDENTICAL PAIRS OF CHILDRENS SHOES WHICH I FOUND IN A CHARITY SHOP THEY'RE BRILLIANT AND THEY ONLY COST £30.

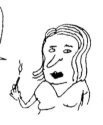

I WENT AROUND TOWN AND ASKED DOSSERS IF I COULD BUY THEIR UNDERPANTS FROM THEM. I GOT SIX PAIRS FOR £5 EACH AND USED THEM FOR MY SHOW IN FRANCE.

I GO AROUND BARS AT THE WEEKENDS AND DELIBERATELY GET INTO FIGHTS AND GET MY HEAD KICKED IN WHILE A FRIEND OF MINE VIDEOS IT.

During 2000 to 2001 ZKM Center for Art and Media Karlsruhe, held a succession of exhibitions on influential and close-knit art scenes in cities such as Berlin and Los Angeles. The artist and educator David Harding gave this talk at the gallery in March 2001 to coincide with the exhibition *Circles 4 ONE FO(U)R ONE* curated by Christoph Keller. It showed the work of over twenty artists including Claire Barclay, Nathan Coley, David Shrigley and Cathy Wilkes. Harding retired as the Head of Environmental Art at The Glasgow School of Art in 2001. The department, founded in 1985, did not focus on a single medium, but placed a particular emphasis on the importance of context for contemporary art and on working outside of the studio. It had been influenced by Harding's experience in working in social and public art practices and the Art and Social Contexts course at Dartington College, and in particular by his close association with the artists John Latham and Barbara Steveni whose Artist Placement Group pioneered the placing of artists in industry and government. Artists who graduated from the Environmental Art Department in its early years include Christine Borland, Martin Boyce, Douglas Gordon and Louise Scullion. When this talk was given, the art scene in Glasgow and Harding's department in particular had already become the subject of much attention and a certain amount of mythologising in the international art world. Harding continues to work as an artist, most frequently in film with the artist and lecturer Ross Birrell, and to explore issues of art education and cultural activism with Sam Ainsley and Sandy Moffat under the name Ainsley, Harding, Moffat or AHM.

David Harding

FRIENDSHIP, SOCIALISATION AND NETWORKING AMONG A GROUP OF GLASGOW ARTISTS 1985–2001: THE SCOTIA NOSTRA – MYTH AND TRUTH

'A community can accomplish that – effectively and speedily – which a single person sometimes attempts in vain.' These words were included in the proclamation which launched the building of the great medieval, gothic cathedral of Salisbury in England. I will attempt to trace how a community of artists in Glasgow in the late eighties and in the nineties formed and helped to turn the city into an internationally recognised centre of contemporary art practice.

In John Ford's film, *The Man Who Shot Liberty Vallance*, the newspaper editor says, 'If the legend conflicts with the facts, print the legend.' Myth is an understandable and necessary modus vivendi – a way for people to characterise themselves and to tell the world about it. But it is not neutral because to entertain it, even ironically, may involve becoming part of it.

One of the most enduring stories in the history of the British Isles is that of King Arthur. In fact it is so well known that it is often the only episode of the story of Britain that is known by non-Britons. Yet there is no archaeological evidence, nor any hard historical evidence, to prove beyond doubt that Arthur existed. Certainly a Celtic British chief, whose name could have been Arthur, led some successful battles against the relentless occupation of Britain by the Saxons delaying, for some decades, the inevitable settlement of what is now England. The Britons eventually retreated to consolidate their lands in the south west of Scotland, Wales, Cornwall and Brittany. This short period of history gave rise to the legends of King Arthur and the Knights of the Round Table. The point I want to stress is this: that while we revel in the notion of myths and legends, they seem always to have been begun with a certain element of truth. Facts are embellished and enlarged and a dull world it would be without this natural human inclination. Oral traditions benefit from this phenomenon. In the early nineteenth century the mother of the writer James Hogg knew this when she castigated Sir Walter Scott for writing down the old oral ballads of

the Scottish borders. She was acutely aware that, by doing so, the ballads would cease to be embellished and developed.

Much has been talked and written about the role that friendship, socialising and networking has played in the creation and consolidation of a vigorous and successful contemporary art 'scene' in Glasgow. However, it would need an in-depth study drawn from numerous interviews with a wide range of people to ascertain how much truth there is in this claim. I have not done that for this presentation but have put together something that is more more 'off the top of my head'. It is, therefore, a personal take on this acknowledged phenomenon. I could be accused of being non-objective, of being part of the myth and not to be trusted. Myth, as I said before, is not neutral.

Glasgow, with a population of around 600,000 people, is not a large city. However, the area covered by the former Strathclyde region, of which Glasgow is the main city, has a population of two and a half million which is half the population of Scotland. The first groups of students in the Environmental Art Department at The Glasgow School of Art came almost exclusively from this region. As far as I can recall none of the students came from Edinburgh, the capital of Scotland, just forty miles away. Despite the 'great stain' of religious bigotry which blights Glasgow and the west of Scotland, the student group was a remarkably enfolded community and some had met prior to coming to the school of art at art camps for school pupils. It might seem that this cultural and geographic closeness would be inclined to foster a certain narrowness and 'provincialism' – a cultural inbreeding – but nothing could be further from the truth. I do not know how this came about but the dominant forces in these early groups of students were well aware of contemporary Western art practice and had already, at the age of eighteen or so, rejected specialising in the other disciplines of the School of Fine Art: Painting, Photography, Printmaking and Sculpture. This was an informed political gesture repudiating what they perceived as the limitations of such art forms. They did not want to be bound by a single medium and this new Department of Environmental Art, which had been set up in the year 1985-6, was a non-media specific discipline.

I need to say something about art schools in the UK which are very different from those in continental Europe and the USA. They are part of the mass education system and, with the advent of Thatcherism in 1979, saw the numbers of students rise and the numbers of staff decrease. For the staff this has resulted in a full-time commitment to the school and by this I mean being in the school every day, of every week, of the academic year and no sabbatical leave of any consequence. I do regard this as an important contributing factor in that a small group of staff works with the same group of students for three years. We get to know each other well. We also, from time to time, get drunk together, party and travel abroad together. Certainly that was a feature of the Environmental Art Department at Glasgow. Socialising

came to be seen as an important part of the education and became an expectation, a tradition of the department. Of course this was not planned. It just so happened that the teaching staff rather enjoyed drinking and socialising with the students.

I could not possibly present this topic or to try to understand it and communicate it to others without stressing the enormous role that Sam Ainsley played, and still plays, in it. She worked with me full-time in the early years of the course. Many students and ex-students have been on the receiving end of her inspired teaching and very special generosity of spirit and they, more than I, would be better able to speak to it.

I have been asked on many occasions what we actually taught the students in the department. I usually reply, half in jest and with tongue in cheek, 'singing', and proceed to quote a short, three line poem by Adrian Mitchell in which I have changed one word; I use the word 'singing' where Mitchell used the word 'poetry'.

LETTER TO A POLITICIAN
I HAVE READ YOUR MANIFESTO WITH GREAT INTEREST
BUT IT SAYS NOTHING ABOUT SINGING

On being asked a similar question by a curator in Amsterdam, a few years ago, 'What were you taught in the Environmental Art Department?' Douglas Gordon replied, 'To sing. Not how to sing but simply to sing.' Not everyone of course feels inclined to sing publicly in company, but I learned in my family upbringing, and in successive other situations, the value of a few drinks and a 'sing-song' in forging a close and friendly community.

Where there is a mutual and supportive respect for the efforts of the individual a confidence is bred in which people do perform whether it be a song, a poem, a story, a dance, a joke or play an instrument – whatever takes their fancy. That for me is singing. As the poet Shelley said, 'social enjoyment in one form or another is the alpha and omega of existence'. Not only were we educating artists but also people to take their place in society.

This is not new in education. It is an element long practised at, among others, the universities of Oxford and Cambridge. When the first university in Europe was set up in Bologna it described itself as 'a company of scholars'. While, on the other hand, the prevalent ethos of teaching in art school, certainly in the UK, was that it was necessary first of all to destroy the student before then building her / him up. This ethos had no part in the teaching in the department. Environmental Art introduced two other things that were different and which have a bearing on this topic they were context and collaboration. No other course in the school offered these. Moving art out of traditional venues to new contexts required new attitudes and sensibilities summed up in the slogan, 'the context is half the work'. This had been coined by John Latham in the early seventies to represent an approach to the

work of the Artist Placement Group otherwise known as APG. Collaboration was encouraged and workshops were devised in which it could be practised. Being a new department also set us apart. We occupied, till 1994, the strangest and most stimulating building of all the art school buildings, the old Girls High School. The unoccupied and decaying parts of it offered unlimited opportunities for contextual installation and performance. This set us apart. We were different, we felt different and difference drew us closer together. We got to know each other well and, despite the age and status differences. We became, and remain, friends.

There was also, to a certain extent, a shared interest in traditional Scottish culture. Glasgow is a friendly place and has, according to those whose interest it is to draw these conclusions – visitors, foreigners and sociologists – a very different ambience to that of Edinburgh with which it is most often compared. I do not like generalisations but visitors have so often told me that there is a real difference between Glasgow and Edinburgh that I do now believe it. Glasgow seems a warmer, friendlier, more welcoming place and I say this as a native of Edinburgh, albeit from that part of it called Leith, poor and working class as it once was, that always felt that it was not really a part of the capital city. This special Glasgow 'effect' could also be felt in the department. It is best described by the German word *gemeinschaft*, there being no equivalent word in English, meaning an organic community with a strong sense of tradition, mutual association and locality. But it is one of the dangers of any group that forms itself into a supportive network that by that very act it excludes others. I would argue that in this case the very strength derived from *gemeinschaft* made it such that people from other cultures and places were positively welcomed. A Scandinavian critic, Gunnar Arnason writes, 'There has been an influx of artists from the four corners of the world who have begun to move to Glasgow and settle there.' Individuals from successive waves of graduates were also absorbed into the network.

Socialising among peer groups is a common feature of society so therefore it cannot be argued that this alone was the chemistry that brought about the colleagueship, the fraternity and sorority that played, and still plays, such an important part in the formation and the sustaining of the Glasgow art scene. Socialising is nevertheless a key factor. One need only look to the various art movements and groupings of the twentieth century to see how important socialising has been because it offers also the opportunity for the exchange of ideas and information and lends mutual support. This is exactly what this particular network of Glasgow artists did. After art school the Transmission Gallery then became the focus for this.

Demography too played an important role. I have mentioned that the core of the early network came from the west of Scotland. There are at least two other demographic features which contributed to the formation of the network. The larger one relates to Scotland's relationship with England and particularly with

London. The attitude of 'Us against Them' is a common feature in other areas of Scottish life and this again served to strengthen the network. It was the 'other' as a term of resistance to the metropolitan centre, repeating the historical habit of Scotland forming partnerships with, among others, France, Holland, Flanders. By staying in Glasgow and not being seduced by London, these artists were playing out an old tradition. In this they were innately recognising Jan Fabre's response to the question, 'Why do all the best artists in Flanders come from Antwerp and not Brussels?' Fabre's answer was that 'The provincial is universal and the metropolitan is specific.' The other demographic element is that certain parts of cities become identifiable as art quarters. In a small city like Glasgow the whole city centre could be construed as an art quarter. Certain bars and cafes become the place to meet and as important as that is the casual meeting in the local supermarket or laundrette, which serves to sustain that sense of being together.

The aphorism of 'being in the right place at the right time' must also be taken into account. In the early eighties the success and prominence given to a group of painters all of whom graduated from The Glasgow School of Art had already attracted the attention of art critics and gallerists in London, continental Europe and the USA towards Glasgow. This was new and it was in the same way a phenomenon. These artists led the way in turning the art world's attention to what was happening in Glasgow. This very success and the attention given to their painterly figuration formed part of the reason for the resistance of the younger artists coming after them. Notwithstanding these differences it speaks volumes, at least in terms of Scotland, that The Glasgow School of Art should have spawned two successive groups of artists that gained international recognition, albeit for very different reasons, in such a short space of time.

Furthermore, in the early eighties Glasgow had embarked on a massive makeover of its image, notorious as it was for religious bigotry, high crime rate, unemployment and poverty. In 1988 Glasgow was host to the UK's annual Garden Festival which included a very large programme of visual art. (It is interesting to note that the first Documenta exhibiton in Kassel in 1955 was a small part of a much bigger event: a flower festival.) Following that Glasgow was European City of Culture in 1990 which again featured a large art programme. These two events, coming one after the other, raised enormously the stature of Glasgow in the cultural world and the policy of the city was that where culture leads regeneration follows. Being the European City of Culture in particular gained an immeasurable amount of publicity for the city. However, neither of these two events directly supported or gave prominence to any of these, at the time, young artists, but there is no doubt that the attention of journalists, art critics and curators had been turned towards a city for which the biblical phrase 'can anything good come out of Nazareth?' would seem to have been created. What was of real value was the funding made available

by the city to artist-run spaces and projects which began in the lead up to 1990 and carried on for some years after it. This support can now be seen to have been critical in creating the opportunities for these artists to organise for themselves, and to exhibit in, artist-run spaces. However, all was not entirely positive at this time. The then director of the city's museums and galleries was positively opposed to these new emerging talents and, of the huge budget he had for exhibitions and purchases, none of it went to support or to purchase the work of any of these artists. Extraordinary as it may seem, much of the money for these artist-run spaces and projects came directly from the city's finance department under an enlightened director of finance.

Some of the first wave of graduates had already had national exposure, while still students, performing at the National Review of Live Art at the Riverside in London and a year later at the same event in Glasgow. More importantly, to my mind, was the taking over of Transmission Gallery by Malcolm Dickson. He recognised early on that something special was happening in the Girls High School and exhibited the work of two or three of the artists while they were still students. His work, I believe, prepared the way for the eventual take-over of Transmission by the graduates of Environmental Art. I need not deal with this history here as others closer to it and involved in it will have a clearer picture of how things evolved from that point on. Key projects and exhibitions which have to be noted and in which these graduates participated and/or initiated were the *Saltoun Project*, *Sites Positions*, *Windfall* and *The Bellgrove Project*.

Another set of contributing factors cannot be left out of the equation in promoting and sustaining the network and in creating and negotiating opportunities, they were the filofax, the fax machine and later the mobile phone.

The year 1995–6 marked ten years of the founding of the Environmental Art Department. I co-curated, with Rebecca Gordon Nesbitt, an exhibition to celebrate this decade. It was a massive project that included not only an exhibition in the Old Fruitmarket in Glasgow but also numerous billboard works around the city. Unfortunately, I was very ill at this time and feel that, although it achieved everything that we had planned, it could have been much more if my energies had been able to give Rebecca more support. She did a wonderful job with not very much in the way of funding. Several of the artists were on the working party and Roddy Buchanan came up with the title of *Girls High*. For me one of the most satisfying things was the fact that forty-three former students of the department exhibited work. Part of the reason for the exhibition was to bring together all of these artists from different generations of students to endorse that notion of a family of artists. When Douglas Gordon thanked the Scotia Nostra in his remarks in accepting the Turner Prize he was simply describing a fact. We still meet, socialise and support each other.

In *The Corrosion of Character* Richard Sennet writes that a society / regime, 'which provides human beings with no deep reasons to care about one another cannot long preserve its legitimacy'. These Glasgow artists genuinely care about each other. In the art world this must seem to be a contradiction in terms.

The term 'The Scotia Nostra' was coined by my friend Peter Stitt in the early seventies to describe a group of painters from Edinburgh College of Art who taught in and/or held positions of responsibility in a number of art schools in England.

Graham Fagen, who trained at The Glasgow School of Art and now
teaches at Duncan of Jordanstone College of Art & Design in Dundee,
is an important contemporary artist and very experienced in working in
the public sphere. In 2001–2 he worked in the community of Royston,
north Glasgow as part of a landmark series of projects commissioned
by the agency The Centre under the directorship of Lucy Byatt. His
work *Where the Heart Is* was twofold. Firstly, Fagen worked with local
schoolchildren to name a new rose, which was then distributed free for
planting in the area. The second aspect of the project, *Royston Road
Trees*, was a tree-planting project, which extended the boundaries of
the local park in an historically deprived area of Glasgow. But it also
served as an informal memorial for the community's lost loved ones,
including, tragically, young people who had died of drug use. Fagen's
text is a reminder of how to work sensitively as an artist, but would also
serve as useful ethical guidance for most of us in the workplace.

First published in the art magazine, *Matters*, issue 11, spring 2001

Graham Fagen

DOS & DON'TS re: ROYSTON ROAD TREES (SOME RULES FOR MYSELF)

Don't think of Sculpture.

Don't even think of Art.

Do think of where you are.

Do look around.

Do try and understand what you see.

Do think what it means.

Do ask yourself why it is there.

Don't make a grand gesture.

Don't think of yourself as different.

Don't think you are doing people a favour.

Do talk to people.

Do listen.

Do think of an object that fits into what you see.

Do think what that object might mean.

Do think of ways to enhance the meaning.

Don't force it.

Don't look for answers.

Don't look outside the area.

Dr Sarah Lowndes is a lecturer at The Glasgow School of Art and author of *Social Sculpture: The Rise of the Glasgow Art Scene,* 2010; *All Art is Political: Writings on Performative Art,* 2014 and a curator of exhibitions including *Studio 58: Women Artists in Glasgow Since World War II,* 2012 and *The Glasgow Weekend: Art, Design and Music from Glasgow,* 2013.

Sarah Lowndes

THE KEY MATERIAL IS TIME

On Saturday night I went to the dancing. You were working late in the shop so you went straight there … you had your dancing shoes at work with you, and something for your tea. The Plaza was nice with the coloured fountains and the wee tables. John and I liked it there. But we went to the F and F Palais in Partick too, and Green's Playhouse, the Locarno, and the Albert … I loved the dancing.[1]
(Anna Blair, 1991)

By 1946, Glasgow had ninety-three dance halls, almost three times as many as London per head of population. The Saturday night dancing was a kind of counterpoint to that of the local heavy industries, being devoid of tangible goal or object. The dance hall was a place where a kind of subcultural currency (of seeing and being seen) was in operation – where young people could elevate their social standing through their self-fashioning and dancing skills alone. Dick Hebdige famously characterised the 'subcultural response' as 'both a declaration of independence, otherness, of alien intent, a refusal of anonymity, of insubordinate status. It is an insubordination. And at the same time it is also a confirmation of the fact of powerlessness, a celebration of impotence.'[2] The subcultural response played out in Glaswegian nightspots in the post-war era matched Hebdige's definition, serving as it did to alleviate the alienating effects of 'normal' society.

After 1945 Glasgow began a gradual descent into post-industrial decline, which lasted until the late 1980s, when the city arose again as a 'destination city', with a post-Fordian economy based on shopping and services. The artists, musicians, filmmakers and writers emerging in this period in Glasgow no longer had to make a choice between conventional labour and their artistic practice, given that there wasn't much traditional employment to be had. As local poet Donny O'Rourke put it, this created 'a whole generation of artists, who, absolved of the old polarity between employment and one's real work, just do it'.[3] In those years of high

unemployment, the city's subcultural scene grew incrementally until its reach extended beyond the parameters of the weekend. New models of living and working were fashioned in those years, which would eventually culminate in a unique and largely self-initiated arts infrastructure. By the early 1990s, the 'free' space of the nightclub had found a kind of representational corollary in the art that was emerging from the city: work that was process-based, rooted in social co-operation and often realised with an economy of means and materials. This work reflected its point of origin: a city constituted and made meaningful by social relationships and marked by identifications or emotional investments.

I moved to Glasgow in 1993 to study at the university. One night I met Toby Paterson and Robert Johnston, who were volunteer committee members of Glasgow's (then) only artist-led gallery, Transmission, which had been established by painting graduates from The Glasgow School of Art back in 1983. Crucially, the gallery was non-commercial: established not to generate sales of works, but to offer opportunities for the exhibition of work and a social space for discussion. It answered to Nancy Fraser's description of a democratic public sphere: 'not an arena of market relations but rather one of discursive relations, a theatre for debating and deliberating rather than for buying and selling'.[4] The committee members supported and encouraged the work of others, motivated by a belief in the importance of community.

I went out dancing with my friends at clubs like The Arches and the Sub Club, where you could feel the bass through your entire body. Detroit techno and Chicago house were the order of the day, played by visiting American DJs like Derrick May, Juan Atkins, Blake Baxter, Jeff Mills, Larry Heard (aka Mr Fingers) and Cajmere. But there were also local heroes with equally strange monikers: Harri at Atlantis; Twitch of Pure; H'atch and J'Ilkes, who ran Knucklehead at the art school; not to mention A-man and Panic of Tangent, putting on raves on trains and boats and in underground bunkers, and mobile sound units like Desert Storm and Breach of the Peace, who staged riotous 'Party and Protest' events in flagrant contravention of the 1994 Criminal Justice and Public Order Act, which attempted to prevent raves by outlawing public gatherings with 'amplified music' and 'repetitive beats'. As cultural theorist Hillegonda Rietveld noted:

The participants of the party and club life surrounding the musical discourse of house music were empowered by the celebration of a sense of community, which shaped identities that were excluded from, or given less power by, the world in which they were administratively ruled by government and mass media. The very existence of the house scene as a space for the bonding of 'alternative' identities was therefore a starting point for an opposing strategy.[5]

The main thing that was really striking was that the situation seemed exciting, and it also seemed wide open. You could get involved.

I remember going to the opening of the *Girls High* exhibition in 1996, at the Old Fruitmarket and seeing a work by Jonathan Monk called *Whatever Will Be Will Be* that

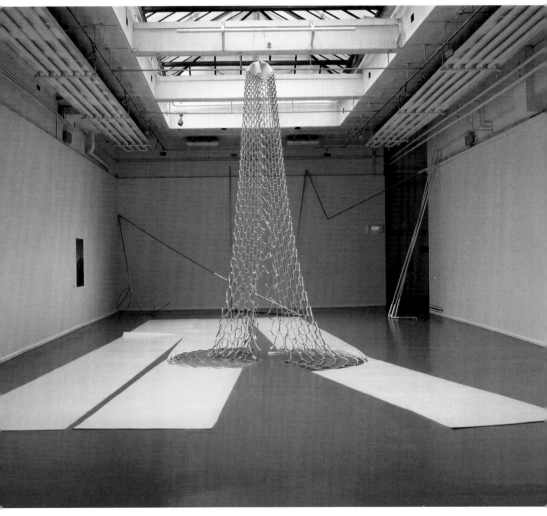

Claire Barclay **Out of the Woods**, 1997

consisted of a big mirror that had been dropped on the floor, and a sculpture by Jim Lambie, one of the constituent parts of which was a black pudding. I also remember seeing Claire Barclay's exhibition *Out of the Woods* (1997) at CCA on Sauchiehall Street, curated by Nicola White. The main space was dominated by an enormous acid-yellow plastic sculpture that stretched from the floor to the ceiling rafters: a giant fluorescent cut-out bag. There was something so audacious about that. I remember the colour but also the smell of the work, the sense of knowing it somehow. I remember Toby Webster's trio of shows for the CCA, the first of which was the group show *Lovecraft* (1997), which he co-curated with Martin

McGeown, and which included pornographic pencil drawings by Tom of Finland alongside works by Glasgow-based artist Cathy Wilkes, an enormous quilted multicoloured cube by Jim Isermann and a whole wall covered in biro drawings, handwritten poetry and badly typed stories by fans of the Manic Street Preachers called *The Uses of Literacy*, put together by Jeremy Deller. Glasgow-born artist Lucy McKenzie later wrote that Deller's work had discomfited her, 'because it related directly to experiences with somebody real and not imagined'.[6] That was how I felt, too. The final show Webster curated for CCA was called *Waves In … Particles Out* (1997), and featured a Piotr Uklański disco floor that Martin Creed's band Owada played on at the opening. I don't remember them being particularly good, but by that point I understood it was less about mastery, and more about having a go.

Tony Blair had come to power in May 1997. That seemed, at the time, a point of great optimism and Labour very quickly began the process of devolution for Scotland that was so necessary and so much desired.[7] After I graduated that year, I started bringing out my own fanzine, and then started organising my own events. All the time I was going to gigs and clubs and exhibitions and thinking about and observing the scene in the city, which was beginning to attract more and more interest from outside. I carried on writing arts reviews for various places, initially local publications but later on London-based art magazines like *Untitled* and then *Frieze*. I was particularly interested in the work of artists like Hayley and Sue Tompkins, and loved their solo show *Sounds of Grass*, held at Transmission in 1999. I wrote:

They have subdivided the space with a diagonal chipboard partition, and hung it with loosely draped squares of hessian sackcloth. There are a few cheap gold earrings, the kind they sell in Ratner's, hooked into the sackcloth. You pause in front of a dark cluster of what look like leaves hanging on the wall. They are magazine pages, crumpled until they are soft and shapeless in the palms of the sisters' hands. The floor in the space is painted black, but they have left a dusty area unswept and then one of them has walked through it. You look at the footprints and think it's like a kind of portrait. On the floor they have arranged, like a picnic blanket, a large hessian square, with a neon pink seam, set with a glass of orange liquid, probably paint water but possibly orangeade.[8]

One of the most important changes in the local situation came when The Modern Institute was set up in Glasgow in early 1998, by Will Bradley, Charles Esche and Toby Webster, with a view to promoting Glasgow artists in ways that extended beyond the remit of the city's existing museums and galleries system, chiefly by showing their work at key commercial art fairs in cities like London, Basel and New York, and forming relationships with curators and collectors outside Scotland in order to secure both exhibition opportunities and sales for their artists. Bradley later recalled:

Toby Webster, Chas Esche and myself had all been thinking of starting something. Toby and I had been at Transmission, and Chas had left Tramway. It's partly you get into a habit

of doing things and you want to keep doing them – but it came about really from having experience of what's going on outside Glasgow. Also a lot of artists who were working here were starting to become quite successful – the artists that we knew were starting to get involved, and showing abroad. We got a real sense something like [a commercial gallery] could work in Glasgow, and wanted to give it a try. We wanted to be everything: a record company, a publishing company, organising exhibitions and representing artists. We'd be all singing, all dancing. We tried to keep the definition of The Modern Institute loose: we called ourselves a research organisation and production company rather than a 'gallery'.[9]

The Modern Institute offices were located on the first floor of a decayed red sandstone building on Robertson Street, which also hosted the offices of socialist MSP Tommy Sheridan, a pro-life organisation, a private detective agency, a bookbinder, an 'invisible mender' and a maker of masonic regalia. On the top floor, Lucy McKenzie established Flourish Studios, where she and several artists including Keith Farquhar, Alan Michael and Craig Mulholland made work, rehearsed music and staged performances. I remember attending one Flourish Night where Lucy McKenzie played the clarinet while her collaborator, the Polish artist Paulina Olowska, formed the shapes of letters of the alphabet with her body. The evening ended in disarray when one of the guests started an unscheduled fire in a sink in a corner. Several of the artists who worked with The Modern Institute also had studios within the building, including, at the beginning, Martin Boyce, Jim Lambie, Toby Paterson, Jonnie Wilkes and Richard Wright, so the dingy corridors often echoed late into the night with sounds of sawing, hammering and broken electronic filters.

The Modern Institute in those early days hosted a number of three-day exhibitions by artists, both from their own (mainly) local roster[10] but also artists from other cities that they were interested in working with, such as the Belgrade-born installation artist Bojan Šarčević. That show sticks in my mind especially because Šarčević built a very high shelf around the gallery space and then put all The Modern Institute's files and paperwork on it, meaning that whenever the gallery staff wanted to refer to any document they had to climb up a ladder to get it. Those shows were real events, because the rest of the landscape had been fairly subdued since Charles Esche had left Tramway and Nicola White had left CCA in 1997. In 1998 and 1999 Tramway and CCA both closed for lottery-funded renovations. Tramway's newly appointed visual arts officer Alexia Holt organised off-site projects in the interim, but until Tramway reopened in June 2000 and CCA reopened in 2001, Transmission and The Modern Institute were the two main heat spots in the city. Their activities were shored up by low-budget temporary exhibition projects that artist organisers set up either in empty properties or in their own flats, like James Thornhill's Ready Steady Made (1999)[11] and Marianne Greated and Sorcha Dallas's Switchspace (1999–2004).

In 2000 I began to write *Social Sculpture*, my book about the Glasgow art and music scene. I was working during that time for The Modern Institute and went with them to the Chicago art fair in 2001, where we showed the work of Martin Boyce, Richard Wright and Eva

Rothschild. I remember meeting the American Fine Arts gallerist Colin de Land at a dinner one night and telling him about my research on Glasgow, and how owing to a comparative lack of support in Scotland, the city's artists had really come to rely upon opportunities elsewhere, in Europe and America. We were interrupted by a woman on the other side of the table, who opined loudly, 'Of course, the model for that is jazz.' It seemed to me then, that there was something particular and special about Glasgow that made it different from everywhere else. It didn't follow a model; it wasn't logical. Many of the most interesting artists in the city didn't even produce a saleable product like a photograph or a recording that could be circulated outside the city.

One case in point was Christopher Mack, who began performing his emotive fingerstyle acoustic songs under the moniker The James Orr Complex in 1996 but did not release his first recording, the EP *Figa* on the Glasgow independent label Rock Action, until 2001. But when he played, often in the pungent basement of the 13th Note on King Street, the audience knew all the words to his songs, because they had attended all his other gigs. The work being made in Glasgow in the late 1990s was made with all manner of materials, but perhaps the central material was time. The scene wasn't motivated by profit but was rooted in a desired social experience, one that rested upon people investing time in supporting one another.

In the early 2000s, two galleries opened in Glasgow that had grown out of the flat-gallery tradition: Sorcha Dallas, which evolved out of the Switchspace temporary exhibition project run by Dallas and Marianne Greated, and Mary Mary, which had begun life in a tenement flat on Bath Street. One of the first times I saw Glasgow-based artist Karla Black's work was in 2004, in a solo show at Mary Mary's first premises. Black had devised her own method of working over a number of years, actively avoiding traditional or learned techniques in order to develop her own language of making, using materials such as clay, paper, cellophane and non-art materials such as skin ointment and make-up. I wrote:

Black's art is not only about the body; it also speaks to and of the surrounding space. This exhibition, for example, reflects and amplifies its setting, in a tenement bedroom that doubles as the artist-run gallery Mary Mary. Walls with painted-over cracks and holes paved with Polyfilla reappear in the texture of Black's work. In the days she spent in the space the artist created images not only of herself but also of the atmosphere of the room.[12]

Since the late 1990s the scene in Glasgow has changed as the city has become established as a noted art centre. As the scene has grown, it has become more elastic, with a variety of different styles and motivations at play, and, it must be said, an increased sense of competition – for audiences, for attention, and for funding. Since 1996, no fewer than thirteen artists associated with Glasgow have been nominated for the Turner Prize, including Douglas Gordon (1996), Christine Borland (1997), Martin Creed[13] (2001), Jim Lambie and Simon Starling (both 2005), Nathan Coley (2007), Cathy Wilkes (2008), Lucy Skaer and Richard

Wright (both 2009), Susan Philipsz[14] (2010), Martin Boyce and Karla Black (both 2011), Luke Fowler (2012) and David Shrigley (2013). Of these, six won: Gordon, Creed, Starling, Wright, Philipsz and Boyce.

Up until the 1980s The Glasgow School of Art, where many of the city's best-known artists studied, attracted a largely local student body. Nowadays the cohort has a much more geographically diverse demographic: 20 per cent are international students and a further 20 per cent are from the rest of the UK. The MFA programme at the school, which had a year group of just twelve mainly UK students during the 1990s, now recruits over thirty students, many of whom hail from countries such as Switzerland or Canada but who then post-graduation have been selected to represent Glasgow or Scotland in international exhibitions. The success of The Modern Institute[15] has led to other changes – in 2006, the organisation took the decision to relinquish the moderate amount of public funding it was receiving, and to channel that into a new non-profit project in Glasgow, The Common Guild, which would be helmed by Katrina Brown (then curator and deputy director of Dundee Contemporary Arts). The Common Guild was originally based in Robertson Street, in premises lent by The Modern Institute, before moving to Douglas Gordon's town house at Woodlands Terrace in 2008 where it has been based ever since, presenting a programme of projects, events and exhibitions by international artists including Roni Horn (2009), Tacita Dean (2010), Wolfgang Tillmans (2012), Carol Bove (2013) and Phil Collins (2014).

In the last decade, The Modern Institute has been followed by other independent galleries in the city, such as Sorcha Dallas (2004–2011), Mary Mary (est. 2006), The Duchy (est. 2009), David Dale Gallery (est. 2009) and Kendall Koppe (est. 2011), which have helped to take the work of the city's artists out of Glasgow and to collectors and collections elsewhere. It is no longer the case that everyone will turn up to the Transmission opening or The Modern Institute opening, because the level and variety of activity in Glasgow has increased so dramatically – both through the young galleries and through the activities of studio and exhibition complexes such as Glasgow Sculpture Studios, Southside Studios, SWG3 and the Glue Factory which provide vital support for the development and exhibition of work within the city.

Scotland's participation in the Venice Biennale since 2003[16] and the growth of the Glasgow International Festival of Visual Art have also helped focus attention on the Glasgow scene. Glasgow International began as a relatively modest undertaking in 2005, led by CCA Director Francis McKee, who grew the budget and ambition of the festival in two further outings in 2006 and 2008. Katrina Brown directed the 2010 and 2012 editions of the festival, which in 2012 showed 130 artists across almost fifty venues, attracted 205,067 visitors and generated £1.7m for Glasgow's economy and a further £436,878 for the rest of the country.

However, Glasgow remains a city in which many artists make work that they do not expect to sell. A survey conducted in 2012 by the Scottish Artists Union (SAU) confirmed that three-quarters of visual artists in Scotland earn less than £5,000 a year, putting them in the lowest socio-economic group of income earners, alongside pensioners, casual or

lowest-grade workers, benefit claimants and students. Indeed, many of the artists who live and work in Glasgow continue to work with inexpensive everyday materials, out of which they have formed their own unique language, after years of experimentation. This approach has been defined by Richard Wright as 'a tactile element to the work, that has to do with a reinstatement of a concern with material and its poetry, still done in a stripped-down way'.[17] Some of the most significant and distinctive artistic work made in Glasgow since the 1990s remains intrinsically bound up with ideas of performativity: the material form is 'secondary, lightweight, ephemeral, cheap, unpretentious and or dematerialized'.[18] The scene is dialogic, centring on talks, discussions and live events of all kinds. It is rooted in the body, in song and dance, and concerned not only with style but also with the sound, scent and feel of things. It lives in memory more effectively than in photographs. It's about empathising with and being curious about other people. It is an approach that was fostered in the free space of Glasgow's post-war nightclubs, and that still informs the city's many independent exhibition spaces, music venues, record labels and publishing imprints today.

As you get in the driver regards you through the rear-view mirror. 'A girl like you should be going up the dancing.' 'What? Oh, I'm a bit tired tonight.' He turns right onto Oswald Street and stops at the lights. 'Mind you – it's quiet tonight.' He drives on, up Renfield Street. 'I've been doing this job forty year, and I mind the days when all they street corners would be packed with folk queuing up for the dancing.' He gestures out the window at the empty corner of West Regent Street. 'Aye, the Locarno, Green's Playhouse, I mind them all.' You see the queue: the boys in their best suits, with their hair slicked back, smoking and rocking back on their heels. The girls with their eyeliner on, their hair set in waves. The stiff skirts of their dresses, just with a little pocket for their cloakroom ticket and comb.[19]

1 Anna Blair, Interview with Bunty Angles, *More Tea at Miss Cranston's*, Edinburgh, 1991, p.419.

2 Dick Hebdige, *Hiding in the Light*, London and New York, 1988, p.35.

3 Donny O'Rourke, in *Ross Sinclair: Real Life and How to Live It*, The Fruitmarket Gallery, Edinburgh, 2000, p.51.

4 Nancy Fraser, 'Rethinking the public sphere: A contribution to the critique of actually existing democracy' (1992), *The Cultural Studies Reader*, London and New York, 2007, p.489.

5 Hillegonda Rietveld, 'The House Sound of Chicago', in Steven Redhead (ed.), *The Club Cultures Reader: Readings in Cultural Studies*, Oxford, 1997.

6 Lucy McKenzie, in Luke Fowler (ed.), *Accelerated Learning*, Duncan of Jordanstone College of Art & Design, Dundee, 1999.

7 In every General Election from 1957 until 1997, Labour did better in Scotland than elsewhere in the United Kingdom, while a third party, the Scottish National Party (SNP), grew in popularity. Following the establishment of a devolved Scottish Parliament under Labour in 1998/1999, SNP continued to grow in influence, and in 2007 SNP formed the first minority government of the Scottish Parliament. At the 2011 election SNP won a majority sufficient to call for a referendum on independence, which has been scheduled for 18 September 2014.

8 Adapted from a review by the author published in *The List*, 13–27 May 1999, p.73.

9 Will Bradley, in conversation with the author, April 2001.

10 The initial group of 13 artists represented by The Modern Institute were all Glasgow-based, with the exception of Eva Rothschild, who lived in London. The other artists were: Martin Boyce, Jim Lambie, Victoria Morton, Toby Paterson, Mary Redmond, Simon Starling, Hayley Tompkins, Joanne Tatham and Tom O'Sullivan, Cathy Wilkes, Jonnie Wilkes and Richard Wright.

11 Nine artists produced solo exhibitions for Ready Steady Made: Michelle Naismith, Annette Heyer, Will Bradley, David Bellingham, Jim Hamlyn, Nina Lehrfreund, Andrew McNiven, Douglas Kerr and Richard Wright.

12 Sarah Lowndes, 'Karla Black', *Frieze*, issue 89, March 2005.

13 Martin Creed was born in Wakefield, England, but moved to Glasgow when he was three. After attending Lenzie Academy, near Glasgow, he trained at the Slade School of Art.

14 Susan Philipsz was born in Glasgow, but trained in Dundee and Belfast and now lives in Berlin.

15 In 2014, Toby Webster co-directs The Modern Institute with Andrew Hamilton, and the gallery represents 39 artists, 12 of whom are from his original roster of Glasgow-based artists, and the rest from cities all over the world, including Monika Sosnowska (Warsaw), Chris Johanson (Los Angeles) and Urs Fischer (New York).

16 The artists who have been shown as part of *Scotland + Venice* are: Claire Barclay, Jim Lambie and Simon Starling (2003), Alex Pollard, Joanne Tatham and Tom O'Sullivan and Cathy Wilkes (2005), Charles Avery, Henry Coombes, Louise Hopkins, Rosalind Nashashibi, Lucy Skaer and Tony Swain (2007), Martin Boyce (2009), Karla Black (2011) and Corin Sworn, Duncan Campbell and Hayley Tompkins (2013). Of these 18 artists, 16 were Glasgow-based at the time of the exhibition.

17 Richard Wright, in conversation with the author, September 2001.

18 Lucy R. Lippard, *Six Years*, New York, 1973, p.vii.

19 Sarah Lowndes, *You and a Hundred Others*, work in progress, 2014.

2002

The writer and curator Will Bradley trained at The Glasgow School of
Art, and was a co-founder of the The Modern Institute in Glasgow in
1998. He is now the director of Konsthall, Oslo. His essay *Exploits* was
written for the catalogue of a landmark exhibition *My Head Is on Fire
but My Heart Is Full of Love*, which he curated with Henriette Bretton-
Meyer and Toby Webster at the Kunsthal Charlottenborg, Copenhagen
in 2002. The essay identifies a key perspective on both recent contem-
porary art and the art and design of previous ages which he describes
as 'pyschedelic minimalism'. The text, and the exhibition, marked a fluid
approach to historical material, drawing unexplored parallels between
unlikely works, for example, Mick Rock's photographs of David Bowie in
1973, the work of the twentieth-century French jeweller Jean Vendome,
and a contemporary artist like Jim Lambie. It reflects the way that, in
the digital age, artists and curators can reinterpret history, art works or
objects in a fresh light, shaping new and unexpected narratives from
the existing archive.

First published in *My Head Is on Fire but My Heart Is Full of Love*, exhibition
catalogue, Kunsthal Charlottenborg, Copenhagen, 2002

Will Bradley

EXPLOITS

The word 'exploit' has a technical meaning to computer programmers. It's not a bug in the code that sends everything haywire, and not a hack, which is a forced break-in. It's not even a feature, which is a bug that does something pointless but non-destructive. An exploit is a flaw in the design, a gap in the structure, an open door where there should have been a wall. It lets you go somewhere you're not supposed to go.

Mescaline and LSD are exploits in human perception. They make it possible to get inside the system. For a long time it was believed that hallucinogenic drugs accessed other worlds beyond this one, that they were the key to knowledge from outside, visions that were powerful but unreliable and had to be interpreted, decoded, revered. These days we know that the psychedelic experience is a manifestation of the very structure of our perception, it's inside our heads. These days it's the world we see when we're straight, the real world, that's somewhere outside, uncertain and mediated, and not to be trusted.

If we had to figure out the meaning of everything we saw or heard or felt from first principles we'd be useless as babies, overwhelmed by information, stunned by all the pretty lights. Luckily we learn, and we take short cuts. When we see the back of someone's head we can assume there's a face on the other side and most of the time we're right. When we get the hang of it, we can watch ten minutes of a film, read a paragraph of a book, have a five minute conversation with a stranger, hear the first eight seconds of a Madonna single and we think we know what to expect. Even better, we have ways to cut out the donkey work. We read reviews, we take advice, we only go to certain clubs, or cinemas, or cities, or countries. We learn to rely on received interpretations.

Since the mid-1960s it's been accepted that the meaning of art, or of most things, is a moving target. Everybody knows that an artist can't control the way their work is received – that everyone who sees a given artwork will have a different

experience and will give it a subtly or wildly different meaning that will also change from day to month to year. But once a work gets given its place in the canon of art history, in the museum or the catalogue, most of those unique interpretations are reframed as wrong, or ill-informed, or just no longer relevant. We get the short-cut version. The work becomes the emblem of its own significance, and that's the thing that strangles it, traps it in a well-maintained dead end.

Jorge Luis Borges suggests a way out. In the essay *Kafka and His Precursors*, he lists several unrelated texts: Zeno's famous paradox against movement; a paragraph written in the ninth century by Han Yu; Kierkegaard's religious parables; Browning's poem *Fear and Scruples*, a story by Léon Bloy; and 'Carcasonne' by Lord Dusany. He explains his choices by saying:

If I am not mistaken, the heterogeneous pieces I have enumerated resemble Kafka; if I am not mistaken, not all of them resemble each other. The second fact is the more significant. In each of these texts we find Kafka's idiosyncrasy to a greater or lesser degree, but if Kafka had never written a line, we would not perceive this quality; in other words it would not exist … His work modifies our conception of the past as it will modify the future.

If you follow Borges's argument through, it doesn't rely on Kafka for its effect. Everything that happens alters our conception of the past, and our desire for the future is to remake the past, to justify it. But this isn't confined to the distant past or to lost literature. It applies just as well to very recent events. All of history that we know or understand is implicated in this two-way communication, because we experience it all right now – there is no other way.

Sometimes it feels like a mystery why artists should struggle – and some of them do definitely struggle – to make more things when the world is already over-flowing with things. Objects multiply. A sword creates a shield, the car designs

the highway, the process repeats; things agglomerate, lock together. Artists can't compete in these conditions. The desire to remake the world is the megalomaniac impulse of a dysfunctional personality, futile and irrational. Given the world we've got, though, it looks sane and even necessary, but artists can't do it by themselves. Even art can't be redefined by artists alone.

Sometimes, looking at an exhibition of art, you can get the feeling that the objects it contains want to get out, to break free of the containing order and run wild. But they need assistance. A radical aesthetic isn't necessarily a convulsive revolution, an assault on convention or a dive into obscurity. It's anything that can lead you into a reassessment of formal language, a refusal to accept orthodoxy. It's the fake, the pastiche, the unfashionable. It's the handmade, the forgotten, the substitution of an obvious lie for a false claim of truth. It's industrial production understood as politics, or the idea of beauty as something specific that cannot be transferred. It's a pathological sensitivity to ideological content and context and, above all, it's deliberate misreading.

Most ideas in the history of art can be usefully misread, mirrored, turned upside down. Minimalism, for example, the most Modern of formal movements, is a reiteration of ancient forms and structures. Its simplicity is pure mannerism, a performance for the art world, elaborate and contrived. Because it denies realism, the works it produced are perhaps the most allusive and romantic ever made – they're kaleidoscopes, mathematical baroque, ecstatic visions. They imply that the infinite, the sublime has not been lost, but is only trapped by its own image, its own reflection. Expressionism, in contrast, has an aesthetic of absolute precision, because it aims for the creation or transfer of specific meanings and sensations. It's method-acting, a denial of the conditions of representation.

Historical forms and ideas can be reused not as inspiration or quotation but as raw material. Functionalism becomes ornament, decoration becomes ideology,

buildings are designed to leave beautiful ruins. Objects seem to hallucinate themselves, caught between the basic physical attributes that enable them to function and another set of forms that are trying to somehow materialise in the space they occupy and take them over completely. Order and disorder are exchanged. In the rigid confines of modern society it's necessary to introduce disruption, confusion. In the wreckage of modern civilisation, there are moments of balance and harmony that need to be preserved, given space.

It's possible that this openness, these exploits, will be short-lived. For all the talk of the disposability of contemporary culture, art these days is built to last. Artists have acid-free papers, glues and sizes, light-fast pigments and permanent dyes, non-corroding alloys, archival tape, lossless and infinitely copyable digital recording media. Art is made in the light of the uncertainty of history for a precise future. No more will future generations have to struggle to interpret a weathered neolithic cup-mark that has somehow survived three and a half thousand years on the back of a fallen stone in a field on an island in the north Atlantic. There won't be any 'Last Supper'-style controversy over colour schemes, no painstaking reconstruction of faded manuscripts. Our culture will live on, because we have created not only the artefacts themselves but the means of their preservation for future generations. It's likely, however, that this won't help much at all.

At the end of human history – which I'm assuming is at some point in the distant future and not just around the corner, through it's easy enough to make the opposite case – there's a museum that contains just about everything that survived until the sun burnt out, or everybody left the planet, or we all turned into lizards, or we just stopped caring too much about the past and we threw it out. Somewhere in the museum, which is massive and labyrinthine and takes many months to journey through, is a department that holds everything now contained in all the museums on earth. It's a small department, in comparison, but it's important, because it

contains the primitive beginnings of the race. Somewhere in this department is a tiny sub-section which is the section of art, and somewhere in there is a sub-sub-section devoted to the twentieth century, the era in which the category began to disintegrate. It causes conflict among the curators of the museum. Some of them want to organise the exhibits according to contemporary ideas, so the audience can better understand them; others want the displays to reflect the values of the ancient world. This second group argues that the artefacts cannot be comprehended without an understanding of the environment in which they were originally made. But the second group are also opposed by a third group whose research has led them to believe that the function of the artefacts was never precisely understood or agreed upon even at the time of their creation. There is evidence that, in some cases, even the original makers were reluctant to elaborate their meaning or purpose, and that for every interpretation it is possible to find a refutation or opposite reading. Some even venture to give this last suggestion the status of historical law.

Francis McKee is a writer and curator based in Glasgow. He first worked in the contemporary art scene in the 1990s. In 2003 he and Kay Pallister co-curated *Zenomap*, Scotland's exhibition at the Venice Biennale. In 2005 he presented the first of three editions of the Glasgow International and in 2006 took on his current role as director of CCA, Glasgow.

Francis McKee

INTO THE LAGOON

It started back in the Barnes Building on West Graham Street in Glasgow with an afternoon interview in the Round Room. The curator Kay Pallister and I had applied jointly to curate an exhibition of contemporary art from Scotland in the upcoming 2003 Venice Biennale. Our proposal was based on the premise that if this project was to institute a regular series of appearances for Scotland in Venice then artists across the country had to be represented and not just those in the central belt. To do that, we would cross the country on a series of studio visits: at the same time we suggested framing the exhibition within the story of the Zeno brothers, two Venetians who made their way to America, before Columbus, in the company of Henry Sinclair of Orkney in the 1390s.

We were awarded the commission and so our expedition across Scotland got underway. Looking back now, it's the Scottish journeys that have the greatest resonance in my memory of the project. There was the landscape itself and the range of cultures that still seemed to jostle shoulder to shoulder in contemporary Scotland. In Skye we were very aware of the inward migration that occurred at the end of the 1960s when the counterculture moved northwards in search of a fresh start on the land. In Orkney we were struck immediately by the Norse pride of the local population and the layers of history spanning the construction of Maes Howe, Viking incursions and the scuttling of a German fleet. At almost every location we found ourselves close to standing stones, so that our research for Venice was paralleled by an informal education in megalithic sites.

Just as we discovered theses different eras and cultures existing side by side, we found something similar in terms of arts practices. It became clear that not only was Scottish art history marked by a series of fractures and ruptures, but contemporary art across the country and across a wide selection of artists demonstrated the coexistence of many different approaches to what art could be and how it should be created.

Jim Lambie **The Doors (Hot-Cuisine)**, 2003
Installation view: *Paradise Garage, Zenomap*, Scotland + Venice, 50th Venice Biennale

Again, my memories are not just so analytical. I remember the pleasure of seeing a vast but intricate mosaic piece by Michael Mallett in his otherwise chaotic kitchen in Dundee. I remember epic tales told by Hebridean artist Ian Stephen as we looked out across the ocean, and Jenny Brownrigg describing her work on the last stop of a long road trip. There were happy moments talking Larry Levan with Jim Lambie and a proposal from Beagles & Ramsay for burgers made from their own blood (though we chickened out of that beef surprise). And on a regular basis the sheer privilege of having so many artists show us their work in the most open of dialogues.

The best memories of Venice are all from the site visits: the opportunity to visit so many private palazzos and old naval buildings, the out-of-season melancholy of the city – so much better than the ice-cream swelter of the summer – and the curious discovery of the Venetian ways with cuttlefish. Nothing in Venice is modest. The palazzos and churches reflect the city's roots in trading and the accumulated wealth of a city-state. And yet, it's a faded grandeur – rich traces of something passing. Anyone in Glasgow can understand that and work with the oddities of the spaces Venice offers up for exhibitions. Securing one of these spaces, however, is a labyrinthine venture: unknown forces vying with unnamed circumstances, the whole mystery punctuated by badly needed thimbles of espresso.

The selection process itself was remarkably fast. Research in Venice had uncovered two potential spaces – the Palazzo Giustinian-Lolin and a school playground and gym nearby. The Palazzo, with its untouchable walls, helped us quickly reach a consensus on Claire Barclay, Jim Lambie and Simon Starling. The much less formal gym and playground encouraged a sense of mischief, which we couldn't resist, as we commissioned a further twenty-five artists to create films, editions and performances. It's still hard to believe we got away with that … but the quantity was important in establishing that Scotland at Venice would reflect the energy, diversity and life of its contemporary culture. We also managed to squeeze in an opening party that had all the craziness and celebration the artists deserved (the DJs were Optimo, in fine form, with Mu and Jimi Tenor as guests).

Looking back in 2014, it wasn't so much that in 2003 we found one generation at a high point but that we found several generations of working artists. What we also experienced, though, was the growing awareness of a Scottish arts infrastructure that was now at a stage where such practices could be supported and encouraged to grow; funders and the state were acknowledging the creative explosion that had been gathering pace for decades.

The Venice Biennale was the ideal place to articulate this growing confidence in Scottish culture. The sense of occasion that it generates is a little like a wedding. I don't intend to get sentimental about this: there are fractious moments in the past and spiky aesthetic arguments to be had in the future, but for the duration of the event itself it's possible to celebrate the achievements of a community. Artists and public alike need that kind of release. So much in contemporary art is built around conceptions of critique that the exhilaration of the act of making, or viewing, can be overwhelmed by cynicism or fraught with doubts. Once in a while, you have to order the cuttlefish.

The sculptor Karla Black places an emphasis on play, improvisation and direct engagement with materials in her large-scale sculptures that use media such as chalk, soil, polythene and soap. This text is a personal manifesto that describes Black's own desires to make abstract art. But it is also a playful polemic that addresses the very particular expectations surrounding women artists, the artist's feminist beliefs and her profound rejection of suggestions that her own artwork is 'about', or is shaped by, her gender.

First published in *Karla Black, Mistakes Made Away From Home,* Mary Mary, Glasgow, 2008

→ Karla Black

A VERY IMPORTANT TIME
FOR HANDBAGS

The handbag that Carla Bruni carried when she accompanied her husband, French President Nicolas Sarkozy, to meet the Queen in London was unusually and, therefore, noticeably small. In contrast, the red Hermès version that Katie Holmes had in her possession when she appeared on *Good Morning America*, without her husband Tom Cruise or baby Suri, was absolutely enormous.

At the moment 'status handbags' are prominent. Janet Street Porter wrote in *The Independent* that, 'Bag fever [is an] illness that has gripped us for the last couple of years … the handbag stopped being something you stuck a packet of tissues, your purse and makeup in, and started to be an object so desirable that you would do almost anything to own one by the right designer … most of the ads in glossy magazines feature … women pushing, not their breasts towards us, but a handbag.'[1]

Handbags are not inherently bad or anti-feminist. Their earliest versions, depicted in Egyptian hieroglyphs, were invented and used, initially, only by men. From the fourteenth century onwards, via their expensive materials and embellishments, they denoted the financial and social standing of both sexes. The recently achieved completeness with which women now possess 'status handbags' exclusively for their own gender had its beginnings in the 1800s.

Farid Chenoune, the curator of an exhibition of bags at the Musée des Arts Décoratifs in Paris, believes that the key to the handbag's importance in today's society is that it 'holds a secret'.[2]

Is a kept secret a powerful possession? Perhaps what gives the handbag its peculiar, even feminist, potency is that it is not attractive to men. Unlike, for example, shoes or bras, it does not reshape the body and, therefore, does not send out a sexual message, or call in a man's aesthetic judgement. Separate from the body, it, paradoxically, somehow, often unlike the female body itself, belongs only to woman.

In the 1920s, the handbag was recognised as a symbol of women's independence: she could now go where she wanted without a man to hold her belongings.

Handbags are part of an active, experiential life. They allow movement, at the same time as material possession. A handbag can exist completely outside of the shocked, stopped, self-conscious life as 'image' within which we feel watched, our attention drawn away from a physical connection with the world into worrying about how we look.

Movement is intrinsic to Simone de Beauvoir's idea of the independent woman who 'wants to be active, a taker, and refuses the passivity man means to impose on her. The modern woman … prides herself on thinking, taking action, working, creating on the same terms as man.'[3]

If handbags are a signifier of status, then the size difference between Carla Bruni's and Katie Holmes's could indicate that, in public life, a lone woman now possesses most power.

A shift away from 'victim feminism' towards 'power feminism' is being encouraged in our generation.

In *It Changed My Life*, Betty Friedan famously said, 'If you are serious about anything … to make it fashionable helps.'[4] It is generally assumed that, while handbags are hugely fashionable right now, feminism is not.

This, according to Susan Faludi, is because of a 'backlash'. She claims that, since the early 1990s, both men and women have been 'anxiously remarking that it has all gone too far'.[5] Juliet Mitchell and Ann Oakley suggest in their third collection of essays, *Who's Afraid of Feminism? Seeing Through the Backlash*, the 'whole subject of who women are and what they want challenges our division between public and private life' and, therefore, makes people uncomfortable. Could we, whilst retaining a view that feminism has not gone far enough, also pander to that discomfort? Could we keep what is judged 'too personal' or 'too political' private? Perhaps we already have. What if it is not true that feminism is unfashionable? What if, instead, it is actually just fashionable to keep one's feminism secret? Would such a stance be feminist at all? Possibly. If that secret were kept in the furtherance of a cause.

Disregarding whether or not the recent tendency to keep quiet is a conscious choice, would it have any power if actually adopted as a feminist tactic? What could such behaviour achieve? Who would it serve? Could it, for example, hamper the prevalent propensity in the art world to judge only women's work as gendered?

Judgemental gendering succeeds in putting any aesthetic achievements of form, colour, composition, or structure secondary to the fact of an artist's femaleness. And goes some way towards encouraging agreement with the sentiment, expressed by a journalist to Betty Friedan in 1981, that 'I don't want to be stuck today with a feminist label any more than I would want to be known as a "dumb blonde" in the fifties. The "libber" label limits and short-changes those who are

tagged with it. And the irony is that it emerged from a philosophy that set out to destroy the notion of female tagging.'[6]

Does the need of a woman, at any time in history, to engage with feminism come only from outside of herself? From a cultural judgement that presumes that the origins of her self-expression must be different from those of any man? Rebecca West seemed to think so in 1913 when she said, 'I myself have never been able to find out precisely what feminism is. I only know that people call me a feminist whenever I express sentiments that differentiate me from a doormat or a prostitute.'[7]

In the early twentieth century, when 'first-wave' feminism demanded civil and political equality and in the 1970s when 'second-wave' feminism gave promi-nence to sexual and family rights for women, it was necessary to speak up and to point to one's femaleness. If change were to be effected then everything about a woman's private life had to become public property, in order that inequalities be most obviously seen. This attitude was epitomised by the popular 1970s slogan, 'The personal is the political.' I am in no doubt that this statement continues to be true. However, refusal to disclose that which is 'too' personal is political also. Couldn't keeping quiet about the fact of our gender now be an equally provoca-tive stance? If everyone is pointing out that I am a woman, should I join in? Isn't that a trap? Isn't it collusion? By pointing at that part of myself, don't I concur with what is being said, which is something like, 'we will accept you only if you admit that you are problematic. Since your femaleness is an issue for us, we would welcome and appreciate your engagement with that.'

However, if women's power is now being represented, not by speaking freely but by carrying around material possessions, aren't we in danger of, again, invok-ing the wrath of Germaine Greer waged against Natasha Walter's new feminism? Although Walter, Greer argues, assumes that feminism was, by the late 1990s, all about 'money, sex and fashion', 'it was not until feminists of my own generation began to assert with apparent seriousness that feminism had gone too far that the fire flared up in my belly. When the lifestyle feminists had gone just far enough, giving them the right to "have it all", i.e. money, it would have been inexcusable to remain silent.'[8]

Naomi Wolf, though, continues to say that, since there has been a 'genderquake', with more women than ever in powerful positions, we have permission to 'stop complaining' and give up 'victim feminism'.

In *Sisterhood, Interrupted*, written in 2007, Deborah Siegel explains that, its replacement, 'power feminism', has been criticised by some 'second-wavers' for encouraging younger women to equate only sex with power; to actually believe they can get what they want solely by reclaiming a sexualised female image.

However, if this were indeed a true description of the new 'power feminism' said

to be upon us, if sex were our only route to power, wouldn't we be spending more money on shoes and bras than handbags? And this is not the case.

In her anthology of personal essays, *Jane Sexes It Up*, Merri Lisa Johnson suggests that, while sexual bravado is part of a new wave of feminism, those engaged in it are 'lodged between the idea of liberation and its incomplete execution.'[9]

So does the emergence of the 'status handbag' push us any closer to an endgame? Does it at least show that woman's power, once intrinsically linked to man's and then reliant on her collective gender group, is now held by the individual?

Is this sardonic and economic phenomenon also symbolic of a general, societal power shift from the up to the down? Although most of the symbols of patriarchal power, especially the religious ones, like, for example, the sceptre, can be held up high, wielding power and control over others, the handbag really only lends itself, by its gravitational propensity, to hang down towards the ground. But is the ground actually a more secure place? A place where desire for power over others transforms into a wish for possession only of one's self?

Hundreds of years ago young women, just like today's 'sexually brave' generation, were encouraged to wield their physical beauty as power. But, even in 1792, Mary Wollstonecraft knew that 'taught from their infancy that beauty is a woman's sceptre, the mind shapes itself to the body and roaming round its gilt cage, only seeks to adore its prison.'[10]

What is ultimate power? Is it a future breaking-out of the prison of my gender? Or is it power enough that, now, in order to get what I want, I, alone, need know it?

I want to make abstract not figurative art; I want to prioritise material experience over language; I want formal aesthetics rather than narrative, autobiographical detail; I want the lived life to be primary, not the looked-at image. How much is all of that determined by the fact that I am a woman? Since I cannot tell, it will have to be my secret.

1 Janet Street Porter, 'Handbags Are More Addictive Than Drink, Drugs, Or Dreary Sex' *The Independent on Sunday*, 29 April, 2007.

2 Farid Chenoune, *Carried Away: All About Bags*, New York, 2005.

3 Simone de Beauvoir, *The Second Sex*, London, 1965. First published in 1949.

4 Margaret Walters, *Feminism*, Oxford, 2005.

5 Ibid.

6 Ibid.

7 Ibid.

8 Germaine Greer, *The Whole Woman*, London, 2000.

9 Deborah Siegel, *Sisterhood, Interrupted: From Radical Women to Girls Gone Wild*, New York, 2007.

10 Mary Wollstonecraft, *A Vindication Of The Rights Of Women*, Harmondsworth, 1992. First published in 1792.

2009

An experienced and influential artist in performance and public art projects, and former director of the public art research project PAR+RS Public Art Scotland, Ruth Barker is currently completing a PhD at Newcastle University. As an artist, Barker's work explores storytelling and the continuing power of myth and archetype to shape our understanding of the world. Artists who make work for public places are subject to a number of pressures and expectations about who they are working for and why. This text, published on Barker's own website, is a poetic response that reflects on the conflicting ideas that surround public art practice and the ethical position of the artist.

First published on www.ruthbarker.com, 2009

Ruth Barker

STATEMENT ON THE OBLIGATIONS AND NON-OBLIGATIONS OF PUBLIC ART

Public Art has no obligation to be art
Public Art has no obligation to be anything other than art

Public Art has no obligation to be never before seen
Public Art has no obligation to be familiar

Public Art has no obligation to be for an elite
Public Art has no obligation to be for all

Public Art has no obligation to be for sale
Public Art has no obligation to be for free

Public Art has no obligation to be liked
Public Art has no obligation to be controversial

Public Art has no obligation to be present
Public Art has no obligation to be invisible

Public Art has no obligation to be contemporary
Public Art has no obligation to be traditional

Public Art has no obligation to be there
Public Art has no obligation to be here

Public Art has no obligation to be unrepresented
Public Art has no obligation to be documented

Public Art has no obligation to be worthy
Public Art has no obligation to be confrontational

Public Art has no obligation to be ethical
Public Art has no obligation to be corrupt

Public Art has no obligation to be stupid
Public Art has no obligation to be clever

Public Art has no obligation to be outside
Public Art has no obligation to be inside

Public Art has no obligation to be such a joke
Public Art has no obligation to be so serious

Public Art has no obligation to be forever
Public Art has no obligation to be temporary

Public Art has no obligation to be useful
Public Art has no obligation to be useless

Public Art has no obligation to be vandalism
Public Art has no obligation to increase the value of private property

Public Art has no obligation to be ugly
Public Art has no obligation to be beautiful

Public Art has no obligation to be public
Public Art has no obligation to be private

Public Art has no obligation to be socialist
Public Art has no obligation to be conservative

Public Art has no obligation to be conceptual
Public Art has no obligation to be formal

Public Art has no obligation to be vindictive
Public Art has no obligation to be supportive

Public Art has no obligation to be moral
Public Art has no obligation to be abhorrent

Public Art has no obligation to be egalitarian
Public Art has no obligation to be feudal

Public Art has no obligation to be nasty
Public Art has no obligation to be nice

Public Art has no obligation to be discrete
Public Art has no obligation to be flagrant

Public Art has no obligation to be pleasant
Public Art has no obligation to be a pile of piss

Public Art has no obligation to be easy to understand
Public Art has no obligation to be self-referential

Public Art has an obligation to be art
Public Art has an obligation to be everything other than art

Professor Neil Mulholland is Associate Head and Director of Research and Postgraduate Studies in the School of Art at the University of Edinburgh. He moved from London in 2000 to teach at Edinburgh College of Art. As well as being an influential teacher, he is a writer for numerous art magazines and catalogues and an independent curator. His writing and research concerns the production, distribution and consumption of contemporary art. This essay, written in 2009, was originally intended for a proposed Edinburgh College of Art publication that never made it to print. It is a polemic about the cultural atmosphere in the city, the state of art education at Edinburgh College of Art and an assessment of the importance of artist-run initiatives. It is also a time capsule in more ways than one: Edinburgh College of Art began merger talks with the University of Edinburgh early in 2010 and formally merged with the University on 1 August 2011. The essay documents artistic activity in the capital between 2000 and 2009, a period which was marked by many new artist-run initiatives, many of them with Mulholland's active involvement or support. Like much of his writing it combines the championing of artist-run culture with a provocative attitude towards common cultural assumptions.

This previously unpublished text was written in 2009.
A postscript was added in 2014.

→ Neil Mulholland

TEN YEARS IN AN OPEN-NECKED SHIRT

When I first arrived in Edinburgh in the summer of 2000 it had a robust if rather safe and predictable infrastructure consisting of national venues focusing on the work of established artists – such as The Fruitmarket Gallery, the Scottish National Gallery of Modern Art and Inverleith House – and more local cottage industry, member-oriented organisations including Stills, Collective, Wasps and Out of the Blue. Edinburgh, being small and Scottish, is a very sociable city. Its art is particularly bound by loose networks of exchanges and temporary confederacies that ebb and flow with the movement of ideas and friendships. While the smaller venues did more than their fair share to support emerging artists, especially Collective's imperative New Work Scotland Programme, there simply weren't enough things happening to sustain the interest and acumen of aspiring artists and so, at least it seemed at the time, the tide was mainly out. These organisations were not to blame for this, artists were. If you don't make your own culture, it will be made for you.

Where were the liminal spaces in which to practice? Established by sharp impresarios Mel Gooding and Charles Esche, Protoacademy was an ambitious attempt to bridge the emergence gap, to bring together different artisans and the local intelligentsia of the city to construct something as yet undefined. It was a considerable attempt to dramatically up the stakes of the game and to work in a very different way.

Edinburgh College of Art (ECA) collaborated with the Edinburgh University Settlement to provide a number of changing spaces and basic facilities for Protoacademy; in this sense it was umbilically shackled to ECA and thus always lacked the true urgency and invention of Scotland's far more celebrated artist-run initiatives. The dilemma it faced was rather like the Whitney Independent Study Program in New York (ISP) – that is, while it offered a base for a critical interrogation of the ecologies of art in Scotland and beyond, it was entirely reliant on a conventional ecology of paternalistic support from an intransigent host

institution that instantly recuperated its critique. Did I say recuperated? I meant ignored. While Protoacademy looked outwards to polymathic approaches to art-as-education being developed in Scandinavia and by the Free University movement, the host institution buried its head in rearguard action, conserving artisanal silos that most art schools dropped in the early twentieth century. While Protoacademy's agenda was by no means controversial, at least not beyond the Flodden Wall, it simply wasn't engaged with by ECA and, alas, the pedagogic renewal its contribution might have taught about living happily and healthily in the real contemporary art world are yet to be learned by many in Edinburgh.

Culture is a process of vernacular mobilisation that produces and is produced by the social system. If a city can't establish its own infrastructure on its own terms then it doesn't have any basis upon which to exchange culturally with anyone anywhere. Protoacademy attempted to run – with an analysis of an infrastructure that wasn't worthy of an analysis and a programme of exchange when it had little to exchange – before the city could walk. It lacked a big or diverse enough supply of talent to keep it moving. Despite its magnanimous agenda to encourage participation and engage with globalisation, Protoacademy's ultimate weakness was, unsurprisingly, the same as ECA's – it was a closed system that moderated itself only according to its own standards.

Around the same time, Ingleby Gallery (1998-)[1] and doggerfisher[2] were establishing their reputations in Edinburgh, the only viable private galleries to open in the capital for many years. These galleries brought a much welcome sense of commercial viability to Edinburgh – something that art students really need to witness for themselves first hand. Prior to their inception there were no contemporary private models visible in Edinburgh – so it's no surprise that students left college with such a distorted fantasy of what the commercial art world was like. 'World famous. In Edinburgh.'

Ingleby Gallery and doggerfisher are more ambitious than this. They (occasionally) sell work in Scotland and (more commonly) at international art fairs. They both contribute a great deal to the visibility of the arts in Scotland. Notably these two galleries differ from the three commercial spaces in Glasgow in that they do not originate from artists' organisational practice. They are rather more conventional in this sense: dealer-run rather than (ex)artist-led. While this is by no means a bad thing, it has led, very visibly, to a shortage of artists based *in Edinburgh* to stock the galleries. The main doggerfisher artists *today* (Claire Barclay, Nathan Coley) are based in Glasgow and are very famously associated with The Glasgow School of Art.[3] A dearth of talent emerging from ECA in the late 1980s and throughout the 1990s has, lamentably, made this inevitable if not essential – it's not in the interests of a decent private gallery to show the work of cheerless artists, they are not charities and nobody benefits or thrives on mediocrity. The question is, how might this be changed for the better? How can we help to ensure that the artists being represented in private galleries in future include those living in Edinburgh?

The answer surely lies in the artist-run initiatives. ARIs provide a remarkable apprentice-ship for artists, writers and curators, helping them cut their teeth in ways that art schools

and universities more than often fail to. Artist-led start-ups often tend to bring with them graduate peer groups who work together in their formative years. Think of Glasgow's Modern Institute – Toby Webster represents a number of artists with whom he studied and with whom he has established himself as a fellow traveller as well as an advocate. The same is true of Sorcha Dallas and of Mary Mary (Hannah Robinson). ARIs in Edinburgh have, so far, failed to move on to the commercial 'stage'. In some ways this asceticism is encouraging, it shows that artists are chasing their practice rather than a buck, but, on the other hand, it's a major missed opportunity. The cultural capital that these artists have accumulated is being sold off to the lowest bidder in freelance cultural work or, worse still, to a brain drain directly out of the city. It's okay to cross-subsidise your art practice with demoralising part-time work for a few years following graduation, but for how long can you live on the reciprocal altruism that fuels gift economies?

Participating in your own exploitation is not, ultimately, *voluntary* simplicity. Public sector commissions and opportunities are never going to offer enough to live on; therefore artists are left with no option other than to make their own structures. How are artists ever going to lift themselves out of poverty if they don't establish their *own* commercial foundation for their practice? Artists who have spent more than two or three years in Edinburgh tend to leave after burning out their considerable energies in ARIs – no where to go but out via the path of least resistance to Glasgow, London, New York or Berlin. This is a great pity since it was only by sticking it out that artists living in these cities founded something worth moving to and something worth growing up with.

To stand on the shoulders of these giants is often to miss the hard work that went into establishing the reputation of the world's exceptional art ecologies. To miss this is to miss what gives art its value. Cultural capital is carefully accrued through much hard work, it isn't ready-made, nor can it simply be appropriated. The lingua franca of leading international art practice starts life through internal interactions, self-organising and self-defining of boundaries. It's impossible to invent such rich cultural phenomenon out of thin air.[4] Nonetheless, it's worth observing that art ecologies that are already well established are the ones that are often hardest to change; they require that you adapt *to* them rather than build them to suit your own needs. This is why great things tend to happen in places many people least expect them to. The question prospective artists need to ask themselves is this: do you want to *be* someone or do you want to *do* something? The answer they give to the question must be an honest one; it's an answer that will not only determine their fate it will shape the lives of others.

Confederacy of the Cats[5]

There's absolutely nothing standing in the way of doing something. In the early 2000s artists started to use K. Jackson's bar on Lady Lawson Street as a venue for a number of exhibitions. This was the perfect social space in which art could flourish. Staff and students at ECA were in there practically every night since you couldn't leave the college without passing

its windows. It was open all day every day and so was invigilated constantly by Ronnie, Lesley and bar staff. Some of the shows there included *Isluvmann* (featuring artists from Manchester such as Dean Hughes, who is now Head of Intermedia at ECA), *Ronnie Heeps* (a retrospective of Glasgow-based Heeps' infamous Christmas card designs), *Hampstead Achieved* (a range of international zines and some oil paintings by Los Angeles-based artist Edgar Bryan co-curated with Alex Pollard).[6]

Most important of all the K. Jackson's shows, I'd say, was *Jessie Phillips You're Mine to Kill*, a fantastic Halloween show put together by a group of ECA art graduates who would go on to found Win Together Lose Together Play Together Stay Together in an erstwhile book-ies in Tollcross (Dave Maclean and Tommy Grace later still would form the band Django Django). From this grouping of talented artists grew Embassy, formed by some members of Win Together Lose Together Play Together Stay Together and by associates of Magnifitat,[7] a tenement based space in Bruntsfield.[8] The supergroup used their collective know-how to establish Embassy as a registered charity, creating a handsome gallery space in Southside, running an ambitious series of live events in the Sculpture Court of ECA and also organ-ising the professional practice programme for art students. They have curated numerous exhibitions in Edinburgh as well as representing Scottish artists in public exhibitions and art fairs. The work of the four committees that have formed since Embassy opened and of its many members has been widely exhibited internationally and they have contributed to the reputation and identity of the city's art in volumes that deny their tender years.

Artists' collectives are the guilds of our time, unions that help members get themselves

Shop exterior, 28 Leven Street, Tollcross, Edinburgh

noticed and that help others develop in the process. It's no secret that most funding bodies and sponsors are far more likely to support a responsible group with a bit of a track record for doing things well, on time and in budget than a shower of shadowy untrustworthy bohemians – so getting organised like this was paramount. Around 2003 there were many other ARIs (some big, some involving a single director-member) setting up in the city, including indie magazines such as *dodelijk*[9], Edinburgh's *One O'Clock Gun* periodical[10] and *Product*[11]. Transient and nomadic ARIs such as Total Kunst, Cell 77[12], Aurora[13], Wuthering Heights, EmergeD[14], OneZero[15], and Hyperground established themselves in this period. Embassy helped to corral this activity in the form of the Edinburgh Annuale[16] – a detournement of festival culture much in the spirit of the original Fringe. Some of these organisations are in it for the long haul, others are temporary. Both are equally valuable and valid. They are not, however, all sustainable or equally worthy of preservation – to insist that they are would be to encourage the kind of cultural stagnancy they rally against.

Following a pioneering group of postgraduates staging *UK Gold* in an empty shop in Tollcross, I altered the MA Contemporary Art Theory programme at ECA to include a major curatorial component. Since then the MA CAT have curated an exhibition annually at venues including Cell 77, Embassy, Green Room Venues and Talbot Rice Gallery. Master of Fine Art students have also been busy curating shows of their own work around town and further afield, including recent shows at Embassy, Lauriston Castle[17] and in Berlin. There is a spirit of willingness and cameraderie that flourishes well. It seems to me that most of the art students at ECA now understand that making and producing go hand in hand; that you can't just show your work without also carefully building a context for it. There's still a lot of work to be done here, it's by no means good enough and, at least as far as contemporary art is concerned, the college is yet to coherently enter the twenty-first century.[18] Graduates will need to improve the quality of their work, stage many more sophisticated events and establish smarter more connected, more world-savvy organisations before Edinburgh will blip on the radar never mind make a significant contribution to international art practice.

Coalition of the Willing

Edinburgh may be a relatively small geographically isolated city, but the location and density of a place is no guarantee of its cultural capital. Think of how small the population of Florence was during the Quattrocento and that a global city such as London has nearly twice the population of Scotland. Location is no guarantee of parochialism or cosmopolitanism. History tells that art flourishes where it is carefully nurtured (e.g. NSCAD, Halifax, Nova Scotia[19]) and where it is most intelligently patronised (e.g. Newcastle, New South Wales) – it has no 'natural' vital centre. *Because* it is the Festival City, Edinburgh has a lot to do to make up its reputation as a patron of the arts. Visual art languishes in the shadows during and after the Festival. Festival culture is widely regarded to be a drain rather than a boon to resources. Edinburgh cannot rest upon its laurels for, as far as visual art is concerned, it has no laurels. Emerging artists must internalise an awareness of this situtation and be fully

prepared to take on the city and help to re-establish its reputation as a bastion of intellectual and creative prowess.

A second wave of ARI activity has come in the form of a number of overtly nomadic organisations, including Standby[20], the Back Garden Biennale[21], Echo[22], Steve Ovett Effect[23], Artachat[24], and Re-make[25]. It's significant that so many of these organisations should make extensive use of the various Web 2.0 platforms that have exploded since 2004. The social web gives these artists instant free space online to build an identity and following. They are immediately networked this way with peers based in Scotland (e.g. Aberdeen's Project Slogan[26]) and internationally. The social web hasn't put out the fire of Web 1.0 or of the older forms of DVD and print media. New publications continue to emerge that function primarily as sites for artists' practice, including *Fool's Gold*[27] and *Bareface.*[28] While there are no newer private galleries of note in the city, there are a few new ARI venues opening up, including Green Room Venues (GRV), Anthony Blunt Projekts, PICNICPICNIC[29], The Bowery[30], Rhubaba and Sierra Metro.[31] If enough momentum is built to establish cultural capital, then a new ARI-spawned commercial venture is surely bound to emerge from this mix eventually. Planning for the future in this way is difficult when the collapse of this ecology remains a clear and present danger. In the summer of 2008 Embassy suffered the devastating loss of its base in East Crosscauseway as its landlord withdrew the property back into private use. The committee went into limbo for over six months and almost collapsed.

My contention is that one way of dampening (rather than eliminating) the destructive nature of cycles of boom and bust, expansion and contraction, is to tackle scalability. If they are to be adaptable to constantly changing circumstances, artists' organisations need to work more closely together in a consortium or cell-like arrangements. While retaining vital independence they can maintain the spirit of the Edinburgh Annuale all year round, bringing skills and knowledge to help each other out where needed and planning ahead together to ensure that new ARIs are given the kind of start-up support they need. Involving ECA, Collective, Embassy, Stills and Edinburgh Sculpture Workshop, Edinburgh Contemporary ensures that lines of communication remain open and that the small specialist institutions that share a common interest in the latest research and development and in nurturing new art practices, art writing and theory meet regularly to discuss their plans. This 'collective of collectives' formed on Valentines Day 2009, the twenty-fifth anniversary of the founding of Collective. It aims to develop and improve education, research and curatorial links between the organisations, to work together to find more, bigger and better opportunities for artists based in the city. To achieve these goals, it has to set its sights on the foreground as well as the horizon.

The City of Edinburgh Council have no official arts strategy – which is bad in one sense, but good in another. The lack of a strategy means that artists are in a position to pitch their preferred way of working to the council. They must do so in collaboration with foresighted and community-minded consortiums of local small businesses (e.g. the Tollcross Traders Association[32]), with which they have much in common. These models of ARI/small business

collaboration can work to ensure that communities do not become run-down, that shops that shut can be used temporarily to host cultural events and ensure that the slow death of on-street shopping and socialising is stopped in its tracks.[33] It's a model that is proving to be particularly successful in Australia, where Marcus Westbury[34] has not only spearheaded the *Renew Newcastle*[35] project but has fronted two series of the nationally syndicated ABC television programme *Not Quite Art*[36] in the process. Focusing on Glasgow as a model for how a similar post-industrial city like Newcastle, New South Wales might regenerate itself, Westbury, who lives on the other side of the planet, shows more knowledge of and insight into the arts scene in Scotland than our Scottish politicians!

For now the City of Edinburgh Council remain blind to the possibilities for regeneration that Glasgow City Council leapt upon back in the mid-1990s and upon which they are now basing the bulk of their Merchant City renewal scheme. This will be easily changed when artists make themselves audible and their valuable contribution visible. I expect that the current recession will be good for artists based in Edinburgh. With fewer demands from the finance sector for high-end shops and speculative building grinding to a halt, gaps are opening up that artists, if they are quick to react and given half a chance, can fill. Responsive civic conditions have and will continue to play a crucial role in the production of some of the world's greatest artistic endeavours, allowing artists in turn to establish cultural imaginaries that contribute to a sense of community. This is what happened in the last recession in London, Manchester, Glasgow and, to a lesser extent, Edinburgh.

While there's nothing to gain from getting into bed with knee-jerk public-private partnership (PPP) schemes such as those being developed in Glasgow's Merchant City, there's much to be done to improve the relationship with the public sector in Edinburgh, to get some access to a city that has chucked nearly all of its eggs at the vampiric finance sector. A new smaller, leaner, smarter more grassroots private arts sector should be something that emerges out of this breathing space, a natural by-product of learning from experience. Growth for growth's sake is over, at least for the foreseeable future. The world has rapidly become a very different place in 2009, expectations are different, a seismic shift is happening. My hope is that Edinburgh doesn't miss this, that it doesn't continue to confirm that it's the barren cultural desert that most of the world thinks it is (or, perhaps, wills it to be). A patient, glacial approach may *eventually* bear rich fruit but timing is perhaps more important when confounding expectations. The opportunities that shift is offering right now should not be knocked; you've nothing to lose but your Colinton Mains.

Postscript: 260 Weeks Later

In the half-decade since this was penned, what has changed? Many of Edinburgh's smallest ARIs have come and gone, as they must, while some of the biggest beasts are extinct. By 2010 Edinburgh College of Art was in financial difficulties. It relaunched in August 2011 as a research-intensive school within the University of Edinburgh's College of Humanities and Social Science. It is now twice its former size, incorporating departments of Architecture, History of Art and Music into its own vastly improved repertoire. It has rapidly transformed into one of the most intellectually ambitious, internationally engaged, and largest art schools in Europe.

Meanwhile, many venues have moved north, clustering around Hillside, Broughton and Leith. While doggerfisher gave up its space – which is now the artist-run studio-gallery Whitespace – Ingleby Gallery took over the former Venue, a music complex behind Waverley Station, now the largest private gallery in Scotland. Collective is now perched atop Calton Hill in the old City Observatory and has expanded its innovative programme considerably. Embassy is now in its fourth venue, currently, a former photography studio off Broughton Street. It still coordinates the Annuale, now entering its eleventh year. Annuale is joined by other grassroots festivals such as Leith Late. Embassy co-founders Django Django are a critically acclaimed band touring internationally. Rhubaba has become a key venue with an inviting studio and gallery complex in Leith while Edinburgh Sculpture Workshop has completed a huge estate expansion and are now Scotland's biggest studio-workshop. The City of Edinburgh Council are enabling artists access to their property. Forest Centre+ and Interview Room 11 currently occupy the vast office building on Castle Terrace, host to numerous free studios happily occupied by graduates. Meanwhile, the former Dick Veterinary School has been transformed into Summerhall, a cavernous arts venue and host for start-ups.

1 www.inglebygallery.com

2 www.doggerfisher.com

3 It must be said that doggerfisher immediately engaged with the work of young artists based in Edinburgh, showing Jonathan Owen and Lynn Lowenstein within a few months of opening its doors and that it continues to do so where feasible. Ingleby was, until more recent years, more concerned with representing established artists in Scotland rather than younger artists living in Scotland.

4 There are many Glasgows, but there never was a 'Glasgow Miracle' (and I'm not referring to St Mungo). Likewise there won't be an 'Edinburgh miracle', so don't go holding out for one.

5 Borrowed from Keith Farquhar – www. keithfarquhar.co.uk

6 At the same time, I curated exhibitions featuring some of the K. Jackson's artists in Edinburgh (Protoacademy and Collective), Dundee (Generator Projects), Manchester (International 3), Prague (1st Biennale at the National Gallery) and New York (preview of Liverpool Biennial show). The 'local' and the 'international' are one and the same thing.

7 www.magnifitat.net

8 Magnifitat staged a number of memorable shows, one including Scotland and Venice exhibitors Joanne Tatham and Tom O'Sullivan (Glasgow) alongside Jonathan Owen (Edinburgh) and Lucy Stein (Berlin).

9 www.dodelijk.co.uk

10 *One O'Clock Gun* was the offspring of the Top Slot Club, a legendary conspiracy of plotters. www. paxedina.co.uk

11 www.productmagazine.co.uk

12 This was an experimental space donated by a graphic design office at 77 Montgomery Street.

13 www.auroraprojects.co.uk

14 www.emerged.net

15 www.onezeroprojects.com

16 www.annuale.org

17 www.myspace.com/bigcaseedinburgh

18 A new BA Intermedia programme has recently replaced Tapestry, bringing conceptual rigour, clarity and focus to bear upon contemporary art practice in its fullest sense.

19 www.nscad.ns.ca

20 www.myspace.com/standbyprojects

21 www.back-garden-biennale.co.uk

22 www.myspace.com/echoedinburgh and www. echogogo.co.uk

23 www.steveovetteffect.org

24 www.facebook.com/Artachat

25 www.facebook.com/remake.edinburgh

26 http://projectslogan.com

27 www.foolsinprint.com

28 bareface.wordpress.com

29 www.picnicpicnic.co.uk

30 www.thebowery.org.uk

31 www.sierrametro.com

32 www.tollcross-edinburgh.co.uk

33 www.artistsandmakers.com/staticpages/index. php/emptyshops

34 www.marcuswestbury.net

35 www.renewnewcastle.org

36 You can watch this series here: www.abc.net.au/ tv/notquiteart

Jenny Brownrigg is a writer and curator who has been Exhibitions Director at The Glasgow School of Art since 2009. In 2006 she was co-curator of The Young Artists' Biennial, *Absent Without Leave* (AWOL), 2nd edition, Bucharest, Romania. Her collection of short fictional and literary non-fiction works *The Job Never Ends for the Paranoid* launched the important art writing journal *2HB*. Created and supported by CCA, Glasgow, it is a quarterly publication dedicated to creative and experimental writing in contemporary art, edited by Ainslie Roddick, Jamie Kenyon and Francis McKee, with Louise Shelley as editor-at-large. It has been a key platform for art writing, working with artists and writers in Scotland and far beyond.

Brownrigg's short story *Opening Speeches* is a witty, yet melancholy, tale that reveals the complex dynamic of art institutions. Set at an exhibition opening in an unspecified country and venue, it reveals the tensions surrounding the roles, and different perspectives, of a museum director, a curator and the artist whose work is on show.

First published in *2HB*, vol.1, CCA, Glasgow, March, 2009

Jenny Brownrigg

OPENING SPEECHES

*The audience is gathered in the top mezzanine of a city gallery. Pausing
expectantly from their chatter, they look across some roughly-hewn wooden
constructions filled with mud, towards four men who stand facing them.*

PRESIDENT: I would like to thank our sponsors and the board for their continuing
investment in this very building – the very clay of our existence here. Our esteemed
director would like to say some words.

[Mild applause]

DIRECTOR: Thank you President, for your kind opening. I would like to talk about
this exhibition we have the good fortune to see in front of us.

Imagine this, [emphasises with hands] the clay is the life. This man digs it out from
the banks of the mighty River. He sweats under the sun and freezes in the rain,
as he prepares to heave this clay, the stratified conglomeration of time, the very
material God made the first humans out of, into this gallery. As the soil is shovelled
into the plastic bags, so too is the flora, carried with it. Its roots adhere tenaciously
with the same dogged persistence that this artist has towards breathing life into
his creations.

Now in the gallery, a second life has begun. This man alone [clasps artist on shoulder] scoops the clay out of the containers and places it within the pyramids of charred wood he has placed upon the gallery floor. The wood itself is an archaeological find, blackened by the weight of ages that kept it hidden under the river banks, sleeping, until the artist found it and dragged it back from the dead. Its rawness is here for all to see. Its geometric planes bring order to the organic mud that rests within it. It lies like furrowed land waiting to be planted.

Remember my friends. [Significant pause] The clay is the life.

[Round of applause]

Yes, we are proud indeed to have this man in our midst, who toils for us. As we have gone about our day in our offices, this man, this worker, has done our dirty work for us. He is in it to his elbows. And all for us!

If we were to touch what he has taken, we could return back to nature! We would step aside from our geometric plan desks. We would walk away from air conditioning to feel the wind on our faces. We would perceive layers of time. We would become people where the mud was enough for us. Mud people. For this, my friend, we thank you for showing us how our lives should be.

[Curator applauds artist, audience join in fervently. All look at artist expectantly]

ARTIST: I cannot speak for others. Just myself.

I want to be part of the problem. I want to be questionable not congratulated for my actions that are part of this malfunctioning society. Where is our sense of community, of us reaching out to help each other? We only help ourselves and get further into the mire of our own making.

I want to get dirty. I must be in shit up to my elbows because it signifies the fucking shit I myself am in. I am in fear of losing my job, in fear of losing food for the table. I fight failure all the time. I always rush. My mother comes tomorrow, and my girlfriend. What am I to give them when I live in so disorganised a state? I am a prisoner to my mobile phone. I must be here and here at a certain time. Yes I did not answer you and yet you can reach me in my dislocation. I want to be alone. The clay is the shit.

Yet I am in love with poetry. And all of this I try to do with a joyful spirit.
That is all I want to say.

[Confused and lesser round of applause as the speeches have come to an end]

2009

In March 1999 Dundee Contemporary Arts opened as a new flag-
ship venue in a building designed by Richard Murphy on the site of a
former garage at 152 Nethergate. Under its founding director Andrew
Nairne and curator Katrina Brown, DCA established a programme
that included significant international artists such as Olafur Eliasson,
Thomas Demand and Christopher Wool. Dundee Contemporary Arts
also commissioned landmark projects with artists based in Scotland
including Claire Barclay, Christine Borland, Roderick Buchanan and
Simon Starling. The work of the current team, including director Clive
Gillman and exhibitions curator Graham Domke, has included impor-
tant exhibitions by Thomas Hirschhorn and Jutta Koether. In recent
years, the venue has continued to commission artists from, or based in,
Scotland such as Torsten Lauschmann, Ruth Ewan, Scott Myles and Alex
Frost. Dundee Contemporary Arts curated *No Reflections* by Martin
Boyce in 2009, for the 53rd Venice Biennale.

Also in 2009, to mark the venue's tenth anniversary, Graham Domke
curated an exhibition, *The Associates*, of seventeen artists who had
graduated from Duncan of Jordanstone College of Art & Design,
Dundee, since the nineties. The artists exhibited included figures like
Lucy McKenzie and Luke Fowler. This period was one of growing artistic
confidence in the city and these simple recollections give some sense of
the atmosphere of the time and the experience of education for young
artists. The title of the exhibition referred to the influential band The
Associates whose members, the late Billy MacKenzie and Alan Rankine,
had hailed from the city.

First published in *The Associates*, Dundee Contemporary Arts, 2009

Katy Dove, Luke Fowler & Raydale Dower

ON DUNDEE

When I started at Duncan of Jordanstone College of Art & Design in 1995, there was less going on in Dundee than there is now. Dundee Contemporary Arts and Generator were yet to exist. We took a DIY approach, organising our own exhibitions and parties. The college was a great support. The exhibitions department sometimes gave us financial assistance to put on exhibitions and we screenprinted our fliers in the printmaking department. We formed an artists' group called Unit 13 and organised exhibitions in a derelict cellar of someone's house, a supermarket, a night club and the botanic garden. Tutors such as Graham Fagen and Cathy Wilkes provided invaluable support and inspiration. **Katy Dove**

Dundee is the land of jazz funk, stovies and all night bakeries. I loved staying in Dundee for the years that I attended art college. I came up with a friend, John Carroll, from the portfolio course in Glasgow, and we soon befriended local lad Derek Lodge, who graciously welcomed us into his fold. There was a great bond between people involved in the local music scene – Mark Wallace and Andy Balneaves and us students. Other kind, funny and influential people I met in Dundee were Steve and Fiona, Katy, Duncan, Mickey, Kevin, Mark, Lucy and Anna, Cathy and Victoria, the late great Alan Woods, Frank and Egor. In my year I will always remember Michael, Janie, Andy, Duncan, Andy and Duncan (underlings) and Dan (prefect) who I curated a drawing show with in the college.

I recall one day in first year encountering a very alien sight – a funeral procession of some of the most finely dressed, aging rock stars I've ever seen, mixed with a bunch of Dundee folks entering the local church (next to Dundee Contemporary Arts). My older, more savvy, flatmate John realised that it was Billy MacKenzie's funeral procession; it was the first time I'd heard of the Associates. **Luke Fowler**

The factory was key to my decision to study in Dundee. An empty garage on Perth Road, where the Dundee Contemporary Arts now stands, was at one time the only indoor skatepark in Scotland. An autonomous space, the factory was a realisation of the DIY ethos of punk and a lucid illustration of skateboarding's approach to urban space.

More keenly aware of my peers outside of college the underground continued to exert its influence. A new wave of younger tutors from Glasgow encouraged us to experiment with this in approach and subject matter. We organised collaborative exhibitions with the inclusion of performance and music.

Through these shows I made my first contact with Alan Woods who was interested in the

Beat spirit of what we were doing. Alan had given a lecture on the Situationist International in a suitably anarchic and disparate style, delivered as he wandered randomly from one idea to another; he introduced the concept of psychogeography and the '*Derive*' as a way to negotiate the city.

I recognised in this idea an echo of the way we approached the streets and architecture on skateboards and he encouraged me to pursue it. Alan also made an impression in the way he wore his trousers: pulled up high like a thirties or forties Jazz musician, with the waistband nearly in the middle of his chest.

Viva Alan Woods. **Raydale Dower**

Dundee Contemporary Arts under construction

Jenny Richards is an artist and curator whose research, writing and projects focus on the politics of collaborative practices. In 2012 she completed an MA in Art and Politics at Goldsmiths, University of London. She has worked as gallery manager of Cubitt Gallery and programme manager of Collective in Edinburgh. Current work includes a post-graduate research project with Curatorlab, Konstfack, Stockholm.

Jenny Richards

AFTER THE CRASH, BEFORE THE CRASH, CRASH[1]

In 2007 the City of Edinburgh Council received what was believed to be the largest planning application in its history. It was submitted by Forth Ports and set down plans for the transformation of Leith Docks over a thirty-year period. The well-known image of the city as constant and unchanging – Edinburgh Castle, Holyrood, Arthur's Seat and Calton Hill – was under threat of transformation.

I graduated from Edinburgh College of Art in 2007. It was the final year that Heriot-Watt University would accredit the college's degrees. As Leith's redundant port was being remapped into a post-industrial vision of commercial shopping malls, real estate and Frappuccinos®, ECA was beginning the process that would lead to its merger with the University of Edinburgh in 2011.

Yet, while these changes were shaped in planning documents and contracts, a closer look at Edinburgh's artistic inhabitants might show a different city. The artistic activity that I will discuss did not participate in Edinburgh's hopes for growth, motivated by the city's economy, but nor did it try to maintain a fixed environment constructed within Edinburgh's historic past. Rather, artists were deviating from both of these narratives to form a new ecology within the very fabric of Edinburgh's medieval and neoclassical foundations. At its heart – and the red thread right across Scotland – was the pursuit of collective working. Artist-run projects and collaborations sought to renegotiate the geography of art and politics to produce new situations and physical spaces where artistic possibility and production sat hand in hand. To reflect on the period I lived and worked in Edinburgh, from 2003 to 2011, is to dwell on a time of significant global political and economic shifts. These inflected life both from the wider perspective of global restructuring and in the detail of my daily existence.

When I left the comfortable surroundings of art college, established artist-run projects like Embassy[2] offered a space for young artists to migrate to. Embassy is a not-for-profit artist-run gallery that was founded in 2004 by ECA graduates Kim

Coleman, Craig Coulthard, Tommy Grace, Jenny Hogarth, Dave Maclean, Kate Owens and Catherine Stafford. The artists formed a committee who collectively organised a programme of exhibitions and events and invited contributions from other young artists through a membership scheme. Over time (approximately every two years), other artists joined the committee. Thus the organisation renewed itself organically, offering recent graduates the opportunity to run a gallery and providing a public platform for their peers to meet and produce work. Other ad hoc informal initiatives like Echo[3] and Standby[4] were self-organised projects that could ebb and flow between sites and frequency of activity: their lifeline was subject to the lived reality of its founders. It is worth noting, too, that the commercial gallery doggerfisher, founded and directed by Susanna Beaumont, where I worked during this period, can't be wholly split from this ecology. The gallery, which ran from Gayfield Square between 2000 and 2010, represented artists like Jonathan Owen and Ilana Halperin and put the development of artists' work at the forefront, often developing exhibitions and events that built alliances of interest and support for artists rather than pursuing purely commercial concerns.[5]

Embassy film and performance evenings at ECA, which took place when I was a student, and projects at Collective like One Mile[6] (2005–8), a three-year programme of large-scale collaborations, captured a shift in which the public presentation of artworks felt like one stage of a body of working, rather than necessarily the end point. Exhibitions in domestic settings – like *Hyperground*, Alexa Hare's project in her Bruntsfield flat (2005–10) or projects like *Re-make* which Charlotte Hale and I set up in disused shop units in 2008 – placed the emphasis on 'doing'. Within our art school education a professionalised institutional approach to exhibition making was emerging through new courses like 'professional practice'.[7] In their focus on the commercialised art world, and on clean presentations in sanitised white-walled spaces, these courses seemed to me to reduce the possibilities of working as an artist rather than expand them. In contrast, out across the city, the curatorial collaboration Sierra Metro[8] who occupied an atmospheric nineteenth-century depot for the Northern Lighthouse Board in Granton, or later the artist-run studio and gallery space Rhubaba,[9] proposed exciting alternatives.

In May 2008, Embassy,[10] which I had become involved with shortly after graduation, was evicted from its home in Edinburgh's Southside and had – like the new contemporary workforce – to adapt to a precarious life. For a time, the gallery had to operate without a long-term fixed abode,[11] and like a freelancer worked on itinerant projects before securing a home within the Roxy Art House.[12] It felt like a premonition of the financial downturn to follow, and the persistence of Embassy over this time is testament to its importance and the work of its committee.

In the autumn of the same year, at the time Lehman Brothers filed for bankruptcy, I was working at the artist-led visual arts organisation Collective, directed by Kate Gray, a crucial space for Edinburgh and the wider Scottish art community. Collective had begun as an artist-run project formed by ECA graduates in an effort to insert a younger perspective

within the larger institutional spaces that dominated the city. Thinking back to the crash that September, I remember it was the start of *New Work Scotland (NWSP)*[13] – a programme of exhibitions and events that had developed annually since 2000 to support emergent artists, writers and curators, including, Katie Orton (2006), Tessa Lynch (2007) and Catherine Payton (2010).[14] In the morning before walking to Collective I would watch the images of redundant Lehman Brothers staff walking out of empty offices carrying their half-filled boxes of belongings – the only material relics from their abstract financial excursions. In contrast, Collective's home on Cockburn Street was steadily populated, hosting discussion events like the *DIY Soapbox*, practical workshops like *Fanzine Sunday* as well as expanding its operations through residency opportunities at Studio Voltaire in London. The variety and intensity of activity provided a framework where current issues and experiences could be discussed and shared openly. The *DIY Soapbox* invited new artist-run initiatives across Scotland to discuss their different projects and approaches. The event reflected artistic concerns as well as the economies of friendship, funding and feedback, which each project had learned to negotiate with.

Yet whilst collaborative working might have been political challenge enough to the commercialised art world, working after 2008 also felt like a call for a more intimate engagement with the potential of art to address larger global crises. For me, Collective was the space where questions of labour and economy, gender and politics could be explored, where ideas were invigorated by working on long-term projects with artists and audiences who shared mutual interests. Zoë Walker and Neil Bromwich's project *Bank of Reason* wandered across the city connecting different economic and ecological activities, calling for a more stable landscape to work within. Over two days we discussed and compared figures such as Edinburgh's political economist Adam Smith – the man who introduced us to what we now know as capitalism – with sites such as the volunteer-run urban wildlife garden at Johnston Terrace. The following year we premiered Hito Steyerl's 2010 film work *In Free Fall*, a co-commission between Collective, Chisenhale Gallery, London and Picture This, Bristol. The film captured the essence of this new world, where a perpetual feeling of groundlessness and uncertainty was explored through images of an aeroplane graveyard in California's Mojave Desert, where disused planes are decommissioned or grounded during moments of economic crisis.

Ironically in 2010 the Conservative Party's manifesto made a pitch for power through the image of 'The Big Society', a doctrine which grasped the symbolic value in harnessing the free labour of collaborative working, exemplified in many of the artist-run projects I've mentioned. That year, exhibitions like *Avalon*[15] and *Hello World*[16] at Embassy reacted to these political co-options featuring artists who were exploring new forms of collectivity and information dissemination rising within digital culture.

The challenges of a world in which economics forms the basis for political decision making and cultural validity fed directly into a project I worked on with artist Jesse Jones at Collective. *Against the Realm of the Absolute* was an expansive project that over six months

mobilised an all-female cast for a film shoot at an East Lothian power station. The bleak apocalyptic landscape of burnt-out coal detritus reflected the unstable future ahead, while the cast recited excerpts from the feminist text *The End of Capitalism (As We Knew It)* by J.K. Gibson-Graham.[17] *Against the Realm of the Absolute* experimented with the possibilities of collective film production. The project started with a series of bi-weekly film screenings and discussions at the Edinburgh Film Guild cinema within the Filmhouse on Lothian Road. Each session we would eat, talk and watch together which would later shape the score of the final film. Watching Lizzie Borden's *Born in Flames* (1983) and Chantal Akerman's *Jeanne Dielman, 23 Quai du Commerce, 1080 Bruxelles* (1975) and reading selected feminist texts created a rich environment in which to question, imagine and conspire. The intensity of the shared experience established close friendships and generated knowledge that for many of us was the beginning of a closer consideration on feminism, production and economy which would go on to influence both our work and life.[18]

The act of writing about these projects and looking at them now as a timeline reveals a turbulent period of transformation within the city. Thankfully, what it also shows is the persistence of artists, writers and curators to engage with these significant changes. A reminder that within the complex socio-political landscape we are confronted by, there is a constant response from artists, creating new possibilities through artist-run and collaborative activity.

I left for London in 2011, exactly three years after the crash. It is clear there is a debt to be paid to Edinburgh. It was a place where the politics of collaboration were opened up to me and a place which encouraged processes that addressed the political urgency of lived reality. My current projects *Manual Labours*[19] and my research on collective practice draw from these experiences and the intertwined ecology of artists who, in a focus on *doing*, developed forms of political expression and resistance.

From Collective's new location on Calton Hill[20] we might glimpse the statue of Adam Smith on the Royal Mile and the developments at Leith Docks, but it is also possible to view an alternative to these models of change and see a different city. Adam Smith is said to have been inspired to write his economic thesis by watching the trading boats of Leith Harbour. The artist collaborations and collectivity I saw and shared in Edinburgh have influenced my thinking and work. They encouraged me not only to see a distinct city, but taught me how to work for it. To ask, as we did in one project at Collective in 2011, '*How to Turn the World by Hand?*'[21]

Thank you to Jill Brown, Matt Carter, Benjamin Fallon, Kate Gray and Tessa Lynch for their support in the research for this text.

1 Hito Steyerl's *In Free Fall* (2010), a new film co-commissioned by Collective, Edinburgh, Chisenhale Gallery, London and Picture This, Bristol, incorporates a series of Steyerl's works – *After the Crash*, *Before the Crash* and *Crash*. Exhibited at Collective in August 2010.

2 See www.embassygallery.org

3 An artist-run initiative set up in 2007 by Tonya McMullan and Paulina Sandberg. Echo worked with Collective on their Guest Room Project – part of the New Work Scotland Programme, in 2008.

4 An artist-run initiative set up in 2006 by Amy Thomas and Rachel Dornan who both graduated in 2007 from ECA. Standby was part of Collective's Guest Room project – part of the New Work Scotland Programme, in 2008.

5 Collaborations with REWIND – a project (2004–ongoing) that provides a research resource to address the gap in historical knowledge of the evolution of electronic media arts in the UK, by investigating specifically the first two decades of artists' works in video – and projects such as *Master of Measurement* (2008), part of *The Voyage of Nonsuch* collaboration between Ruth Beale and Karen Mirza, were all examples of this approach.

6 One Mile was a three-year programme of collaborations between artists and groups of people who live or work within the one-mile radius of the Collective directed by Sarah Munro and led by artist Kate Gray.

7 My year group at ECA was one of the first to be assessed on a 'professional practice' module of the course. This was implemented across Fine Art courses.

8 Sierra Metro was founded in 2008 by Janine Matheson and Martin Minton. Rosalie Doubal and Matt Carter joined Janine Matheson to continue the programming and running of the space from May 2009 until the last project in 2012, an offsite screening by Kevin McPhee at the BBC Big Screen in Edinburgh. See www.sierrametro.org

9 Rhubaba was founded in 2009 as a communal studio and project space. Established in response to a perceived gap in appropriate studio provision for recent graduates and through the desire to create a space dedicated to both the production and presentation of contemporary art, Rhubaba initially housed ten recent graduates from ECA. See www.rhubaba.org

10 At the time the committee involved Shona Handley, John A. Harrington, Oliver Herbert, Norman James Hogg, Tessa Lynch and Daniella Watson.

11 *No Fixed Abode* was a project by artist Kenny Watson taking place at Embassy's location at the Roxy Art House where it produced exhibitions and projects for eighteen months between 2009 and 2011.

12 Since spring 2011, Embassy has worked from its current location on Broughton Street Lane.

13 Now developed into the *Collective Satellites* programme. See www.collectivegallery.net

14 Tessa Lynch and Katie Orton were previously both co-directors of Embassy committee and Catherine Payton is a co-director of Rhubaba.

15 *Avalon* was a project and exhibition at The Embassy in 2010 with Plastique Fantastique, Torsten Lauschmann, David Osbaldeston, Alex Pollard, Andro Semeiko, Ewan Sinclair, Eddo Stern and Emma Tolmie. Curated by The Confraternity of Neoflagellants – a collective formed in 2009 by Neil Mulholland and Norman James Hogg.

16 *Hello World* was an exhibition at Embassy with Darren Banks, Luke Collins, Jonathan Horowitz, Seth Price, Corin Sworn and Stina Wirfelt, curated by Benjamin Fallon.

17 J.K. Gibson-Graham, The End of Capitalism (*As We Knew It*): *A Feminist Critique of Political Economy*, University of Minnesota, 1996.

18 The *Against the Realm of the Absolute* cast included artists, filmmakers, writers and feminists: Jill Brown, Katie Crook, Jeanne dARK, Rachel King, Tessa Lynch, Tessa Mitchell, Ash Reid, Hatt Reiss, Jenny Richards, Anne-Sophie Roger, Bec Sharp, Jasmine Bray Triance, Fiona Watt.

19 Manual Labours is a collaborative research project exploring people's physical relationships to work initiated by Sophie Hope and Jenny Richards in 2013. See www.manuallabours.wordpress.com

20 Since 2013 Collective has been based in the City Observatory and City Dome site on Calton Hill, one of Edinburgh's principal hills which forms part of a UNESCO World Heritage Site.

21 *How to Turn the World by Hand* was a year-long collaborative project between artist-led organisations Collective, Edinburgh; PiST///, Istanbul; and Arrow Factory, Beijing in 2011.

David Shrigley **Untitled (I walked into a room)**, 2006
Courtesy the artist

I WALKED INTO A ROOM
AND I LOOKED AT THE THINGS IN THE ROOM
AND THEN I ~~XXX~~ WALKED OUT
AND THEN I WALKED INTO ANOTHER ROOM
BUT THERE WASN'T ANYTHING THERE
SO I PASSED STRAIGHT THROUGH
AND INTO ANOTHER ROOM
BUT THERE WASN'T MUCH IN THERE EITHER
EXCEPT SOME BITS AND BOBS
SO I WENT INTO ANOTHER ROOM
WHERE THERE WAS A BIG WINDOW
SO I LOOKED OUT OF THE WINDOW
AND THERE WAS A MAN OUTSIDE FIXING HIS CAR
SO I WATCHED HIM FOR ABOUT TWENTY MINUTES
AND IT WAS QUITE INTERESTING

The Glasgow-based artist Fiona Jardine is a key figure in the development of art writing and writing as art practice. She often produces new writing responding to historical and art historical materials and to the artwork of her contemporaries. This previously unpublished text was written for the symposium *The indirect exchange of uncertain value: the performance of public art* at Fettes College, Edinburgh on 5 August 2011 with presentations by Jardine, Vito Acconci, Tom Leonard, Owen Hatherley, Elizabeth Price and Chris Evans. *The indirect exchange of uncertain value* was a project by the artists Joanne Tatham and Tom O'Sullivan developed with Collective, Edinburgh in response to the nature of public and private space within the city. With an emphasis on the role of education and the uses of art within the public sphere, the imposing setting of Fettes College, a prominent public school, brought issues of public and private space into sharp focus.

 Jardine's essay begins with the figure of the Edinburgh novelist Muriel Spark, whose book *The Prime of Miss Jean Brodie* was set in a fictitious Edinburgh girls' school. Jardine uses this premise as the departure point for a wide-ranging investigation into the nature of art and education. It was presented as a talk accompanied by slides showing the route from 160 Bruntsfield Place, Muriel Spark's childhood home in Edinburgh, via the Collective's then home on Cockburn Street, to the symposium venue at Fettes College.

Commissioned by Joanne Tatham and Tom O'Sullivan and the Collective, Edinburgh, 2011, for *The indirect exchange of uncertain value: the performance of public art*. Previously unpublished.

Fiona Jardine

THE TRANSFIGURATION OF THE COMMONPLACE

The title of this presentation is *The Transfiguration of the Commonplace*. It is a title lifted directly from Muriel Spark's novel, *The Prime of Miss Jean Brodie*, prob-ably – on account of the film adaptation starring Maggie Smith – her best-known work. The scheme of the novel seems so familiar that it hardly merits a mention here suffice to say that at a general level, *The Prime of Miss Jean Brodie* embodies a certain type of atmosphere and attitude that seems to be particular to a city and particular to a time – Edinburgh in the years immediately preceding World War Two.

Which is not to say we can't remember it.

We encounter Sandy Stranger, the schoolgirl doyenne of the Brodie set, in her middle age as a nun, Sister Helena of the Transfiguration, clutching at the bars of the grille separating her from visitors to the convent as she reminisces about her education at the hands of the maverick teacher. As Sister Helena, Sandy Stranger is famous for having written 'an odd psychological Treatise on the nature of moral perception' called 'The Transfiguration of the Commonplace'. It is an interest-ing title to break down and investigate in the context we find ourselves in, here, at Fettes College. Spark was educated at James Gillespie's School for Girls in Marchmont, formerly a Merchant Company School like Daniel Stewart's, George Heriot's, George Watson's, and Mary Erskine's. Though Spark's biographer, Martin Stannard, says Gillespie's was 'not one of Edinburgh's glamorous schools… In the second rank behind Daniel Stewart's, Heriot's, and Fettes… it was serious minded, respectable, disciplined.' In short it was ambitious that its pupils should benefit from a similar curriculum, delivered in a similar fashion to those first rank schools, with which it had a shared history.

The term 'commonplace' means ordinary; unremarkable; expected; accepted or assumed. Its English form derives from the Latin *locus communis* which, for ancient rhetoricians, referred to a recognised or oft-quoted source used in the construc-tion of an argument; a place of knowledge; a topic. Otherwise, according to the

Oxford English Dictionary, 'commonplace' is the text of a sermon or discourse; an opinion or statement generally taken for granted; a stock theme or platitude; anything trite, common or trivial; anything plain. Within the ambit of the term 'commonplace' is the mediaeval university practice of 'commonplacing', keeping 'commonplace' books. Essentially this means isolating and ordering extracts from Classical texts in order to inculcate such bits and pieces of knowledge as might be useful in facilitating future discourse. By extension, commonplace books became personal collections and records of information and ideas relating to interests and enthusiasms:

To those, who have been accustomed to the use of a Commonplace Book, the advantage of a convenient Repository of the kind is well known; and to those, who have not, its utility must be sufficiently obvious. The man who reads, and neglects to note down the essence of what he has read; the man who sees, and omits to record what he has seen; the man who thinks, and fails to treasure up his thoughts in some place… will often have occasion to regret an omission, which such a book, as is now offered to him, is well calculated to remedy.

This quotation comes from the flyleaf of a blank journal produced in the early nineteenth century for the purposes of keeping a commonplace book. The journal was 'properly ruled throughout, with a complete Skeleton Index and Directions for its use, Equally adapted to the Man of Letters and the Man of Observation; the Traveller and the Student, and forming a useful and agreeable companion on the road and in the closet.'

I think there are speculative links between the practice of commonplacing as a pedagogical method and the instruction of copperplate handwriting, which is the approved formation of loops in minuscule and majuscule at a slant of fifty-five degrees from the horizontal. That there was an increasing emphasis on copperplate writing – rather than commonplace learning – in the nineteenth century is perhaps indicative of the fact that the measure of public literacy in democracy was based on writing rather than reading ability; of witness rather than facility. According to Ursula Howard, a former director of the National Research and Development Centre for Adult Literacy and Numeracy, the nineteenth century was marked by an increasing need for the population to apply their names to documents: to sign the marriage register, for instance, rather than to mark it with an 'x'. In this mode, writing is a consequence of urbanisation, a technical extension of presence as mechanistic and convenient as the railway.

'Boilerplate' is the term 'copperplate' transmuted by a century and a continent. It is an American term describing the printing plates which were pressed from the shells of redundant boilers and used to print high circulation texts such as adverts or syndicated columns. Boilerplate steel was used for such texts in preference to softer alloys as it was extremely durable and able to withstand wear and tear better: high circulation and syndication demanded it. Via its colloquial use by lawyers to describe form letters, standard language and empty rhetoric, the term 'boilerplate' brings us to the dismal extreme imminent in

the practice of commonplacing: formulaic recitation. I say dismal as we could see modern attitudes towards education framing the idea of learning by rote negatively, characterising it as a didacticism which cauterises 'creativity' – especially when creativity is defined as expressionistic, unbounded, spontaneous. *The Prime of Miss Jean Brodie* is textured by the implication that learning in school is by rote, but one of the fascinating aspects of the novel is that yoked to Jean Brodie and her off-piste mélange of interests, learning by rote – by repeating – is presented as a creative act. It is actually learning by heart.

We have Sandy Stranger, famous for her long vowels, reciting a stanza from the *Lady of Shalott*,

> *She left the web, she left the loom*
> *She made three paces thro' the room*
> *She saw the waterlily bloom*
> *She saw the helmet and the plume*
> *She look'd down to Camelot*

and this recitation is coupled with Sandy's peer, Eunice Gardner, somersaulting in the classroom. Spark neatly parallels the gymnastic exercise of mind with that of body. Later on, the Lady of Shalott manifests for Sandy during a recital by Miss Brodie, a momentary vision, the equivalent of seeing Our Lady at Lourdes, perhaps. We also have Miss Brodie using the opening line from Keats's ode *To Autumn* to open a reminiscence: 'Season of mists and mellow fruitfulness… I was engaged to a young man at the beginning of the War but he fell on Flanders' field', she continues… 'He fell like an autumn leaf, although he was only 22 years of age.' Generally, that recitation precedes both sympathy and invention. Jean Brodie is as much a creation of her set, as they are of her. Thus, Sandy and her friend Jenny Gray write the tragic story of Miss Brodie's lost autumn love as a Sturm und Drang pot-boiler, 'The Mountain Eyrie'. On her behalf, they decline a proposal of marriage from the music teacher Gordon Lowther in pubescently torrid terms, and bury the correspondence they conceive as a result, at the back of a cave near Crail. In short, they make patterns out of facts.

It is no accident that Jean Brodie prepares her girls for the Classical rather than the modern curriculum in senior school.

Within *The Prime of Miss Jean Brodie*, then, the topics of pedagogy and education: the possession of knowledge as power; the force and temporality of the charismatic ideal are constitutive of a major part of the novel's trajectory. Significantly, Spark sets the novel against the success of Fascism in the thirties, its charismatic orators and aesthetic discipline in artistic Italy and reliable Germany. Spark refuses to play history out as a game of Tommies and Gerries as she locates contemporaneous youth movements in Edinburgh – the Girl Guides, for instance – at the thin edge of the wedge. However, Brodie, with her dislike of guides and healthy suspicion of team spirit, is not a Fascist despite admiring Mussolini's approach to the problem of unemployment. She riffs on his epithet *Il Duce* reiterating the etymology of the word 'education': '*The word education*' she says,

'comes from the root "e" from "ex", out, and "duco", I lead. It means a leading out of what is already there in the pupil's soul. To Miss Mackay it is a putting in of something that is not there, and that is not what I call education, I call it intrusion, from the Latin root prefix "in" meaning "in" and the stem "trudo", I thrust. Miss Mackay's method is to thrust a lot of information into the pupil's head; mine is a leading out of knowledge and that is true education as is proved by the root meaning.'

Miss Brodie's approach to teaching might be characterised as 'maieutic', a word deriving from the Greek word *maia* meaning 'midwife'.

The idea that knowledge may be 'birthed' is one to consider in relation to Jacques Rancière's book on the pedagogy of Joseph Jacotot, *The Ignorant Schoolmaster*. Against a general background of debates on the purposes of public education that gave the book its context in the 1980s, Rancière promotes the common sense of Jacotot's method of universal teaching, a method which is predicated on the general equality of intelligence and the notion that learning is not a hierarchical process of explication (necessity being the mother of invention). Stultification – the risk of which increases with the enthusiasm, enlightenment and energy of the dedicated explicator – is the perpetuation of epistemological and pedagogical hierarchies. Emancipation opposes stultification and is the state of being conscious of the equality of intelligence, a state of consciousness that dissolves hierarchical boundaries for those who are notionally above lines of demarcation, as well as those below: 'There is no superior mind that doesn't find an even more superior one to be lower to; no inferior mind that doesn't find a more inferior one to hold in contempt.' It was Jacotot's contention that with the application of will and intelligence, anyone can teach themselves anything:

Young ladies, you know that in every human work there is art; in a steam engine as in a dress; in a work of literature as in a shoe. Well, you will now write me a composition on art in general, connecting your words, your expressions, your thoughts, to such and such passages from the assigned authors that lets you justify or verify your everything.

This is not Jean Brodie speaking, but it might have been. I think at some level, despite Miss Brodie's nominal role as 'teacher' and 'leader' and her attraction to Fascist dictators – bearing in mind the involvement of the girls of her set in creating her for us – Spark's character promotes the same notion of emancipated intelligence. Needless to say, the consequences of emancipated intelligence exercised are unpredictable.

In *The Emancipated Spectator*, published in 2009, Rancière deliberately reconnects with *The Ignorant Schoolmaster* in order to think through the relationship between the theory of intellectual emancipation, the question of the spectator and the position of the audience. Rancière asks if 'it is the desire to abolish the gap between theatre and audience that creates it', because the perceived need to abolish it defines a 'distribution of the sensible' (which is Rancière's term for the implicit law governing 'ways of seeing, feeling, acting, speaking, being in the world with one another… '). Opposing artwork to audience is like

opposing knowledge to ignorance, and like the perpetuation of intellectual inequality by the enlightened explicator, the opposition between artwork and audience is not eradicated by well-intentioned participatory projects. These essentially reiterate the division as a volatile structure. Rancière suggests it is a mistake to assume that members of an audience are passive because they spectate and are not seen to be active agents of a collective practice: such assumptions lead artists into stultifying behaviours. For Rancière, the active principle in an emancipated community – the principle that motivates intellectual adventures – is the process of translation. Translation is effected between the artwork and the audience, between the artwork and the artist too, and it is not a process which occurs in the presence of an artwork, to be done with there and then, nor is it a process to be started and finished in that moment.

Which brings me back quite closely to the title of this presentation: the 'Transfiguration of the Commonplace' and the idea of 'transfiguration'. I would like to take a quote from Martin Stannard's biography of Muriel Spark:

For Muriel, the Transfiguration was fundamental to Christianity, the junction of the divine and the human, of the spiritual and material, of Old and New Testaments. And transfiguration was also the essence of art, the translation of fact into fiction or 'vision'… (Sister Helena's treatise) 'The Transfiguration of the Commonplace'…equally describes Muriel's writing with its constant slippage between natural and supernatural. A sense of wonder and horror co-exist. The ordinary becomes strange, the strange ordinary, an effect enhanced in Brodie by a narrative structure which became a hallmark of her mature style: being at the end and diving backwards and forwards through time. There is, as in all her work, a sense of déjà vu, of double time and split identity.

Although I am reluctant to engage with Stannard's *unheimlich* spin on Spark's writing with all the connotations that has, preferring to read it structurally as absurdist, I would like to emphasise his point that her writing is frequently marked by use of prolepsis – the prefiguring of a future event out of joint in a narrative. Spark's knack for dramatic opening gambits marks the start of her novels so deeply that any 'actual' beginnings are referred elsewhere in the text. She links the porosity of time with the individuation of experience: 'many times throughout her life Sandy knew with a shock, when speaking to people whose childhood had been in Edinburgh, that there were other people's Edinburghs, quite different from hers, and with which she held only the names of districts and streets and monuments in common. Similarly, there were other people's 1930s.' This passage occurs just before we encounter Sandy as Sister Helena, famous for her treatise, and suggests a subtly literal transfiguration of the commonplace, through the temporal shifts and heightened senses occasioned by reminiscence and experience.

Simultaneity of experience is something Matthew Wickman, a senior lecturer in Scottish literature at the University of Aberdeen, points to as evidence of Spark's 'para-modernity'. Certainly in the following passage from the novel *Symposium* she dismantles chronology:

'Some people … are eighteenth century, some fifteen, some third, some twentieth … most patients are blocked … in their historical era and cannot cope with the claims and habits of our century.' Here, Spark parallels the Austrian architect Adolf Loos in his foundational Modernist polemic *Ornament and Crime*:

I live in the year 1908, but my neighbour lives approximately in the year 1900, and one over there lives in the year 1880. It is a misfortune for any government if the culture of its people is dominated by its past. The farmer from Kals lives in the twelfth century … Happy is the country which does not have such backward looking inhabitants. Happy is America!

Needless to say, the para-modern Spark enjoyed that which Loos disparaged. Loos believed that dog-legs, cul-de-sacs, backwaters, any ornamented deviations from the straight and pure – the clean and hygienic – hindered progress. Spark's studies of structural and human anomaly are out of time: the idea of 'progress' has no purchase for her. She poses repetition and recitation, the exaggerations, absurdities and shocking moments of presence occasioned by them, against progress, against copperplate and boilerplate, against linear narrative and immediacy.

Considering Alberti's notion that the myth of Narcissus is indicative of the origin of artistic representation, Arthur Danto, Professor of Philosophy at Columbia University, mentions Jean-Paul Sartre's understanding of the 'Pour-Soi' form of self-knowledge: 'A consciousness which is conscious of itself is Pour-Soi (For Itself) …(that is) an entity … immediately conscious of its not being one of the objects it is conscious of … the Pour-Soi realises that it … is an object for others ''that it can be Pour-Autui (For Others)''.' In *Symposium*, Spark has her characters at dinner briefly refer to the (invented but clearly indebted) philosophy of 'Les Autres': 'a revival of something old. Something very new and very old. It means we have to centre our thoughts and actions away from ourselves and entirely onto other people.' The aggressively toothed Margaret Murchie, who is attached to the philosophy of 'Les Autres', spends time in a convent of sweary Marxist nuns, the Sisters of Good Hope. Speaking to a BBC television crew, the short-skirted Mother Superior Sister Lorne says, 'We are not all cut to measure like the more ancient monastic orders. We are extremely individualistic in our tastes, in our personalities, in our backgrounds, in our views on life and society, including religion and politics.' Thus, Sister Lorne, clothed in her habit, speaks the philosophy of Renaissance painters who abandoned copybooks and icons in favour of life studies and intervention. Nevertheless, the monastic framework insulates the individual, and by allegory, Spark defers the objectness of self onto the rhetorical condition of being.

The connection between Danto and Spark is not limited to an interest in 'Les Autres'. Sister Helena's famous treatise shares its title with Danto's analytical philosophy of art, *The Transfiguration of the Commonplace*. In his preface, Danto explicitly states that he coveted and admired the title 'The Transfiguration of the Commonplace' from Spark's novel, and wrote to her when it seemed he might have a use for the title. He says she replied to say that had she actually written the book, it would have been about art as she practised it. How

Fiona Jardine **Spark for Artists**, 2014
Spark for Artists is an illustrated presentation that explores the role of art and artists in the work of Muriel
Spark. Commissioned by Glasgow International and supported by Outset Scotland, 2014

much this might have taken its cue from Sister Helena is the bare bones of a necessary study hinted at by the character of Dougal Douglas from another of Spark's novels, *The Ballad of Peckham Rye.* However, Danto's book is, as I mentioned, an analytical philosophy of art seeking to understand the exact circumstances which transfigure the commonplace, which literally make, 'banalities into art'. In the course of his investigation, Danto distinguishes between 'transformation' and transfiguration': the former changes the material identity of the subject, the latter throws a glamour over the subject – alters its state temporarily. Danto's book was published the same year as Rancière's *Ignorant Schoolmaster,* in 1981, though it reiterates some of the philosophical concerns Danto addressed in 1964 with the publication of his essay *The Artworld*. For Danto, 'the great thing about the sixties was the dawning recognition that anything could be a work of art, which was something evident in all the main movements of the time – in Pop, Minimalism, Fluxus, and Conceptual art.' In *The Transfiguration of the Commonplace,* he uses consideration of mimetic hard cases – Andy Warhol's Brillo boxes are compared against the boxes designed for Brillo by James Harvey, for example – to pose the question 'given two perceptually indiscernible objects, one an art work, the other not, what accounts for the difference?' Danto contends that the difference between a real thing and an art thing, a real object and an art object, is not perceptual, nor is it merely institutional. The ontological condition of art is characterised by a self-conscious intent to embody unresolved or open-ended meaning (a condition which removes it from the continuum of real things, and brings it into the realm of philosophy). For Danto, the open-ended meaning of art is its rhetorical function. He emphasises art's rhetorical operation in an Aristotelian tradition, through enthymemes and paradigms or examples. Examples are educative narratives or comparisons, and as narratives, examples can be factual or fictive. A fictive example is a fable and we might understand them to be the stock trade of passionate explicators. The enthymeme is essentially a piece of deductive logic from which a premise or conclusion is omitted because it is 'commonplace', because to include it would be to state the obvious. As a term, 'enthymeme' incorporates the Greek word *thumos*, which refers to an individual's capacity for emotions. In its incompleteness, the enthymeme reserves some information in order to engage the audience dramatically. It creates a gap not dissimilar, if we follow Danto, to the gap between imitation and reality, between art and life.

Despite making assumptions about 'the obvious', the enthymeme is not structurally divisive when it demarcates itself from audience: it does not assume the passivity of the audience. On the contrary, the enthymeme assumes spectators and audiences will plug the gap themselves, to no conclusive end other than the plugging itself. It presents the gap as an essential part of its structure; the gap is not an external divide between one complete thing and another. This does not mean that the enthymeme cannot be co-opted for political or commercial ends. Enthymetic art might be defined as art which requires the audience or spectator to apply their experience, their commonplace knowledge to the problem or gap described by the artwork. The sympathies with Jacotot's notion of a presumed equality of intelligence are obvious; equality of intelligence does not proceed on the presumption of

similar experience or background knowledge. In an application of experience, the translation of the gap into knowledge is not necessarily instantaneous; the transfiguration of the commonplace does not necessarily occur in front of the artwork; the artwork does not necessarily produce immediate experience or effect in the spectator or audience and the time of its unfolding is as simultaneous and unpredictable.

Despite some apparent common ground, it is possible to draw distinction between the enthymetic gap and the social interstices that Nicholas Bourriaud sees relational art practice creating in 'the overall economic system, be it symbolic or material, which governs contemporary society.' Bourriaud's interstices, harmonious with – yet separate from – that overall system, suggest 'other trading possibilities' are teleological, determined and overwritten by that system that he assumes they exist in. They have definite, sticky, hyper-economic substance. Bourriaud claims as much: he imagines and hopes people are melded into temporary communities. They become obvious within the economic system that governs them – one of his keynote artists Rirkrit Tiravanija lists people as material. The substance reserved and assumed by the enthymeme – that substance being 'the obvious' – shifts, dissolves and transfigures, always becoming something else, ungovernable, emancipated and unpredictable. Dissolution is essential for the operation of the enthymeme and I think what makes it a persuasive model for art.

I'd like to leave you with a phrase not from Sartre, though it is easy to believe on the streets of Edinburgh during the Festival that 'Hell is Other People'; nor from Spark who describes Jean Brodie as an Edinburgh Festival all by herself; but from Mallarmé's poem *The White Waterlily,* a poem Rancière discusses briefly in *The Emancipated Spectator* and understands as the foundation for relational art practice for the activity of the emancipated spectator: '*Separés, on est Ensemble'* (Apart We Are Together).

Anon., *A New Commonplace Book…*, London, 1799

Nicholas Bourriaud, *Relational Art*, Paris, 1998

Arthur Danto, 'The Artworld', *The Journal of Philosophy*, vol. 61, Issue 19, October 1964, 571–584

Arthur Danto, *The Transfiguration of the Commonplace*, Cambridge, MA, 1981

Ursula Howard, 'History of Writing in the Community' in, *Handbook of Research on Writing*: *History, Society, School, Individual text* (ed.) C. Bazerman, New York and London, 2008

Adolf Loos, *Ornament and Crime: Selected Essays*, Riverside, California, 1998

Jacques Rancière, *The Ignorant Schoolmaster,* Standford, 1991

Jacques Rancière, *The Emancipated Spectator,* London, 2009

Muriel Spark, *The Prime of Miss Jean Brodie*, London, 1961

Muriel Spark, *The Ballad of Peckham Rye*, London 1960

Muriel Spark, *Symposium*, London, 1990

Martin Stannard, *Muriel Spark: The Biography*, London, 2009

Matthew Wickman, 'Spark, Modernism and Postmodernism' in *The Edinburgh Companion to Muriel Spark*, (eds) M. Gardiner and W. Maley, Edinburgh, 2010

2011

Lucy McKenzie is from Glasgow, studied painting at Duncan of Jordanstone College of Art & Design in Dundee and lives and works in Brussels. She is considered one of Europe's most significant artists. Whilst many artists in recent decades have explored fashion and interior design as part of their art practice McKenzie is also actively involved in design through Atelier E.B., her collaboration with the Edinburgh-based designer Beca Lipscombe who studied fashion and print at Central Saint Martin's School of Art in London.

The Inventors of Tradition was an exhibition, film screening and publication conceived by Beca Lipscombe and Lucy McKenzie (Atelier) and curators Panel, in partnership with the Scottish Screen Archive at the National Library of Scotland and exhibition designers Martha. At the intersection between art, design and social history, the project was a study of the history of the Scottish textiles industry since the 1930s and brought together samples of world-class design, the archive material of individuals and companies, and a series of short documentary films sourced from the Scottish Screen Archive. In response to this material Atelier produced a series of new works including clothing, furniture, painting and accessories.

First published in Catriona Duffy and Lucy McEachan (Panel) (eds), *The Inventors of Tradition*, with texts by Lucy McKenzie, Mairi MacKenzie, Nicholas Oddy, Jonathan Murray and Linda Watson, Buchhandlung Walther König, 2011

Lucy McKenzie

RODCHENKO'S WORKER'S SUIT HAD NO FLY

Unlike wool, which is 'born' rather than 'made', traditions, as opposed to customs, can be as constructed as the patchwork of folk paganism in the 1970s horror film, *The Wicker Man*. Hugh Trevor-Roper's 1983 essay *The Invention of Tradition: The Highland Tradition of Scotland* outlines the apocryphal origins of clan tartan. Trevor-Roper proposes that they stem not from an indigenous nobility but from a combination of Walter Scott's Romantic personal vision and eighteenth-century English militarism. Despite the disparaging tone in which it is written, and its obvious contempt for such inauthentic heritage, the essay contains insights that invite further examination.

The designer Beca Lipscombe and I, working under the name Atelier, present our first fashion collection, encompassing high-quality wovens, knitwear, raincoats, workwear and accessories. This collection is part of the project, The Inventors of Tradition, which also included an exhibition, a film screening and this publication. We wanted to discover what lies behind the public image of 'Scottish style', what industry has survived the shift to the Far East, and if the claim that symbolic value has vastly overtaken actual productive and creative might is correct. In so doing we continue Trevor-Roper's analysis of myth, but in a new climate and without his prejudices.

The purpose of the collection was to extend the research of The Inventors of Tradition into reality, and to do this Atelier collaborated with some of the most established manufacturers still producing in Scotland today. These include Mackintosh, Caerlee Mills, McRostie of Glasgow, Hawick Cashmere, Begg Scotland and Janette Murray Handknits. Discoveries in archives, as well as the content of film footage found at the Scottish Screen Archive, directly influence the style and ethos of the collection. After studying their archives and samples we discussed with the companies whether it would be possible with their current technology, labour force and workload to realise a small number of original designs. We tailored our

ideas to these limitations: a finish that would be easily achievable, the adaptation of familiar shapes, working with the wool weight and colours already threaded on machines or fabric in stock.

The concept of the collection is a wardrobe for working women, especially artists and those in creative and artisan professions. As a painter, I understand exactly what I need in a work coat for the studio: it must be inexpensive and durable, but also rather dapper, like those worn by skilled factory workers when Scotland was an industrial power base. The act of adopting formal dress for work is in contrast to the contemporary norm of stained jeans and sweatshirts. In recent years embellishment and adornment have undergone a re-invention, and jeans can be bought pre-paint-spattered on the high street. Together with the tailor Steven Purvis, I designed a series of work coats inspired by historical models, following the example of Denise Van Der Kelen, the director of the decorative painting school I attended in Brussels.

A garment's use is dictated by its fabric. Several of the coats are manufactured in both cotton and silk to highlight this fundamental truth; in silk the same work jacket becomes delicate and can be used as evening wear. To give the best specific silhouette the coats are cut differently for men and women, rather than unisex. The lightweight masculine models echo those worn by designers in the atelier, or men of leisure in the library.

A work coat can simultaneously suggest both drudgery and liberation. The work coat signifies the bohemian emancipation of the women who were able for the first time to enter public and private art schools at the end of the nineteenth century. Whether this is the group of artists and designers in the circle of Charles Rennie Mackintosh at The Glasgow School of Art, known as the Glasgow Girls, or Käthe Kollwitz posing with a beer tankard in her studio, the image of the smock-wearing 'New Woman' is iconic. One model in the Atelier collection is designed for housework, and the combination of white over darker tones alludes to the classic uniform of the domestic servant. As with that other luxury, haute couture, it was the decline of domestic service in the 1920s that ushered in the concept of ready-to-wear. Previously, a 'good' outfit was only needed on the weekly afternoon off, but with their shift from sculleries into offices and factories, working women needed available and practical daywear.

Beca Lipscombe's eponymous label manufactures exclusively in Scotland, a highly unusual undertaking where production limitations lead the design process. In this collaborative work she presents a selection of quality cashmere, pure wool knitwear and wovens to be worn with the work coats, as one inevitably does in a

ATELIER (Lucy Mckenzie/Beca Lipscombe) **Drawing of a Cat Woman wearing garments from Inventors of Tradition (2011) collection: Work Coat – 'Lanoir' (white) and Running Dog wrap skirt – 'Moira' (grey side)**, 2011

cold climate, by layering garments over each other. This honours a truth which is often negated in the aspirational fantasies of the fashion industry.

It is important for us, as in all our work together, that we maintain our separate identities. This creates not only a physical, but a conceptual layering. Our personal fashion histories are different. Beca, as a teenage model, was aligned with casual, expensive British and north Italian sportswear labels, hard-earned or stolen, and worn impeccably. By contrast, my adolescence was immersed in subculture, where fashion related solely to music and Siouxsie Sioux made swastika armbands okay. Gothic style is exceptionally elastic; expanding and splintering, with the enduring component of Celtic – especially pagan Celtic – images and sounds. Casual styles also evolve for each successive generation. There is no need for the result of these influences to be in conflict when no artificial unity is expected. Where we meet is in an appreciation of craftsmanship and in the wish to define our own ideas of what constitutes a personal Scottish style.

Beca shares a colour palette with her artist mother, whose trompe l'œil figurative tapestries use the macaroon, Caramac and neo-navy featured in her knitwear. These 'local' colours complement the shapes of her skirt and trouser suits, which are cut in the comfortable, flattering and luxurious style of classic leisure wear. Her contemporary take on the eternal Aran jumper, where the knit is loose enough to reveal naked skin underneath, typifies the sensuous flair she brings to Scottish traditions of clothing.

> Some may argue, looking at Atelier's new collection: 'It's just a round neck cashmere jumper with a jogging bottom pant.' However, we challenge anyone to be able to shop for such a simple, no-nonsense garment now. We live in an over-designed world where branding, labelling and embellishment overrules quality, skill and style. To quote Jean Muir: 'less is Muir'. You may be able to find a round neck cashmere jumper, but we guarantee the trims on the sleeves and body will have been given the Italian finish (skinny and minimal) and there will be some form of applied symbol to reassure the customer of its status.
> *Beca Lipscombe, 2011*

Beca's handknits are not skimpy, but robust: the kind that, combined with a cagoule or mackintosh, can replace a winter coat. Her mackintosh has deep sleeves reminiscent of the kimono shapes that Muir and Bonnie Cashin devised especially to accommodate chunky knitwear underneath. It is sportswear in its original incarnation, to contrast the formal structure of everyday dress.

Our hat designs are based on recognisable shapes associated with national costume – a Spanish canotier, or the traditional headscarf and bonnet of Scotland, all produced in sombre Presbyterian style. Like the work coat, they suggest the

completion of an outfit considered unnecessary today, and therefore a deliberate action.

Belgium, like Scotland, is a post-industrial, rainy country with a strong manufacturing past. Unlike in Scotland, however, innovative Belgian fashion design has flourished in the last twenty-five years into a globally recognised economic and cultural force. This has happened through support by the state, higher education and an infrastructure of skilled production. Without serious investment by people who care, our industry will die, or at best decline into something devoid of local character. Belgian fashion honours tradition while extending and re-imagining it; can we blame our lack of creativity only on a lack of resources? We know that to dress idiosyncratically in Scotland must be something undertaken with bravery.

Atelier's take on national dress has little to do with the subversion of historicism exhibited by designers like Vivienne Westwood or Alexander McQueen. Nor do we align ourselves with the irreverent re-jigging of woollen golf wear for a younger market. Rather my antiquated shapes echo Glasgow at the turn of the twentieth century; their feminism is whimsically romantic. The Greek ornament Beca often uses, Running Dog, here unfinished on the edges of blanket skirts, is the neoclassical motif loved by Robert Adam and Alexander Thomson. We do not propose that people should be walking amalgamations of symbols, only that Scotland has the cultural and manufacturing potential to define itself away from predetermined myths.

2012

In July 2012 Dr Sarah Lowndes curated the ground-breaking exhibition *Studio 58: Women Artists in Glasgow since World War II* for the Mackintosh Museum at The Glasgow School of Art. The lineage of women artists at the school and their contributions to the wider art world had been somewhat neglected and the exhibition examined the period from 1939 to the present day when women artists in Glasgow are at the forefront of the art scene in the city. The exhibition title came from the studio located on the top floor of the Mackintosh building, which historically was the dedicated workspace for women students. One of the key features of Lowndes's catalogue was that it invited the fifty-seven participating artists to give their own accounts of their experiences. This short selection provides a fascinating snapshot of these experiences, as well as an oblique portrait of some key figures.

Published in Sarah Lowndes (ed.), *Studio 58: Women Artists in Glasgow since World War II,* The Glagow School of Art, 2012

Sam Ainsley, Sara Barker, Adele Patrick & Corin Sworn

STUDIO 58

SAM AINSLEY

Taught at The Glasgow School of Art: Lecturer, Mural and Stained Glass 1981–5
Lecturer, Environmental Art 1985–1991
Co-founder/Head of Master of Fine Art 1991–2006

Artist and teacher Sam Ainsley studied Fine Art in Leeds and Newcastle before graduating with a postgraduate diploma from Edinburgh College of Art in 1979. From 1985 to 1991 she taught on the Environmental Art programme at GSA, before co-founding the school's Master of Fine Art course. Ainsley has served as a trustee or board member of the Scottish Sculpture Trust, the Arts Trust of Scotland, Glasgow Sculpture Studios and many others. She was appointed to the Council of the Scottish Arts Council in 1998 and chaired the Visual Art Committee at the SAC for two terms of office. The most recent of her numerous international exhibitions include *New Scots*, Royal Scottish Academy, Edinburgh (2008) *Atlas of Encounters*, I Space Gallery, Chicago (2009) and *After Growth and Form*, Glasgow Print Studio (2011). She is part of the collaborative trio, AHM (Ainsley, Harding, Moffat).

Experience of living and working in Glasgow

By the mid-eighties I was teaching in the newly formed Environmental Art Department under David Harding's leadership, where a strong philosophical base challenged new generations of students to make contextual artworks. David Harding and I invited many women artists to GSA, including a gender workshop led by Adele Patrick and Janice Kirkpatrick which was (even then) an eye-opener for all the students. The so-called Glasgow Boys were then receiving massive attention, nationally and internationally and I became aware how few women featured in their work. My exhibition *Why I Choose Red*, CCA (1987) was conceived as a counterbalance. All the female figures in this exhibition were twice life size and offered

a perspective on a female experience and 'world view'. My memories of that time are the sheer excitement of every day of teaching and the sense of something important emerging; female students being treated as potential artists and respected by their colleagues and a real shift away from the masculinised art world of Scotland (and Glasgow in particular).

Installation view: **Studio 58: Women Artists in Glasgow since World War II**, a group show curated by Dr Sarah Lowndes at the Mackintosh Museum, 2012

SARA BARKER

Studied at The Glasgow School of Art: BA *Hons (Sculpture and Environmental Art) 1999–2003*

Born in Manchester in 1980, I grew up in the Isle of Man. I was awarded a Visual Artists residency at Cove Park in 2005 and the Rome Residency in 2009. I attended De Ateliers, Amsterdam 2010-11. Recent and forthcoming exhibitions include: *Frauenzimmer*, Museum Morsbroich, Leverkusen (2011); *Pink Caviar: Recent Acquisitions*, Louisiana Museum of Modern Art, Denmark; *Woman at a Window*, Stuart Shave/Modern Art, London; Mary Mary (off-site space); *Drawing: Sculpture,* Leeds Art Gallery and The Drawing Room, London; *Tracing the Century: Drawing from Tate Collection*, Tate Liverpool (2012), and *The Geometry of Things*, GAK Bremen, Bremen (2013).

Experience of living and working as an artist in Glasgow

In 2002, while I was in third year at The Glasgow School of Art, Aleana (Egan) loaned me *Mrs Dalloway* …

While writing *Mrs Dalloway*, Woolf wrote in her diary of her digging 'beautiful caves behind characters … the idea is that the caves shall connect, and each comes to light at the present moment.' The allegory reveals Woolf's concern with a human geography and the power of spaces to unite or divide people.

I studied with a group of inspirational women at The Glasgow School of Art, including Aleana Egan, Hannah Robinson and Harriet Tritton, and I also met my best friend, Tim Facey, there. At GSA we had an interior freedom to develop our thinking and making, and it was clear we would be united by our shared ideas, doubts, such swapped books and films. Together, we looked at things we liked, and things we didn't like (or understand), we asked difficult questions of ourselves, and tried to answer them; somehow we learned to funnel the compulsion to make art into matter. The seeds planted in moments then, are essential to me now.

In my work I often deal with a kind of liminal space: the ceremonial borderline of frame, implied door or window, holding a mythic and even mystical significance in our understanding of ourselves, embodying both restriction and liberation. Crossing the threshold of GSA we entered a new revelatory world, which we would not fully understand the significance of, until crossing out again, altered.

ADELE PATRICK

Studied at The Glasgow School of Art: Embroidered and Woven Textiles Department 1982–4, MA Design 1984–6
Taught at The Glasgow School of Art: Historical and Critical Studies Department 1991–2003

After first completing a BA in Embroidered and Woven Textiles, Adele gained an MA in Design and whilst a postgraduate student she co-founded Graven Images Design company. She taught Gender, Art and Culture Studies in the GSA Historical and Critical Studies Department and gained a PhD in Media Studies in 2004. She has been involved in research and academic and community learning and teaching on gender for twenty years. Adele co-founded Women in Profile and Glasgow Women's Library where she is currently Lifelong Learning and Creative Development Manager and is a Fellow of the Royal Society of Arts.

Experience of living and working as an artist in Glasgow

In the mid-eighties female students could feel immobilised; bookended by 'The Glasgow Boys' of the nineteenth century and our contemporaries, dubbed the 'New Boys'. I have palpable memories of the power wielded by the 'pale, male and stale' brigade, reluctant to relinquish their grip on the institutional laurels and who held ideas about women (artists and designers) that would beggar belief today. It was a challenging environment for anyone embarking on a trajectory of feminist enquiry (hence the rhetoric of the battleground evident in my work from this period). I remember too, the thrill and allure of the city; I will be eternally grateful for the love, care and instruction on how to survive and thrive at GSA and in Glasgow dispensed in the GSA girls' hostel. I valued the fantastic, lone 'female and feminist' figure cut by Sam Ainsley, who was and is a figurehead to so many of us. This felt like a period of risky experimentation and febrile excitement when ideas about feminism, a post-punk aesthetic and the impact of postmodern thinking in art and design was throwing up challenging questions about notions of glamour, fashion, consumerism and commodification for us personally and in our practice.

CORIN SWORN

Studied at The Glasgow School of Art: Master of Fine Art 2007–9

Corin Sworn was born in London; however, her family later immigrated to Toronto. She studied Psychology and Art History at the University of British Columbia; Integrated Media at Emily Carr Institute of Art and Design in Vancouver and obtained an MFA at The Glasgow School of Art in 2009. She attended a residency at the Bauhaus in Dessau and completed the AAP at LUX in London. Recent exhibitions include the following venues: the Chisenhale Gallery, the Kunstverein Aachen and at the 55th Venice Biennale with Hayley Tompkins and Duncan Campbell.

Experience of living and working as an artist in Glasgow

I stopped into Sorcha Dallas Gallery one day. I had been in the city about a year. The exhibition comprised sculptures made from jersey, from denim, some beautifully fashioned hooks, a white branch holding a string of tenuously associated materials and, low on one wall, a spray paint sunset. Intrigued, I reached for a press release but this enunciated its ideas as obliquely as the sculptures stood in the gallery.

I had been used to press releases, which like maps, functioned as carefully laid guides linking material structure to meaning. Here though the terrain was not so forthright.

I would not have described this moment as any specific encounter at the time but looking back the bewildering works and the waylaying text opened a relationship to meaning that I have grown somewhat accustomed to in Glasgow. It is not a straightforward relationship but one that is reticent and provoking, difficult and alluring. I cannot, even now, do justice to it but this fraught encompassing of ambivalence, complexity and difference is one of the things I value most about working here.

2014

A curator, writer, publisher and designer, Juliana
Engberg is currently the Artistic Director of ACCA
(Australian Centre for Contemporary Art, Melbourne,
Australia) and Artistic Director of the 19th Biennale
of Sydney (2014). Curator of the Melbourne Festival
Visual Arts Program (2000–6), in 2007, she was
the senior curatorial adviser for the Australian
presentations at the Venice Biennale.

A DARK ROMANCE

It began with a visit from a group of three curators from Scotland in 1996. I was then senior curator at the Heide Museum of Modern Art in Melbourne. The visit had been arranged with Sydney, but it was my city of Melbourne that the Scots found simpatico. Together with my fellow curators Max Delany, Charlotte Day and Stuart Koop the visit was reciprocated, and we followed it up with a number of exchange exhibitions at the Melbourne venues Heide MoMA, ACCA and Gertrude Street and then with shows back in Glasgow in 1997 and 1998. The love affair between Melbourne and Glasgow had begun.

I've worked with Scottish artists a lot. I came to the country when I was research-ing works for the *Melbourne International Biennial: Signs of Life* in 1999, and my host then was Sam Ainsley from The Glasgow School of Art. The Scots have become close colleagues and friends. After that I made a point of going to Scotland as often as I could. I was invited to become a visiting critic at The Glasgow School of Art. In some years I might visit five or six times. Although I actually live at the other end of the world, I've visited Scotland so many times that I often find people in the wider art world think I live there.

I've travelled a lot and worked with artists from many countries, but Scotland's artistic community really is unique: it's very tight, immensely self-supporting, a collegial group of people. What fascinates me is that there is no style, no single aesthetic. Every artist I have come into contact with pursues their own process and their own problems. If there is a single thing they share in common it is a sense of rigour. I feel that the artists there have been so well educated and the way that they work with their peers is so thorough. They are erudite, self aware, and take art practice very seriously. People are well read, very knowledgeable. Maybe it's the cool climate that allows people to think like this. I never feel things are hurried. And I've noticed that there is always time to stop and eat and talk.

I always tell my colleagues that they will be astonished when they go for a studio

visit with artists from Scotland: it will be so well prepared and the exchanges can be profound. The intensity of that communication is immensely enjoyable from a curatorial point of view. I wonder if it must be something about the early training of artists. But there is also a generosity. With studio visits you come with one purpose, but you are encouraged to visit other artists and pursue other avenues.

In 2009 I was invited to curate an exhibition for the Edinburgh International Festival. I called it *The Enlightenments*. For me, Edinburgh epitomises the ideals of the eighteenth-century Scottish Enlightenment with its neoclassical beauty and places of learning, law and finance. The city also exists as a series of warrens and darker places. Its Enlightenment edifice is built upon a maze of intriguing geological fissures, labyrinthine architecture and iniquitous underworlds. I worked with artists from around the world and my experience in Edinburgh was incredibly enjoyable. There were challenges for me: in Australia we are so used to working with vast space, both big gallery spaces and of course geographically. I was so pleased to help support the renovation of the Georgian Gallery at the Talbot Rice in Edinburgh, where we showed the American conceptual artist Joseph Kosuth. Working relationships were good. Australians and Scots seem to have a natural way of speaking to each other and at the National Galleries of Scotland I felt that I should involve the whole team. At the Scottish National Gallery of Modern Art the Australian artist Gabrielle de Vietri showed *Hark!*, a work where musicians sang the daily news, horoscopes, and the stock exchange

Henry Coombes **I am the Architect, This is not Happening, This is Unacceptable** (still), 2012

reports. I talked to all the invigilators every day; it was important that they understood that they were a part of what we were doing and they could take some joy from it.

This year, 2014, I am the artistic director of the *Biennale of Sydney: You Imagine What You Desire*. It's a huge project with five venues and over 100 artists from around the world. In this year's biennale, there is a fair contingent of artists from Scotland. It's not about showcasing, it's not about saying that Scottish art is hot, but I do hope it shows that Scottish art is good. Everything is very purposeful, everything has its place. It's a set of individual projects, each completely different from the next.

Inviting the artist Nathan Coley, I wanted to commission some of his illuminated text works. I needed something to link my different venues, but it's also about the ideas, to illuminate the night sky, to plant a seed in people's minds. Nathan elected to work with my title and expand upon the quote of George Bernard Shaw that I had: *You Imagine What You Desire*, *You Will What You Imagine* and *You Create What You Will*. Placed at three of my major venues, the words have such a lovely ambiguity about them and send a message to the individual as well as the collective.

With Jim Lambie's work I wanted something shifting and kinetic and boisterous. I gave Jim a room with as many columns and odd corners as I had at my disposal. I also wanted to reveal the romanticism that lurks within the work of the artist Martin Boyce. I think people think of him as hard-edged, interested in architecture and Modernism, but I feel that under that is the beating heart of a romantic. Martin's beautiful oasis is a lively, moody mise en scène. Corin Sworn's work *The Rag Papers* is a fascinating detective story. I first saw her video work *After School Special* at the Gallery of Modern Art in Glasgow; she was so interested in an underlying sense of story that may come from her Canadian background and her immersion in Scotland. I fell in love with Henry Coombes's fabulous video work, *I am the Architect … * when I visited it during the Glasgow International festival in 2012. It had a great run in Sydney and chimed with our Antipodean interest in the myth of the architect as a kind of genius.

I think there is a literary sensibility that underpins much of the work I've seen from Scotland: a lurking and dark romance. That's certainly true of the sensational installation *Phantom* by Douglas Gordon in which he combined his slow-moving tempo of an eye with the ravenous voice of the musician Rufus Wainwright in a moody ensemble of video, piano, mirrors and sound to create a space of great, brooding beauty.

In my work as a curator I welcome spectacle, I even welcome the idea of entertainment because I'm not of the opinion that they are mutually exclusive to content and meaning. I use spectacle as a tactic to lure an audience towards something, and then once I've enticed them I'll sit them down to talk about something complex or demanding. Equally, I am not shy about smaller intimate things. Works that make you bend in and examine and think. The Scots for me sit somewhere between the spectacular and the intimate, and perhaps this is their great aesthetic achievement.

The Glasgow-based artist David Sherry works in drawing, sculpture and music, but he is probably best known for his performances. His work is often humorous and reflects on the absurdities of life in general, but it also cheerfully skews the recent history of art and the peculiar social rituals of the art world. This previously unpublished text is a transcription of a 2012 live performance in which, reading from a handwritten list, the artist recalls the responses his work has provoked in audiences, fellow artists, collectors and art professionals. In 2014 the artist also made a screenprint edition of his original handwritten notes.

Transcript of the performance *What's it all About?*, 2012.
Previously unpublished

WHAT'S IT ALL ABOUT?

One lady said that one of my videos was like a family album.

Another guy prescribed different cults for me to look into.

A girl said my work was like marmite.

A man said it was bullshit.

Someone asked my wife what it was about.

One guy said my older stuff had a lot of spunk.

One lady said she was impressed by how I've kept on doing what I do this long.

One guy said, 'I don't think it's just frivolous; it's got a serious side.'

Two guys kind of attacked me at a talk, one said, 'What's it about? You're like Andy Warhol, just talking and not saying what it's about.'

One guy said, 'You always photograph yourself doing something with other people looking at you in the background.'

One guy said he was going to take me to LA.

One gallerist said he was going to give me a big show, just before he got the sack.

One guy said, 'there's room in Glasgow for that kind of humorous stuff you do.'

One lady said do I feel that, that work's a bit of a vulture on your back.

One guy said he liked my show but that piece is up your ass.

One lady asked me where all the successful artists had gone.

One guy said I was a latent talent.

One man said he liked the fact I didn't take myself seriously.

One guy said my work was something I take away with me rather than the viewer takes away with them.

One woman said to get in touch and maybe we'll do something in Ghent.

One gallerist asked me if those drawings were important to the show.

One guy asked me what music I like.

Another guy asked me if I make work with the radio on.

One lady got really angry when I told her I had made the piece up.

One man said he hopes I make money from my work, because his daughter makes work – the same as mine.

One man came up to me and asked me if I like Martin Creed.

One artist told me he had to take a piss.

One artist told me that they were skint and that we should organise a group to kick-start something.

One artist told me that they were 65 going on 35.

Another I met coming out of a show came up to me and said, 'Now that's a show!'

One lady emailed me to say her daughter was doing a thesis on my work and could I send her info, links and essays as she has a deadline in four weeks.

One curator lost all my DVDs; another gave them to someone else in a plastic bag. One curator says my DVDs are in a big pile in his office and that he has two piles, one he wants look at and one he doesn't want to look at – and my DVDs are in the pile he wants to look at.

One man told me he couldn't draw a straight line with a ruler.

One guy says my name comes up from time to time.

One person accused me of making a work I had never made called *Chicken on the Motorway* so I decided to make that work.

When one artist asked me about a previous work, he said I should stop talking because it was like he was making me relive a trauma.

One gallery emailed me to say that the project had come to an end, and that it was great working with me, wishing me lots of luck in the future.

One curator said I pop up in unusual places from time to time and I am someone to keep track of.

Someone else said it was an important time for me.

One guy said that curators don't want to pick apples from the confused tree.

A lady from New York came to look at my work and said I had a nice flat.

During one performance one artist said I looked like a character from *Blade Runner*.

Another person blew in my ear. Another guy said he just wanted to slap me in the face.

My dad said what about the 3-letter word: job.

One lady said if I was Marina Abramović I would have pulled all of my hair out.

One guy said we need more of my kind of enthusiasm.

One man asked me about my family.

Someone said my work was like the Fluxus movement.

One collector said, 'Yeah, it's fun!'

One writer said that one of my works was like a cross between Nelly the Elephant and Humpty Dumpty.

One gallery said it wasn't financially viable to show my work.

One guy said that it was a pity for me that, that other artist is doing a similar thing over at Frieze Art Fair.

One gallerist said someone at the gallery knew some of my work.

Someone said that someone else was thinking about buying a piece of mine since 2004.

One guy winced at me about prices.

One curator looked at my drawings for 20 minutes in silence and then said, 'I don't know.'

One lady asked me what I'd do if I had a lot of money.

One curator said my work was like another artist's work only he makes beautifully crafted pieces and not as raw as my work. RAW RAW RAW.

GENERATION Project Management

Executive Steering Group
Iain Munro, *Deputy Chief Executive, Creative Scotland (chair)*
Sir John Leighton, *Director-General, National Galleries of Scotland*
Bridget McConnell, *Chief Executive, Glasgow Life*

Advisory Board
Glasgow Life: Jill Miller, *Director of Cultural Services*
British Council Scotland: Lloyd Anderson, *Chief Executive;*
Juliet Dean, *Visual Arts Advisor*
BBC Scotland: Sharon Mair, *Project Executive – Commonwealth Games;*
Andrew Lockyer, *Project Producer – BBC @ the Quay*
Creative Scotland: Leonie Bell, *Director of Arts and Engagement*
Event Scotland: Marie Christie, *International Events Director – Culture*
Museums Galleries Scotland: Joanne Orr, *Chief Executive;*
Lori Anderson, *Relationships and Partnerships Manager*
Visit Scotland: Malcolm Roughead, *Chief Executive*

Curatorial Board
Amanda Catto, *Portfolio Manager, Creative Scotland (chair)*
Katrina Brown, *Associate Curator, GENERATION*
Simon Groom, *Director, Scottish National Gallery of Modern Art*
Sarah Munro, *Head of Arts, Glasgow Life, Director, Tramway*
Keith Hartley, *Chief Curator, Scottish National Gallery of Modern Art*
Victoria Hollows, *Museum Manager for Socially Engaged Practice
and Research, Glasgow Life*
Lucy Askew, *Senior Curator (Exhibitions), Scottish National Gallery of Modern Art*

GENERATION Project Team
Jenny Crowe, *Project Manager*
Iona McCann, *Public Engagement Coordinator*
Moira Jeffrey, *Publications Editor*
Chloe Shipman, *Digital Project Manager*
Lesley Young, *Public Commissions Project Manager*

→ Thanks

The Curatorial Board would like to thank the many individuals who have contributed to the development and realisation of this publication: firstly, to the artists, without whom there would be no project. We thank the individuals who responded to the call for ideas for archival texts which contributed so fruitfully to the selection of writings selected for this volume, and to the artists and writers who gave their permission for these texts to be re-published here. We thank the authors who took up our invitation to contribute new essays to the publication and who responded so eloquently: Juliana Engberg, Dr Sarah Lowndes, Dr Francis McKee, Professor Andrew Patrizio, Jenny Richards, Nicola White and Louise Welsh.

The format and scope of the publications supporting the project were conceived by an Editorial Board and we are grateful to those who gave so freely of their time and expertise to this: Steven Cairns, Curator; Dr Sarah Lowndes, Lecturer, The Glasgow School of Art; Professor Neil Mulholland, ECA, the University of Edinburgh; Dr Dominic Paterson, the University of Glasgow; and Professor Andrew Patrizio, ECA, the University of Edinburgh, as well as Moira Jeffrey (editor) and Katrina Brown (associate curator, GENERATION). We thank the Publishing team at National Galleries of Scotland who have managed the complex production with support from colleagues at NGS and Glasgow Life along with the project team for GENERATION.

We are indebted to the diligence of Moira Jeffrey, who not only helped to define the publications strategy at the outset in her role as moderator of the GENERATION Editorial Board but who has brought integrity, energy and attention to detail in her role as editor of the resulting book you now hold in your hand.